Lothar Hempel
Alphabet City

Lothar Hempel
Alphabet City

Table des matières

Table of Contents

Yves Aupetitallot
Directeur

L'œuvre de Lothar Hempel (né en 1966 à Cologne ; vit et travaille à Cologne) constitue l'une des pratiques artistiques actuelles les plus riches et les plus complexes. Ses installations combinent le plus souvent peintures, dessins, collages, photographies, sculptures et vidéos, qui constituent comme autant d'éléments d'un fascinant théâtre. L'artiste transforme en effet l'espace d'exposition en une scène sur laquelle le spectateur devient acteur d'une narration faite de renvois et de contradictions. Les œuvres sont tout à la fois le synopsis, le décor, les personnages et les accessoires d'une scène de théâtre. Elles représentent les éléments disparates d'un récit créé à partir de références faites aussi bien à l'histoire de l'Allemagne, à la psychologie, à la tragédie grecque, au cinéma, à la musique, à l'histoire politique et sociale qu'à la neurologie.

Lothar Hempel use également de différents styles ainsi que de différentes stratégies, qu'elles aient été inventées par Dada, le constructivisme, le Bauhaus ou encore Joseph Beuys. Il utilise des métaphores visuelles à la fois simples et extrêmement complexes en incorporant des images ou des objets trouvés. Les réponses émotionnelles suscitées par les diverses associations possibles ont en commun de pointer l'échec des utopies, y compris le socialisme et le modernisme, et de considérer les questions morales, idéologiques ou éthiques. Créant, grâce à ce théâtre poétique et transcendant, un contexte psychologique entre conscience et rêverie, l'artiste nous invite à un changement de perspective sur les réalités contemporaines, et à imaginer notre propre rôle.

Alphabet City est la première exposition rétrospective de Lothar Hempel. Elle permet, comme cet ouvrage monographique, d'appréhender l'étendue des recherches menées par l'artiste depuis le début de sa carrière et de découvrir des œuvres nouvelles conçues spécialement par l'artiste pour le Magasin. Plus d'une soixantaine d'œuvres sont exposées : peintures, sculptures, installations, œuvres sur papier (collages, dessins, photographies) et vidéos. Chaque salle permet de faire la lumière sur les différentes phases du développement du travail de Lothar Hempel à travers des installations inédites.

Nos remerciements s'adressent tout particulièrement à l'artiste pour sa générosité et son engagement dans ce projet et à Florence Derieux qui en a assuré le commissariat avec rigueur et patience soutenue par le sérieux de toute l'équipe du Magasin. Nous nous félicitons que la production de nouvelles œuvres ait pu être entreprise dans le cadre de cette manifestation. Enfin, ce projet n'aurait pas été possible sans la collaboration précieuse des collectionneurs, galeries, institutions qui soutiennent le travail de Lothar Hempel ; qu'ils trouvent ici l'expression de notre plus vive reconnaissance.

Yves Aupetitallot
Director

Lothar Hempel (born in 1966 in Cologne, where he lives and works) is the author of one of the richest and most complex artistic practices on the contemporary scene. His installations usually combine paintings, drawings, collages, photographs, sculptures, and videos, all of which combine to create a kind of fascinating theater. Hempel transforms the exhibition space into a stage on which the visitor becomes an actor in a story full of cross-references and contradictions. The works are at once the synopsis, the set, the characters, and the props of a play. They represent the different parts of a narrative created out of references to, for instance, German history, psychology, Greek tragedy, cinema, music, political and social history, and neurology.

Hempel also borrows a number of different styles and strategies, whether invented by Dada, Constructivism, the Bauhaus, or Joseph Beuys. He uses visual metaphors that are both simple and extremely complex, by incorporating images or found objects. The emotional responses elicited by the various associations that can be made all question moral, ideological, and ethical issues, and point to the failure of utopias, including socialism and modernism. With this poetic and transcendent theater Hempel engenders a psychological state between consciousness and dream, inviting us to change our perspective on contemporary realities, and to imagine our own role.

Alphabet City is Lothar Hempel's first retrospective. The exhibition offers, like this monograph, an overview of the artist's interests and experiments since the beginning of his career, and features new works made especially for Le Magasin. In all, over 60 pieces are exhibited: paintings, sculptures, installations, works on paper (collages, drawings, photographs), and videos. Each room gives an insight into a particular phase of Hempel's artistic development through a series of new installations.

Our thanks go especially to the artist for his generosity and his engagement in this project, and to Florence Derieux who took on the role of curator with rigor and patience, supported by the professionalism of the entire team at Le Magasin. We are pleased that the production of new works could be undertaken for this exhibition. Finally, this project could not have been possible without the precious collaboration of the collectors, galleries, and institutions that support Lothar Hempel's work; this is the expression of our profound thanks.

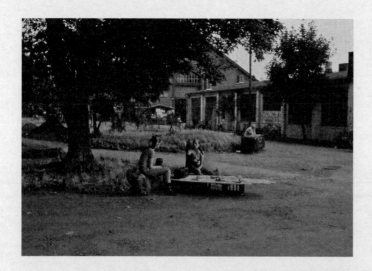

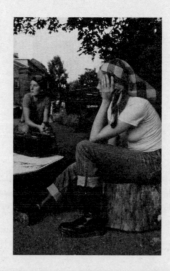

Speaking to the Air, 1996
Performance
Courtoisie de l'artiste

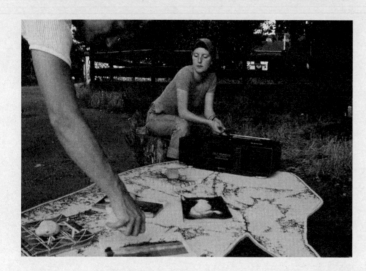

Hilf mir durch die Nacht (Help Me Through the Night), 2004

Aether (Ether), 2004

L'heure bleue de Lothar Hempel

Florence Derieux

« Une histoire ? Non, pas une histoire, plus jamais. »
—Lothar Hempel, *Propaganda*, ICA, Londres, 2002

How deep is your love?

En 1991, Lothar Hempel organise à l'Académie de Düsseldorf une performance qu'il intitule *How Deep Is Your Love?*. Il dessine et imprime 1 000 exemplaires d'un prospectus au recto duquel il inscrit les paroles de la fameuse chanson des Bee Gees en larges caractères noirs. Au verso, apparaissent environ 500 questions tirées d'un test de psychologie : « Dormez-vous nu ? », « Entendez-vous des voix dans le vent ? »... Pendant près de deux heures, Hempel se tient sur un socle blanc, telle une statue, un walkman à la ceinture, et distribue les tracts. Deux petits haut-parleurs jouent en boucle le refrain de « How deep is your love? ». Aucune documentation ne sera réalisée. La performance n'a pour but que de créer de l'expérience – et du souvenir.

Etudiant, Hempel a déjà le souci de prendre en charge chaque aspect des performances qu'il organise, qu'il s'agisse d'une fête ou d'un « set » musical, et il dessine aussi bien l'invitation que le décor, la musique et même les costumes. Ceux-ci représentent les éléments disparates d'un récit créé à partir de références multiples. Il crée alors des situations quasi-cinématographiques qui sont autant d'interventions directes de la fiction dans le champ de la réalité.

« L'œuvre d'art totale » participe également à l'affaiblissement de la polarisation entre « auteur » et « regardeur ». Avec *Speaking to the Air* (1996), Hempel offre ainsi au public la possibilité de prendre la place de l'artiste et de « fabriquer » l'œuvre : réalisé à Christiania, un quartier de Copenhague qui fut occupé à partir de 1971 par différents groupes politiques, le projet consistait à créer des costumes, du mobilier, des posters ou de la musique en collaboration avec de jeunes habitantes de cette « commune » autonome et à élaborer une proposition : une vision spéculative du futur de Christiania.

Images

La mise en place des principes du travail de Lothar Hempel est à rapprocher de ses premières expériences personnelles : l'artiste *se souvient* en effet de Cologne dans les années 1970, celles de son enfance, comme d'un champ complexe mais séduisant de possibilités et de contradictions, un vaste terrain propice à la *dérive*.

Les situationnistes espéraient que leur réflexion sur l'architecture révolutionnerait un jour la vie quotidienne et entraînerait le citoyen ordinaire dans un monde d'expérimentation, d'anarchie et de jeu : « l'architecture, disait Ivan Chtcheglov, est le moyen le plus simple d'articuler le temps et l'espace, de moduler la réalité, d'engendrer des rêves »[1].

1 — Gilles Ivain [pseudonyme d'Ivan Chtcheglov], « Formulaire pour un urbanisme nouveau », 1953, *Internationale situationniste*, n°1, Paris, juin 1958, p. 15–20. Cité par Simon Sadler, *The Situationist City*, The MIT Press, Cambridge, Massachusetts / London, England, 1998, p. 69.

Le rêve pose la question fondamentale de notre rapport au réel. Selon Léon d'Hervey de Saint-Denys, la structure du rêve est diffuse et dynamique : « le rêve est la représentation que se fait notre esprit des objets qui occupent notre pensée »[2]. Il fonctionne généralement sur le mode hallucinatoire, dans le sens d'une *perception sans objet*. Une vue de l'esprit en attente d'activation.

En faisant coexister différentes strates de réalité, Lothar Hempel attribue aux objets un sens fictif, opération qui pour les Surréalistes ne relève pas du jeu mais de la philosophie, et repose « sur la croyance à la réalité supérieure de certaines formes d'association négligées jusqu'ici, à la toute-puissance du rêve, au jeu désintéressé de la pensée ».

Les œuvres d'Hempel, de par leur nature surréelle, semblent opérer directement sur notre perception du monde, comme dans un ultime acte de résistance à la société du spectacle. Car, si le divertissement permanent arrache l'individu à la poésie, à l'art, à la philosophie, si la parole s'appauvrit, devient stéréotypée, perd sa fonction logique ou fonctionnelle et devient slogan publicitaire, Lothar Hempel voit néanmoins dans *l'image* des outils de résistance : « Dans le langage filmique comme dans le langage onirique, vous trouvez des images qui résistent aussi bien à la consommation qu'à l'interprétation »[3].

Utopie

Dans une série d'œuvres récentes, Lothar Hempel revisite un passé qui semble aujourd'hui presque fictif à partir de *The Path to Success* (1989), un livre qui décrit la vie de plusieurs jeunes élèves d'une école de danse de Berlin Est du temps de la RDA, à qui l'opportunité est donnée de jouer sur l'une des plus célèbres scènes européennes. Répétés à l'identique, les personnages révèlent leur incapacité à s'adapter à la situation présente et la discipline des corps pointe moins vers le rêve qu'elle ne désigne l'obsession du contrôle. Conçues comme des publicités inversées, ces figures mettent à nu le récit initial et déconstruisent l'esthétique de propagande originelle.

Au sens où Althuser définissait l'idéologie comme le rapport imaginaire des individus à leurs conditions réelles d'existence, il s'agit moins pour Hempel de remettre en cause des idéologies que la *doxa*, c'est-à-dire l'ensemble des préjugés, des opinions conservatrices et des croyances populaires sur lesquelles se fonde toute forme de communication. A ce système de savoir essentiellement conservateur est opposé celui, progressiste, de *l'épistémè* « où les connaissances, envisagées hors de tout critère se référant à leur valeur rationnelle ou à leurs formes objectives, enfoncent leur positivité et manifestent ainsi une histoire qui n'est pas celle de leur perfection croissante, mais plutôt celle de leurs conditions de possibilité »[4].

Sur cette inscription de l'ordre social au sein même de l'individu, Barthes écrivait « [qu'une] de nos servitudes majeures [est] le divorce accablant de la mythologie et de la connaissance. La science va vite et droit en son chemin ; mais les représentations collectives ne suivent pas, elles sont des siècles en arrière, maintenues stagnantes dans l'erreur par le pouvoir, la grande presse et les valeurs d'ordre. »[5].

2 — Léon d'Hervey de Saint-Denys, *Les Rêves et les moyens de les diriger* (1867), Oniros, Paris, 1995.

3 — Emma Stern (éd.), *Lothar Hempel – Propaganda*, ICA – Institute of Contemporary Arts, Londres, n. p.

4 — Michel Foucault, *Les Mots et les choses. Une archéologie des sciences humaines*, Gallimard, Paris, 1995, p. 13.

5 — Roland Barthes, *Mythologies*, Seuil, Paris, 1957, p. 72 – 73.

Alphabet City

Une partie du quartier de l'East Village à Manhattan s'appelait autrefois *Alphabet City* (la ville alphabet), à cause des quatre avenues A, B, C et D qui la sillonnent. Au milieu du 19ème siècle, ce quartier était appelé «Kleindeutschland» (la petite Allemagne) et était considéré comme la première communauté urbaine non-anglophone. *Alphabet City* a longtemps accueilli les mouvements culturels les plus importants de New York, comme si l'histoire se servait de son nom (de ses lettres) pour écrire le texte des scènes artistiques qui s'y sont succédées.

Commentant le choix d'un tel titre pour son exposition rétrospective, Lothar Hempel définit cette *texture* urbaine particulière comme «le territoire de l'échange et de la perte, où en tant que spectateur l'on est libre de reconsidérer les options disponibles tout en étant au cœur du conflit». Soit, un champ d'expériences, un flux d'images, un réseau d'affects, des plages narratives qui construisent un paysage capable d'inspirer à chacun une réflexion sur son identité. Autrement dit, Hempel pense qu'il est possible de faire, grâce à l'art, l'expérience de quelque chose comparable à un rêve. Et son travail est de construire cette possibilité, ces scénarios ouverts, ces *situations*.

Lothar Hempel, carton d'invitation
Exposition *Fleisch: Maschine*
Magnani, Londres, 2002

Untitled #5, 1999

Untitled, 1999

Untitled (Police Man), 2000

Untitled (Olymp), 2000

Lothar Hempel's "blue hour"

Florence Derieux

"A story? No, not a story, never again."
—Lothar Hempel, *Propaganda*, ICA, London, 2002

How deep is your love?

In 1991 Lothar Hempel organized a performance at the Academy in Düsseldorf, which he entitled *How Deep Is Your Love?* He designed and printed 1000 copies of a prospectus: on the front he put the words of the famous song by the Bee Gees in large black letters. On the reverse side there were about 500 questions taken from a psychological test: "Do you sleep with no clothes on?" "Do you hear voices in the wind?" ... For almost two hours, Hempel stood on a white plinth, like a statue, a Walkman on his belt, handing out leaflets. Two small loudspeakers played the refrain of "How deep is your love?" in a loop. No documentation was to be made. The sole aim of the performance was to create an experience—and memories.

Even as a student, Hempel was keen to take charge of every aspect of the performances he organized, whether the event involved was a party or a musical set, designing both the invitation and the setting, as well as the music and even the costumes. They represented the disparate elements of a story created from many different references. He then created quasi-cinematographic situations which amounted to direct interventions by fiction into the field of reality.

The "total work of art" also plays a part in weakening the polarization between "author" and "viewer." Thus with *Speaking to the Air* (1996) Hempel offered the public the opportunity to take the artist's place and "make" the work: set up in Christiania, a district of Copenhagen that from 1971 was occupied by various political groups, the project consisted of creating costumes, furniture, posters, music in collaboration with young female residents of this autonomous commune, and working out a speculative vision of the future.

Images

The establishment of Lothar Hempel's working principles is closely tied up with his early personal experiences: for the artist *remembers* Cologne in the 1970s, the years of his childhood, as a complex but attractive field of possibilities and contradictions, a huge ground conducive to the *dérive*—exploratory wandering.

The Situationists hoped that their thoughts about architecture would one day revolutionize everyday life and draw the ordinary citizen into a world of experimentation, anarchy, and play: "Architecture," Ivan Chtcheglov used to say, "is the simplest means of articulating time and space, of modulating reality, of engendering dreams."[1]

Dreams raise the fundamental question of our relationship to reality. According to Léon d'Hervey de Saint-Denys, the structure of the dream is diffuse and

1 — Gilles Ivain [Ivan Chtcheglov's pseudonym], "Formulaire pour un urbanisme nouveau," 1953, *Internationale situationniste*, no. 1, Paris, June 1958, p. 15 – 20. Quoted by Simon Sadler, *The Situationist City*, The MIT Press, Cambridge, Massachusetts / London, England, 1998, p. 69.

dynamic: "a dream is the representation our mind makes for itself of objects that are occupying our thoughts."[2] It generally operates in a hallucinatory mode, in the sense of a *perception without an object*. A view by the mind waiting to be activated.

By making different layers of reality coexist, Lothar Hempel attributes a fictitious meaning to objects, an operation that for the Surrealists comes under philosophy rather than play, and rests "on the belief in the higher reality of certain forms of association that have been neglected until now, the omnipotence of the dream, the disinterested play of thought."

Through their surreal nature Hempel's works seem to operate directly on our perception of the world, as in a final act of resistance to the spectacle society. For even if non-stop entertainment draws the individual away from poetry, art, and philosophy, even if the spoken word is impoverished, becomes stereotyped, loses its logical or functional purpose and turns into an advertising slogan, Lothar Hempel still sees the *image* as a means of resistance: "In filmic language as in oneiric language, you find images that withstand both consumption and interpretation."[3]

Utopia

In a series of recent works, Lothar Hempel revisits a past that today seems almost fictitious, the starting point being *The Path to Success* (1989), a book describing the lives of several young pupils at a dance school in East Berlin at the time of the GDR, who are given the opportunity to perform on one of the most famous stages in Europe. Rehearsed in an identical manner, the characters reveal their inability to adapt to the present situation, and the discipline of the body is not so much targeted at dreams as it is indicative of an obsession with control. Conceived as inverted advertisements, these figures expose the initial story and deconstruct the original propaganda aesthetics.

Just as Althuser defined ideology as the imaginary relationship of individuals to their real conditions of existence, for Hempel it is less a question of challenging ideologies than of challenging the *doxa*, i.e. the whole set of prejudices, conservative opinions, and popular beliefs on which all forms of communication are based. This essentially conservative system of knowledge is opposed to the progressive system of the episteme "in which knowledge, envisaged apart from all criteria having reference to its rational value or to its objective forms, grounds its positivity and thereby manifests a history which is not that of its growing perfection, but rather that of its conditions of possibility."[4]

Talking about the way in which the social order is registered deep within the individual, Barthes wrote "[that one] of our major servitudes [is] the oppressive divorce between mythology and knowledge. Knowledge continues on its way fast and straight; but the collective representations of it do not follow, they are centuries behind, kept stagnating in error by power, the popular press, and the values of order."[5]

2 — Léon d'Hervey de Saint-Denys, *Les Rêves et les moyens de les diriger* (1867), Oniros, Paris, 1995.

3 — Emma Stern (ed.), *Lothar Hempel – Propaganda*, ICA – Institute of Contemporary Arts, London, n. p.

4 — Michel Foucault, *Les Mots et les choses. Une archéologie des sciences humaines*, Gallimard, Paris, 1995, p. 13.

5 — Roland Barthes, *Mythologies*, Seuil, Paris, 1957, p. 72–73.

Alphabet City

Part of the East Village district in Manhattan used to be called Alphabet City because of the four avenues A, B, C, and D that cut across it. In the mid-19th century, the same district was called "Kleindeutschland" (Little Germany) and was regarded as the first non-English-speaking urban community. For a long time Alphabet City was home to the most important cultural movements in New York, as if history were using the name (and its letters) to write the text of the artistic scenes that followed one another there.

Commenting on the choice of this title for his retrospective, Lothar Hempel defines this special urban *texture* as "the territory of exchange and loss where as an onlooker one is free to reconsider the available options while being at the heart of the conflict." Indeed it is a field of experiment, a flow of images, a network of affects, narrative streams that construct a landscape capable of inspiring each individual to reflect on his or her identity. In other words, Hempel thinks it is possible, thanks to art, to experience something comparable to a dream. And his work consists of constructing that possibility, those open scenarios, those *situations*.

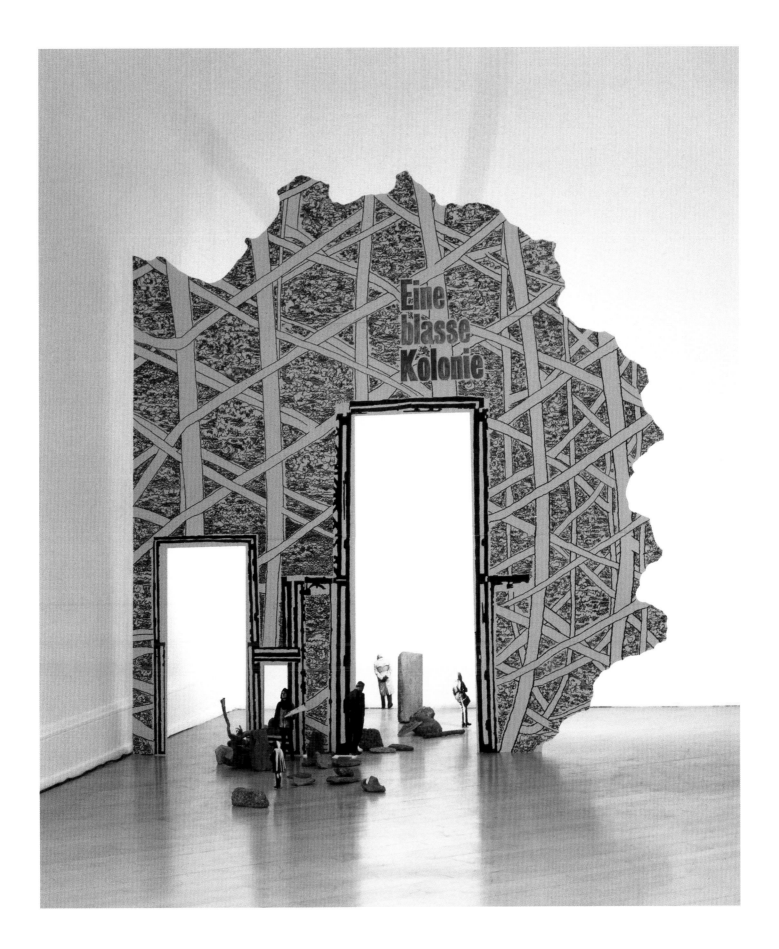

Eine blasse Kolonie (A Pale Colony), 1996

Strom

Anton Kern Gallery, New York

21.09 – 26.10.1996

In the German-English dictionary, Strom, the title of my installation
is defined as:

Strom 1. (large) river; (Strömung) current; (von Schweiß,
Blut – weat, blood) river; (von Besuchern – of visitors)
stream; ein reißender ~ a raging torrent; der ~ der
Zeit (geht) the flow of time; mit dem/ gegen den~
schwimmen (lit) to swim with/against the tide.
2. (Elec) current; (Elektrizität) electricity.

As in a stream-of-consciousness, I brought together here the
juxtaposition of the following elements:

The facade, which might function as a movie set, is inspired by
the view of Broadway from the gallery window. An opening is
made replacing the entrance of the real parking garage which
you can see outside.

Through this opening, "a screen," you can see a model of a
fictional urban scene. This scenario is a montage of driftwood
and stones I collected at the Hudson river side as well as photo-
graphs I took of people strolling down Broadway and Houston
Street.

As a background you see a drawing based on a photograph taken
by members of the Stuttgart Autobahn police exclusively for
this project. There are only 10 Porsches used for patrolling the
Autobahn in Germany. These cars to me always appear as a
metaphor for certain contrasting German motifs—freedom of
speed and methods of control.

The radio is tuned to frequency 95.6 FM, the classical station of
The New York Times.

This work is a proposition.

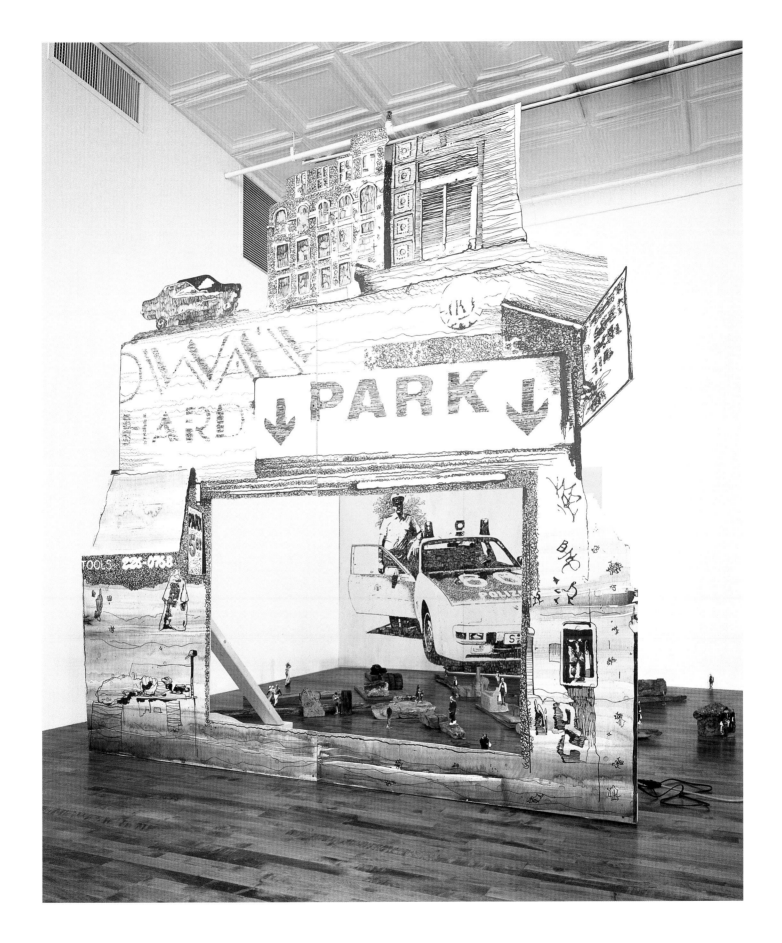

Strom (Current), 1996

APRIL 14, 1982 we are standing on a warm planet with five continents and seven seas. the realization comes clearly and very slowly, calmly and almost tenderly. is it real? is it bad? the blunt gaze, which ate its way through everything like acid, is beginning to slowly rise. the dead are already nearly dead, almost but not quite. franz got it right: a door is closed but through the cracks light still shines. tonight we were standing in a small group under tropical trees in the park and just simply had to laugh.

APRIL 19, 1982 some people have, in the meantime, stopped speaking. a proud disguise for spite. instead they are singing now. laura has found a means against her fear. she stands at the edge of a swimming pool, her back to the water. with closed eyes she imagines that behind her is the deepest abyss. even so, each abyss is finite, she says, and that is my desire. with her arms stretched out in front of her, she lets herself fall backwards.

APRIL 24, 1982 the nights do not have to be black. a burning car lights the sky a pleasant grayish-blue. rumor has it that different brands burn in different colors. peugeots are supposedly the brightest. in the meantime, markus is possessed by an almost missionary zeal. he and his friends gather together flammable materials and build a huge pile in the streets of the entire city. his project is truly gigantic. lit on a particular night, these piles are revealed as a tilted eight, the sign for infinity. this must be wonderful when seen from space.

APRIL 20, 1982 today we went to the stadium. this architecture, intended for crowds of tens of thousands, appears so lonely, strangely unattached and free. the floodlight masts throw cold shadows onto the interior. the grass has grown wild. a few animals already live here. mainly mice, moles, and naturally many birds. one day a small forest will stand here, one that will be visible from the grandstand. we have made bets onto which side of the playing field the first owl will perch on a tree.

MAY 5, 1982 a few people have left the city and have moved to the countryside in search of a limestone cave. the whole time they discussed the possibility of an endless echo and that there must exist a way to make it happen. in the meantime, flying kites has become fashionable. from skyscraper roofs, too. of course, paula has made the nicest kite. almost ten feet long and entirely of tissue-paper, it is a depiction of elizabeth taylor from her stellar role as cleopatra. the effect is most majestic, especially from far away.

MAY 18, 1982 sometimes we think about the past and talk for nights on end, shaking our heads and smirking. some memories have become myths. we compose songs about things we do not want to forget. felix, clara, and kurt are working on a memorial, which will represent the history of different social systems. they have started to erect dioramas on highway bridges. some time in the future one will be able to drive across the highway from the north coast to the south coast, all the while experiencing the political evolution of mankind.

26 MAY 1982 in a church, paul has made a heap of hundreds of pinball machines and lets the taped sounds flow by means of different filters and sound effects. the acoustic is immense and deeply sad in a spiritual way. maria makes large, colorful wax wigs for small dogs, who oddly enough enjoy wearing them. karl has founded a school in whose morning classes the children learn everything about love. in the meantime, it appears that everyone is pursuing their own project, each touching upon another and creating a network through which they are united. sometimes we feel as though each day brings the creation of a dozen new languages.

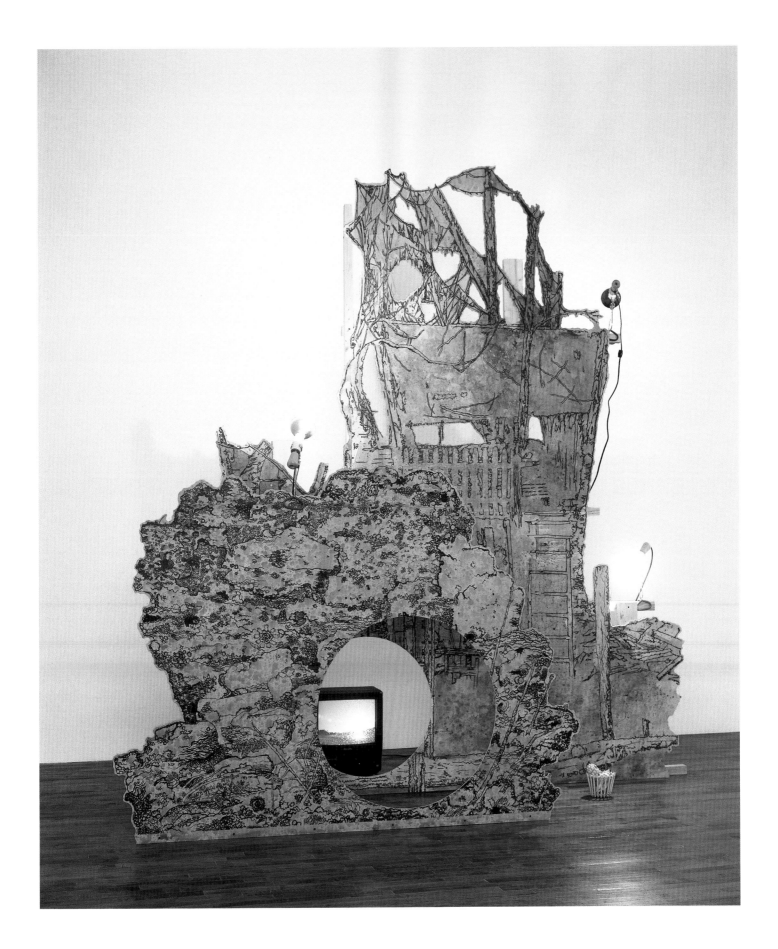

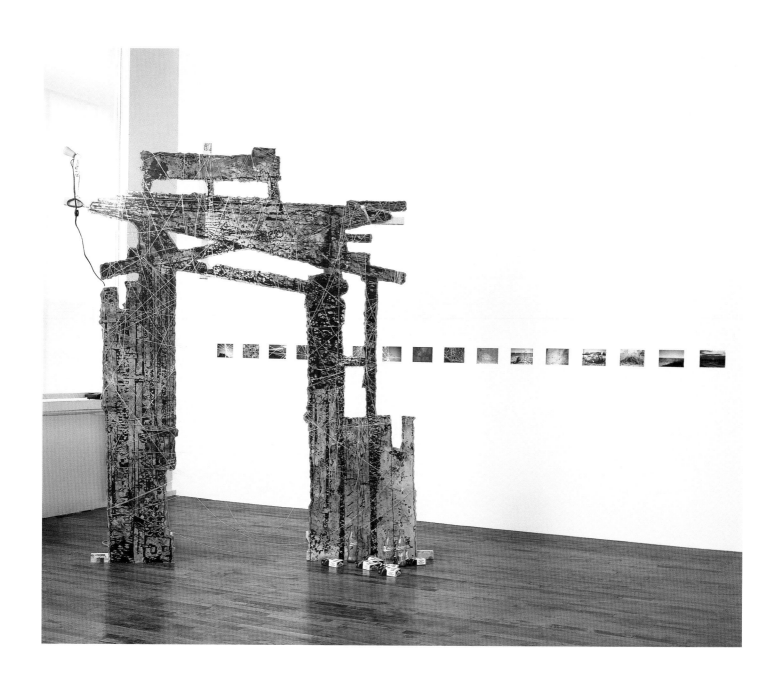

12:00 Uhr Morgens (Twelve O'Clock in the Morning), 1997

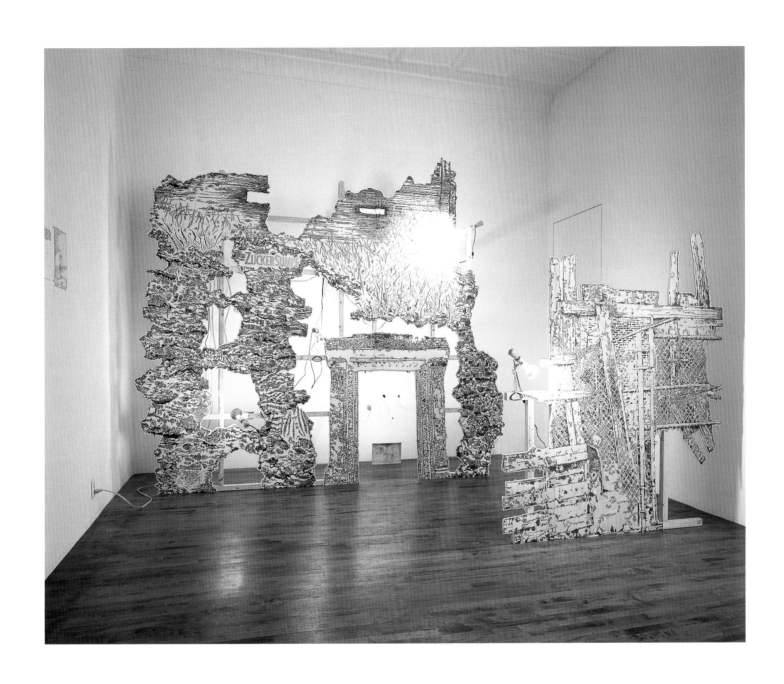

Zuckersumpf (Sugar Swamp), 1997
Eine stolze Form von Trotz (A Proud Disguise for Spite), 1997

Samstag Morgen, Zuckersumpf (Saturday Morning, Sugar Swamp)
Robert Prime, Londres
05.06 – 31.07.1997

THURSDAY "We have to become much more abstract"
said Andrew this morning, and he had to laugh to himself,
because instead of abstract he could have easily said concrete. It
is probably only a question of time before we depart from each
other and work and live in new groups. The new is not going to
be worse or better than the old, only different and possibly only
a way to return to where one had been before. All the possible
attitudes towards life seem to be connected with each other by a
magnificent system of doors, through which you move only to
enjoy the threshold.

[Extrait : le texte original comprend 5 paragraphes (*Monday, Tuesday, Wednesday, Thursday* et *Friday*)]

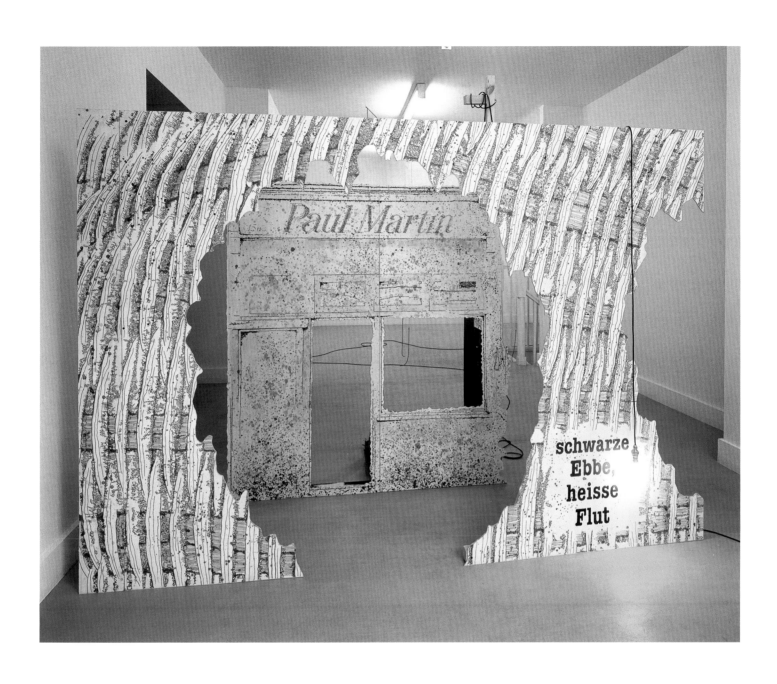

Samstag Morgen, Zuckersumpf (Schwarze Ebbe, heiße Flut / Black Ebb, Hot Flow), 1997

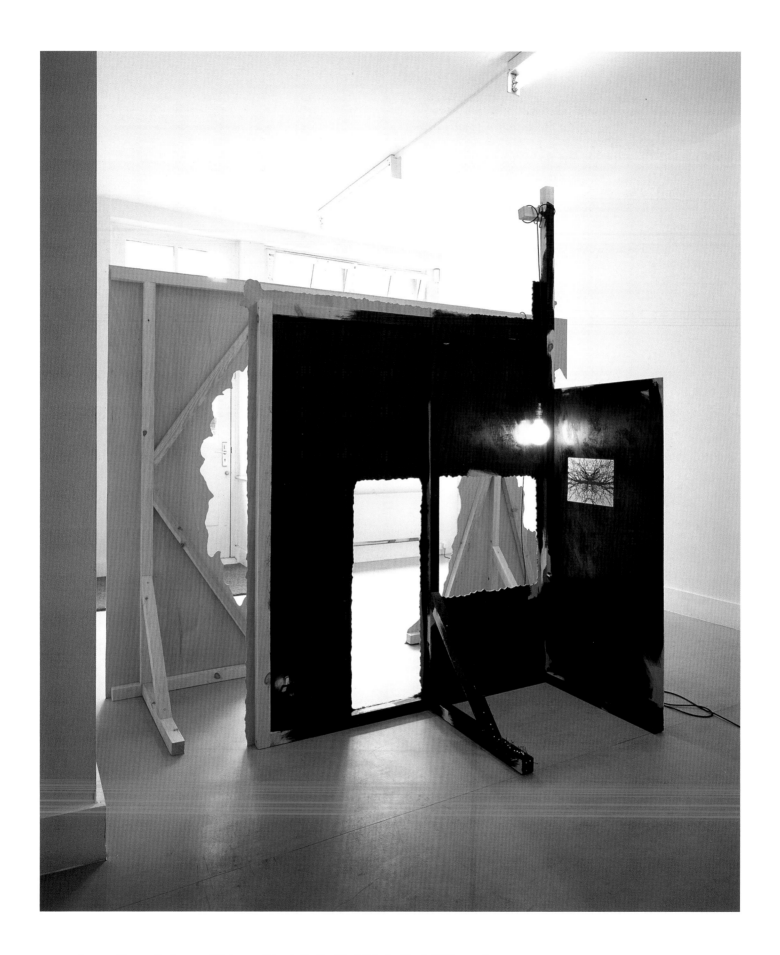

Samstag Morgen, Zuckersumpf (Schwarze Ebbe, heiße Flut / Black Ebb, Hot Flow), 1997 [envers]

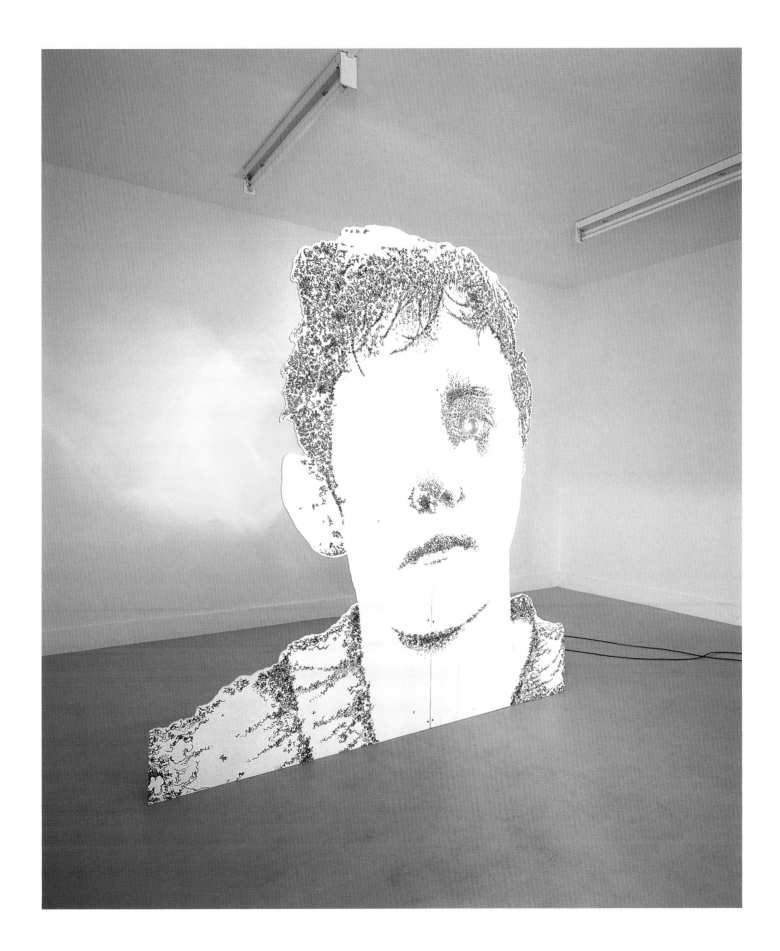

Samstag Morgen, Zuckersumpf (A Clear, Almost Singing Voice), 1997

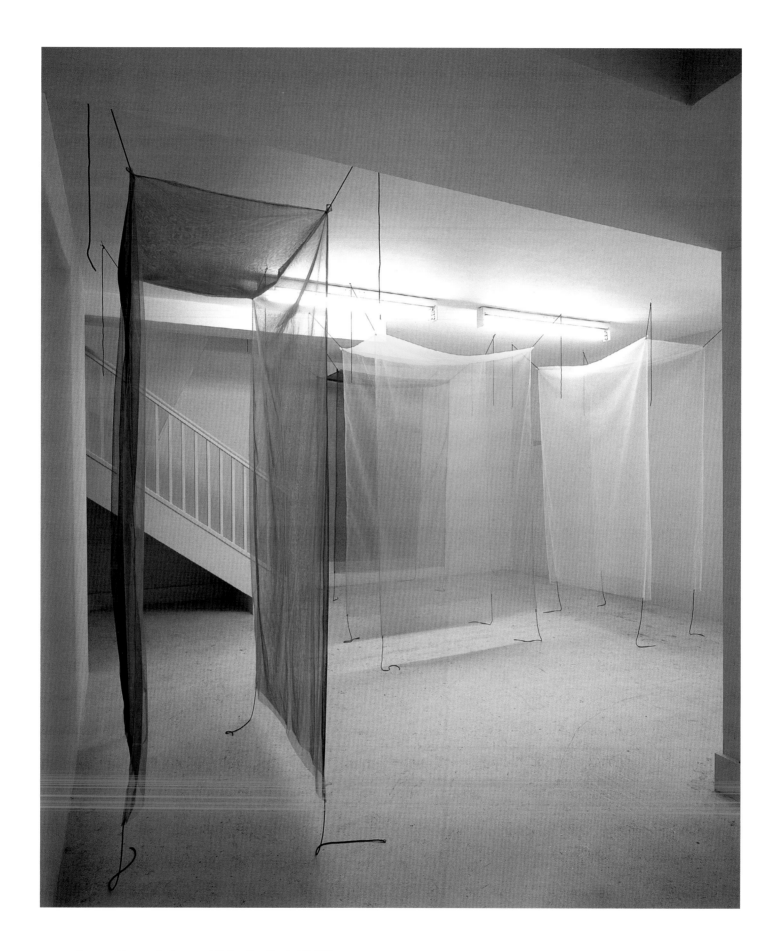

Samstag Morgen, Zuckersumpf (Schwellen / Treshold), 1997

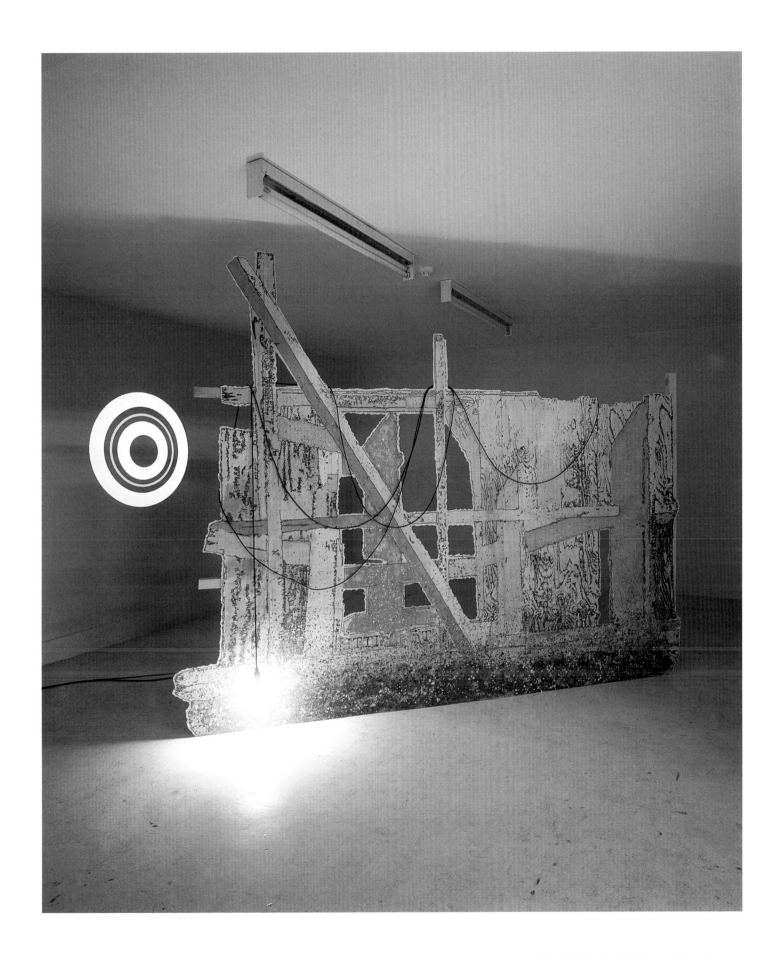

Samstag Morgen, Zuckersumpf (Das kalte Bild / The Cold Image), 1997

Ein Sandstrand voll Glas (A Beach Full of Glass)
Galerie Daniel Buchholz, Cologne
11.12.1997 – 23.01.1998

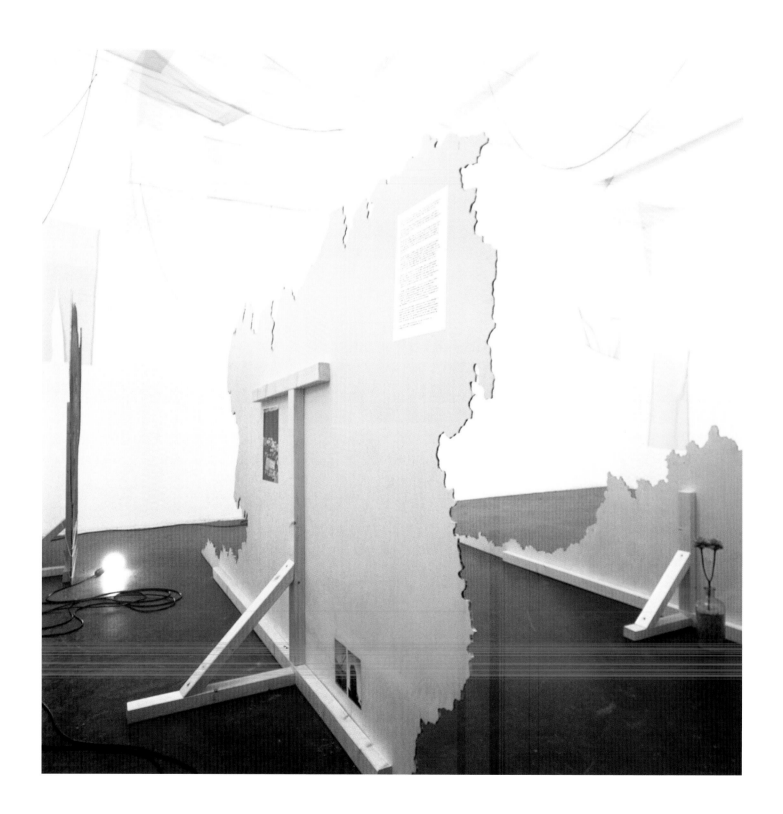

Ein Sandstrand voll Glas (A Beach Full of Glass), 1998 [envers]

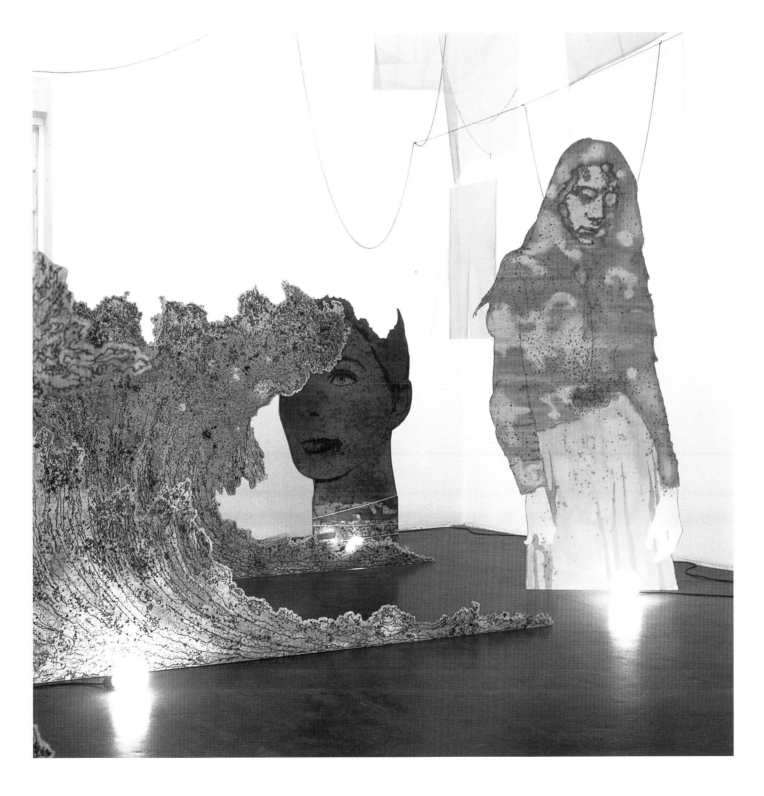

Den Kopf voller Ahnungen (A Head Full of Forbodings), 1999

Kunstschnee will schmelzen (Artificial Snow Wants to Melt)
Stedelijk Museum Bureau Amsterdam
25.04 – 13.06.1998

The Signal Lights Of A Runway

A glass door glides aside. A worn footpath. Muddy and rising slightly, maybe a short track between our way home and a side street. Then a tunnel-like viaduct under a highway. Rain from the last three days collected here in iridescent pools. Then moss-covered stones in a quite ideal yet nevertheless accidental order leading over a small stream. A bridge covered in glass, connecting two office buildings. Silhouettes of birds of prey stuck to the window-panes. Thorns. Then a freight elevator filled with metal containers descending slowly into the basement. Heavy breathing from around a corner. Snow on a layer of ice. Diagonally through a packed auditorium to the emergency exit. Footprints, in a direct line. Sturdy shoes with thick soles. A suspension bridge in a light earthquake. Sudden ravenous hunger. A ditch under a wire fence. Then a wide balcony without plants, connecting two apartments. A swinging door. The ornaments woven into the carpet of another elevator descending back into the entrance hall. Electric current. A metal door, locked tight. The smell of chewing gum melting on a radiator. An empty swimming pool in the night. Imitating swimming movements. A yellow car with a windows that can't be opened. We want to keep going straight ahead, then make a u-turn, then come the same way back. The windows steam up. A path through the woods in late summer, cut across by ants marching in single file. Speed of light. A memory intertwined with a melody. On the horizon, at last the signal lights of a runway. One, or better two, flashlights. Again footprints that we follow, this time in the damp sand of a beach. Sweet cul-de-sacs. Then a pedestrian bridge over a wide exit road. Stupid, much too glaring light. Floating slowly towards the ceiling, laughing. The track in a dilapidated stadium. Floodlight casts four shadows. Rocky ground, earth, linoleum, grass, asphalt, parquet, concrete, glass, or mosaic. A stewardess crying softly.

One Thousand Years Later, 1997

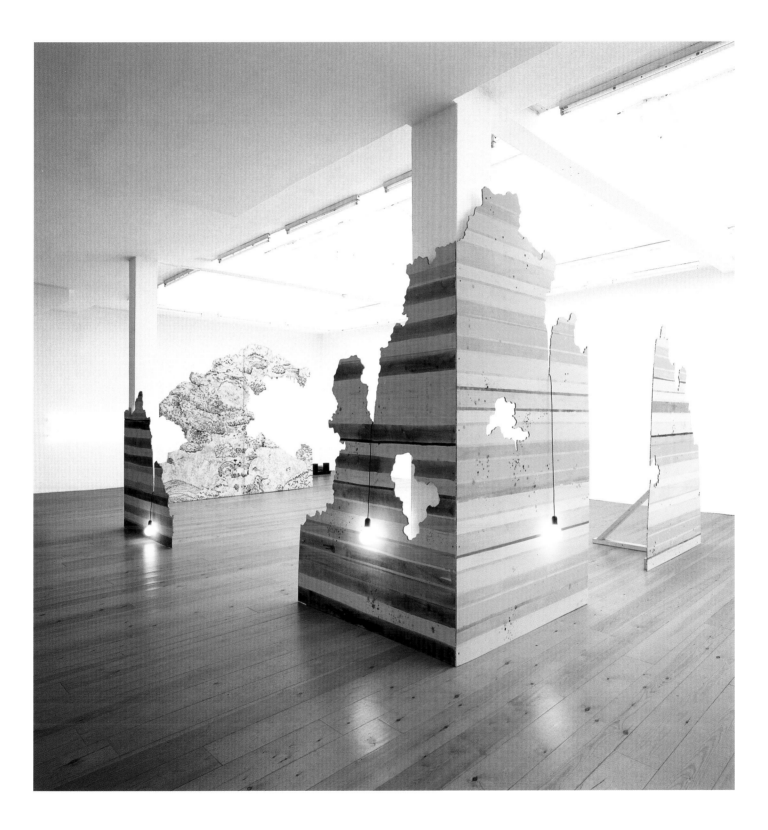

Kunstschnee will schmelzen (Artificial Snow Wants to Melt), 1998

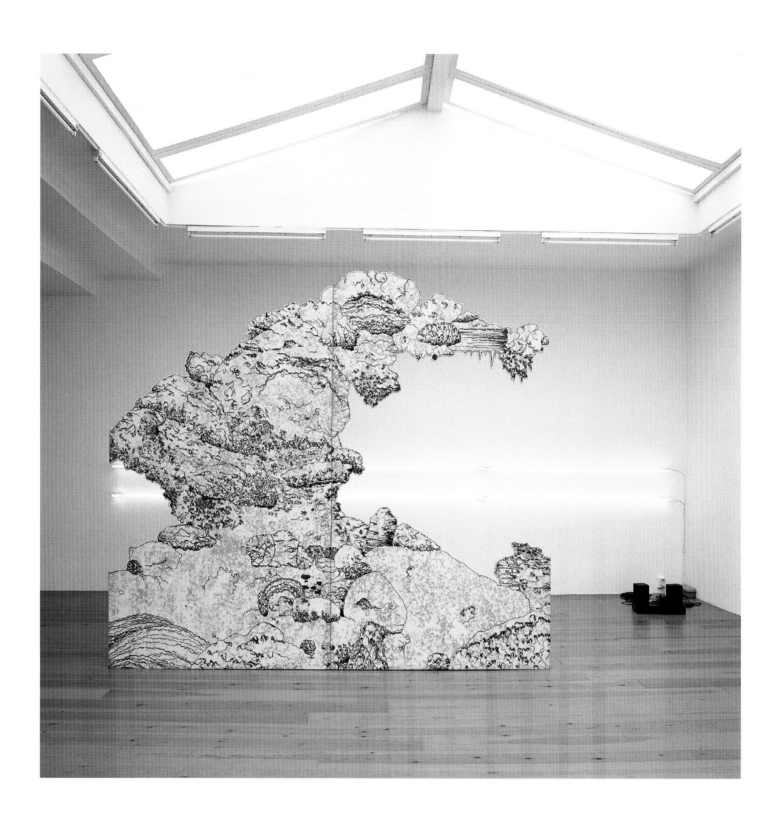

Kunstschnee will schmelzen (Artificial Snow Wants to Melt), 1998

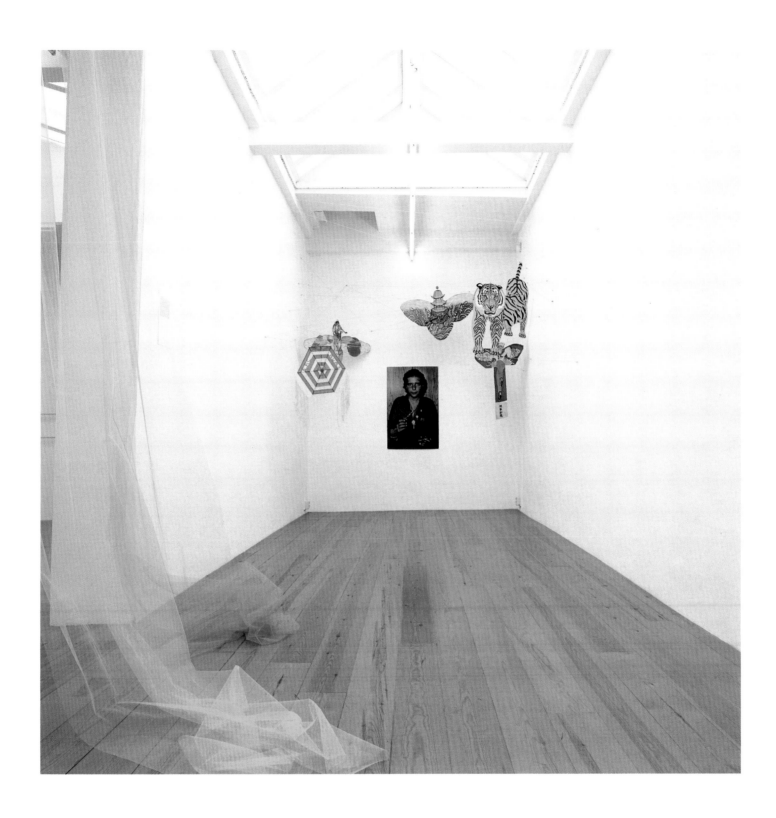

Kunstschnee will schmelzen (Artificial Snow Wants to Melt), 1998

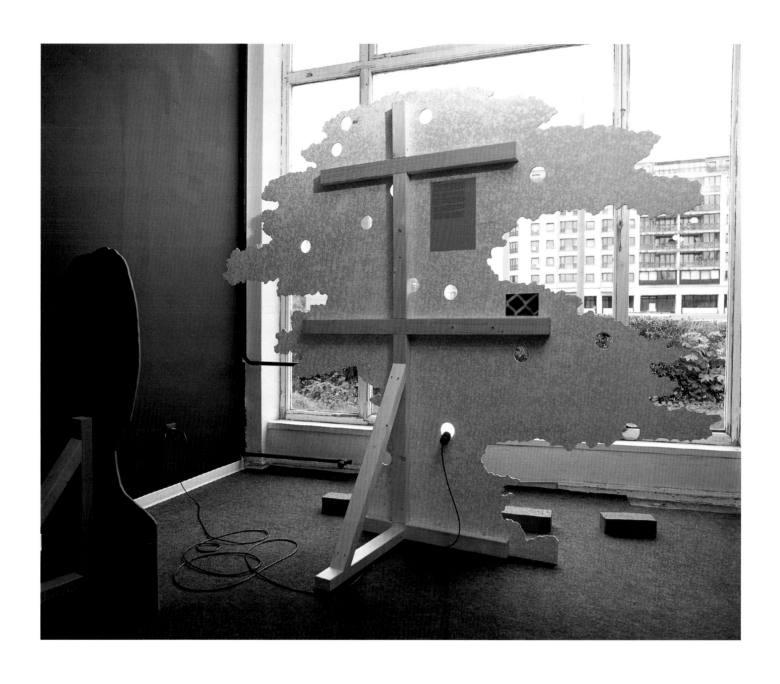

Eine Falle schnappt fast zu (Autumn Leaves), 1998

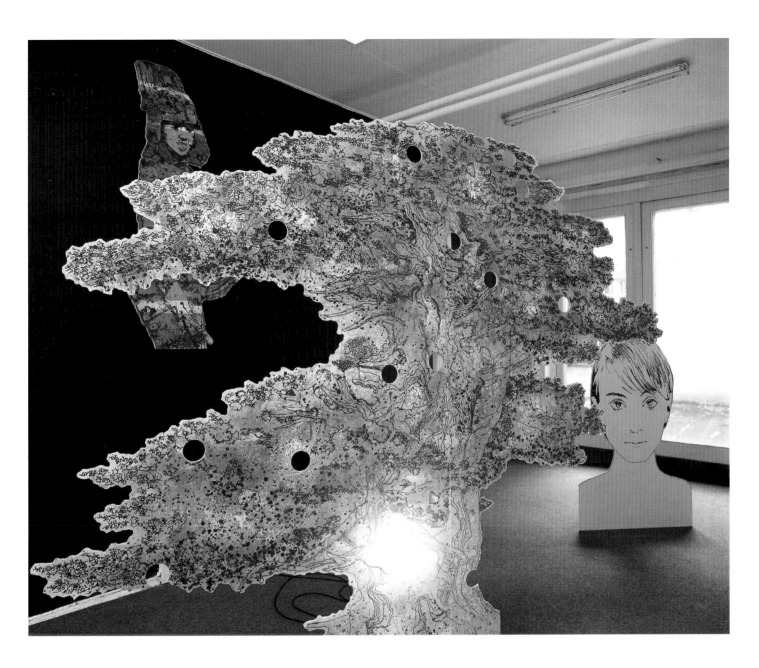

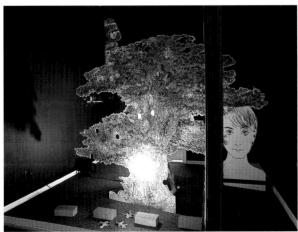

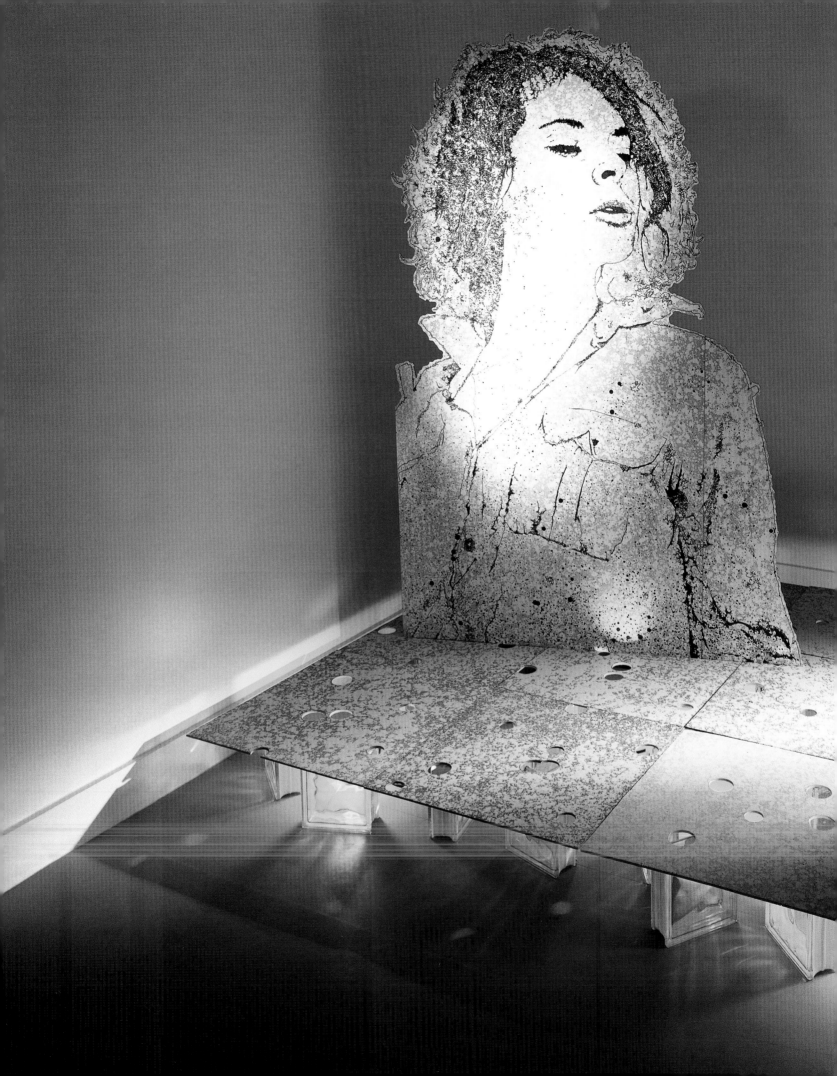

KAPUTT und die Folgen (Kaputt and the Consequences)
Robert Prime, Londres
11.02 – 27.03.1999

Nur das Lächeln bleibt (Only the Smile Remains), 1999

Amerika verschwindet, nur das Lächeln bleibt
(America Disappears, Only the Smile Remains)
Anton Kern Gallery, New York
7 avril – 15 mai 1999

Afternoon Mist

a paper-thin layer of ice crystals on moist, dark mud. a puddle, half-frozen, on which traces of oil slick are swimming. a foolish old engine. the sun of milk. high above it all the condensed stripes of an aircraft. a handful of pale birds, a handful of mild moments. a ballet of bamboo. not now. swathes of mist and dew. a new day and another one, and another one. it doesn't stop anymore. a floating background where all this is just becoming possible. a grasp into the white. solid ground under the feet, first time for weeks.

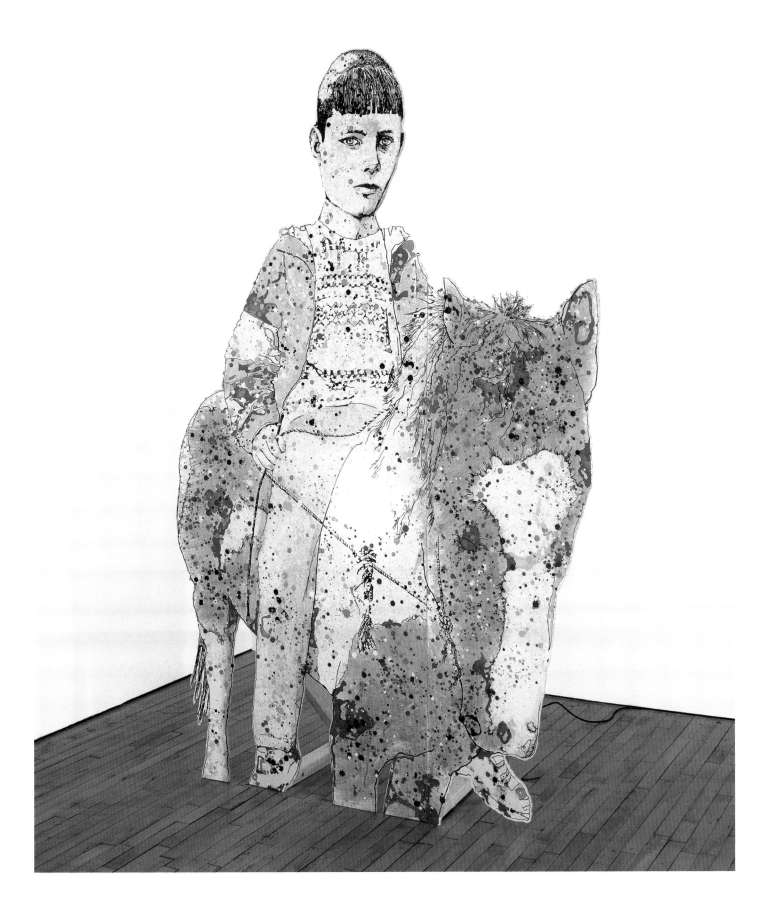

A Simple Story, 1999

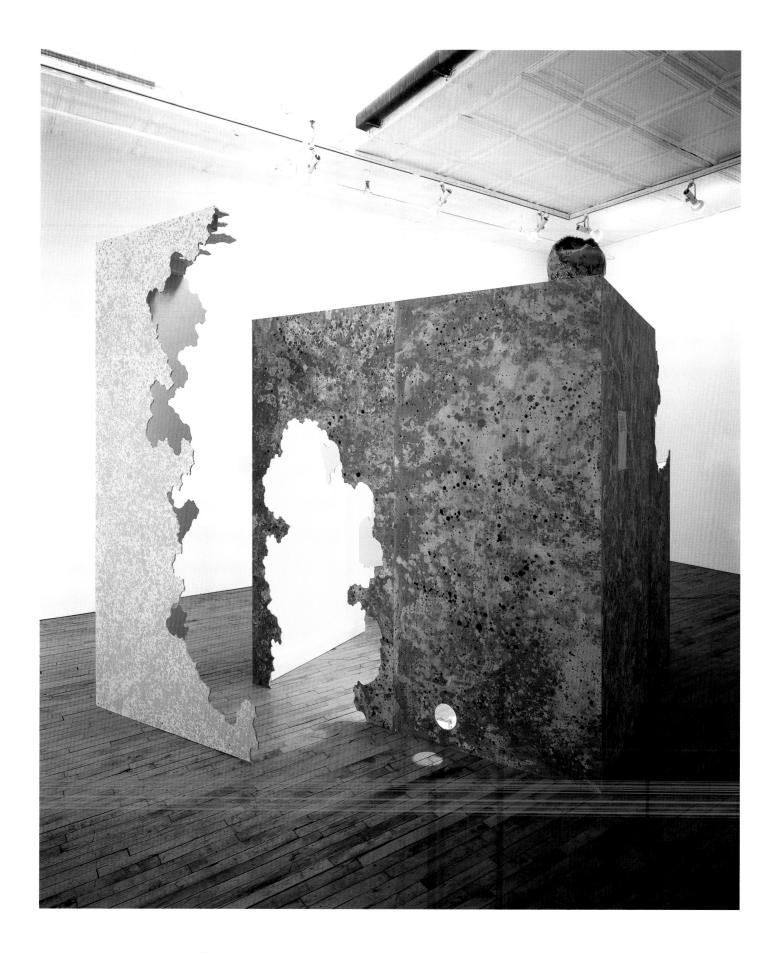

Leave All the Rest Behind, 1999

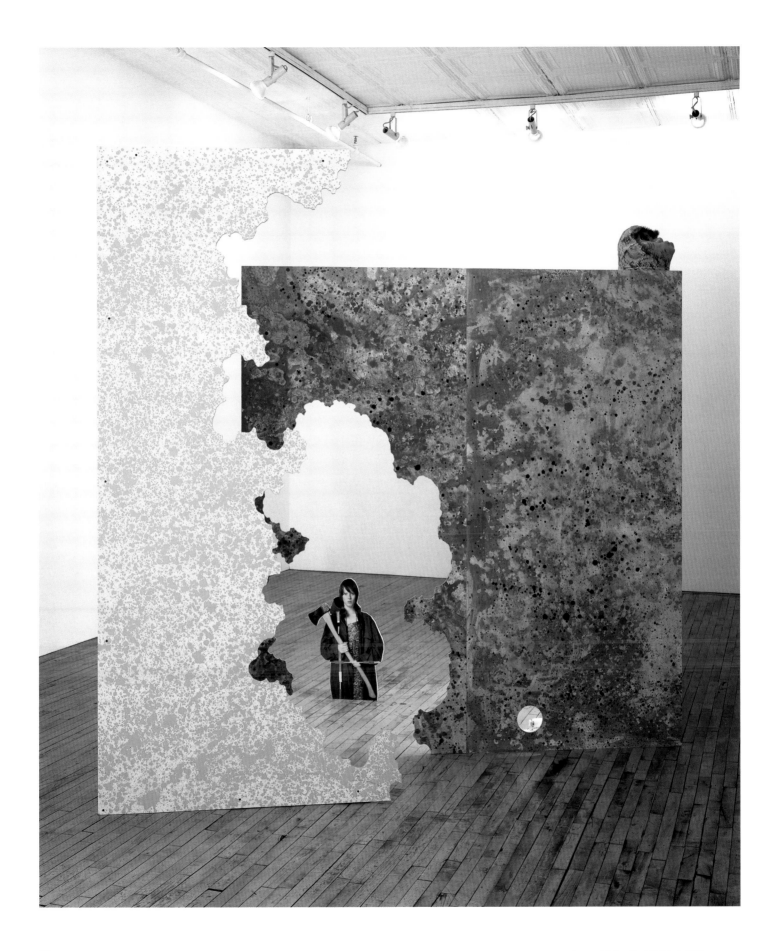

Leave All the Rest Behind, 1999

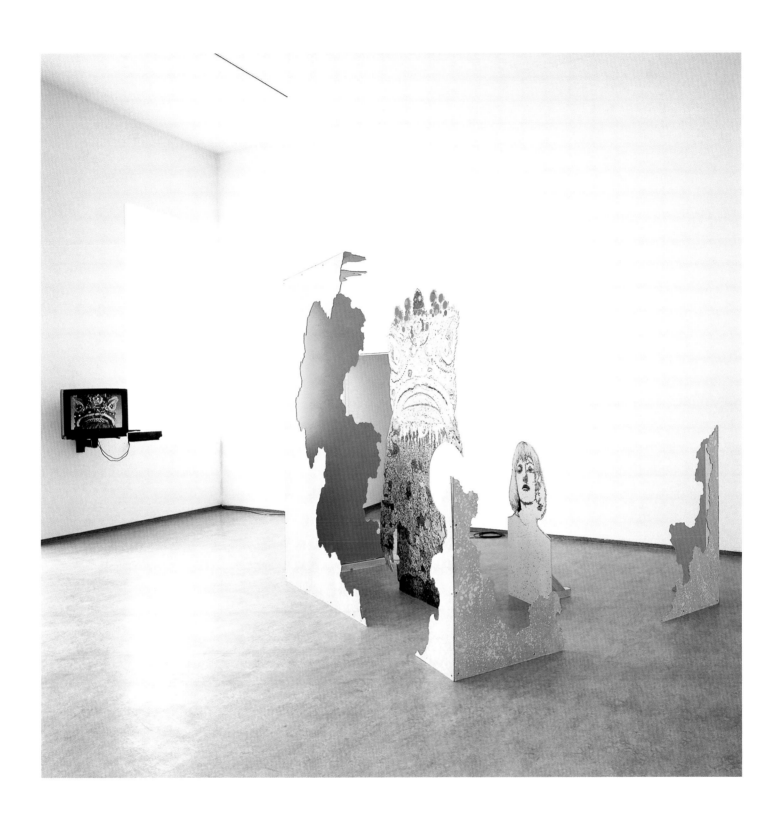

The Observer, 1999

It Is Over

disgusting, these birds everywhere. they are exhaustedly limping through the waste and greedily picking at everything. earlier, centuries ago (when? really?), these birds here in the old entertainment quarter were considered holy, even being offered sacrifices. nowadays, however, they transmit diseases and lose their feathers everywhere and children are throwing stones at them. yesterday you called and you sounded worried. you thought you sense changes taking place everywhere. in many side streets, actually in several places, one could see the impetuous decay. the iron façades are corroding, the rubbish isn't collected anymore, and the light bulbs are not replaced. it squeaks, cracks, and falls apart. and as a matter of fact: the air is polluted with departure and melancholy. nightmares in the darkness and during the day, posters everywhere that summon violence. visions of quakes, floods, and cracks in the earth, that will swallow everything we love, are becoming more frequent. many lock themselves up and despair. one thing is certain: it is over and it will never become like it has been. and if the end comes in only three days or in 30 years, it is not important any more. a group of young fascists stands on the street corner and beats up everyone, who in their eyes has to bear the blame. such an unexampled hysteria and meaninglessness prevails. the catastrophe is total and equals true to nature its own parody in every detail. and so it comes, that in the moment, everywhere where it squeaks and cracks, the entire system collapses like a giant dilapidated building, the underlying darkness is burning up, and here and there one can hear giggling. a cheeky loony laugh which is rising to a chorus, lays hold on all and takes form. the morning after I wake up with a very bad hangover. you are lying beside me, deadly pale.
I go to the kitchen to make coffee and I switch on the television. all news are sending history.

Golden Years

colored chinese lanterns were lit. in direct competition to the moonlight. candles are placed in niches, neon tubes are screwed on wood sticks, so that distinct zones of shadows emerged. yet close to it everything had been intentionally yet carelessly kept in the dark. thoughts are swimming in these thousand light-moods, the night lasting longer today. a woman embraces the rock. the rain becomes dirty water, and is forming streamlets and small brooks, which flow at the backside of the houses. brutal patterns are appearing and cellars flooding. in a house of god, kilometer-long corridors have been built. when you enter such corridors that consist entirely of hard-reflecting stone, you get drunk from the echo into which you dissolve like in acid. Inside another house, everything meets your expectations. you are being shown around to admire. suddenly you find a letter from your mother. she begs you to sacrifice yourself for your country. with it you will be left completely alone. there is fog everywhere thanks to the fog-machines which had been set up.

[Extrait : le document original comprend 10 textes]

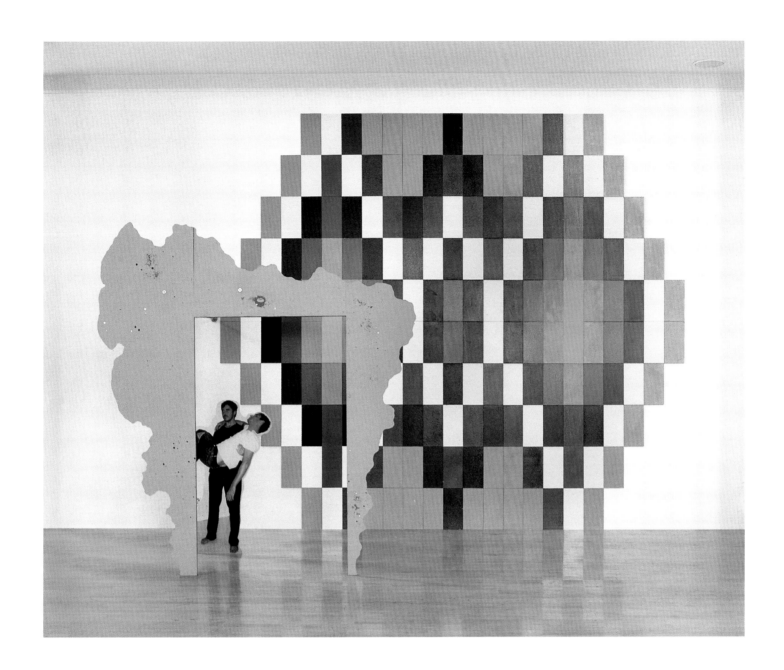

Hindenburg Platz, 2001
Treshold, 2001

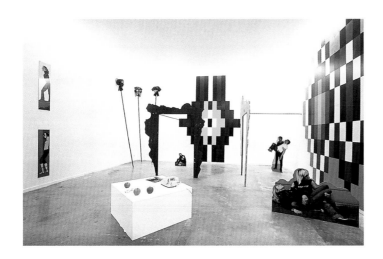

Vue d'installation, Art:Concept, Paris, 2001

L'ivresse des Maîtres
Lothar Hempel et la résistance de la rue

Liam Gillick

Nous voilà devant une série de choses qui opèrent ensemble à l'intérieur d'une étrange série d'espaces. Des territoires artistiques qui ne sont ni complètement narratifs ni essentiellement formels. La pratique de Lothar Hempel s'est progressivement raffinée pour finir par opérer à l'intérieur d'une nouvelle économie de non-espaces. Il a développé une série de lieux opérant dans une zone de totale liberté temporelle. Des espaces esthétiques dominés par les fantômes de moments particuliers du passé. On ne saurait pourtant dire à aucun moment que son œuvre est nostalgique. Sa réussite est d'avoir su concilier les nouvelles logiques corrompues du monde des images et des complexités formelles inédites à travers la création d'un nouvel ensemble de relations instables profondément enracinées dans la résistance et la coquetterie. Des territoires décrochés des passés récents et des présents proches impliqués. Pour autant Lothar Hempel réalise des images et des objets qui ne cessent de défier le présent et ce que la culture grand public considère comme acceptable ou non. Son œuvre génère une série de significations à l'adresse d'une communauté de l'auto-référentialité tout en faisant preuve d'une hyper-conscience de soi quant au pouvoir et au potentiel qui résultent de la combinaison de l'intuition, du désir et de la critique. Dans sa production, on est en permanence confronté à une projection de potentiel filtrée à travers le passé, le présent et l'avenir. Une critique stylisée du moi qu'il présente reflétée dans un miroir déformant. Pratique de l'art qui n'est pas sans référence, enracinée qu'elle est dans une observation et une distillation continuelles de la représentation, de l'équilibre et de l'implosion de la société. Hempel crée une succession de mises en scène qui affirment et nient à la fois la possibilité d'un comportement et d'une vision uniques. Œuvre typique de quelqu'un qui entretient une relation singulière aux images construites qui nous entourent, mais aussi bien critique lucide d'une telle position. L'œuvre est à ce point « présentée » qu'elle devient, en son essence, présentation de la présentation. Chaque structure se fait à la fois support et contenu. Il y a là des gestes excessivement lucides quant à la puissance de la pratique de l'art – un désir évident de découvrir de nouvelles formes de représentation sans pour autant s'en remettre seulement à des expressions formelles. Tout ceci de manière à assurer la continuation des notions assez raffinées qui se sont développées dans le sillon de la critique (post)moderne. Lothar Hempel crée des images et des structures peuplées de désir, de résignation et de dislocation. Une stratification ininterrompue de conscience réflexive tournée vers un nouveau vocabulaire de la puissance sur fond d'images et de structures reflétant ces choses qui résistent à l'analyse dans notre culture, mais restent en suspens et sujettes à conflits à l'interface des nouveaux modèles de comportement, de représentation et de déni. Un langage en suspens et sans cesse inquiété qui ne relève d'aucun précédent artistique spécifique, mais qui est comme enfermé dans la ronde des fantômes du passé, refusant d'être l'instrument d'autres discours didactiques qui sont ou bien eux-mêmes inquiets, ou bien réduits à une collection minaudière de gestes futiles.

Et donc, que voit-on dans une exposition des œuvres de Lothar Hempel ? Une certaine sensibilité graphique s'exprime clairement ici – une série d'œuvres en deux dimensions qui opèrent dans les espaces interstitiels entre les charges des batailles graphiques du présent avec le lourd passé qui est le nôtre. L'œuvre s'installe et se ranime à volonté. Elle occupe des zones de rejet, elle les réactive puis les disloque. L'œuvre n'a pas de temporalité. Elle se trouve en permanence dans un non-temps inquiet. Une pratique artistique se faufilant dans les petits espaces qui se trouvent entre d'autres décors plus clairement identifiés pour jouer à endommager les micro-sensibilités et disloquer toute lecture précise. Lothar Hempel crée des structures qui tiennent dans une pièce. Aplaties, poussées et tordues. Des décors en quelque sorte. Des décors pour une succession d'opérations esthétiques et intellectuelles chargées. Chaque structure consiste à la fois en quelque chose de semi-autonome par elle-même et en une série d'images enfermées sur place via une série d'accessoires à la fois littéraux et délibérément chargés. Il y a des moments où ses collections d'objets pourraient être interprétées comme la toile de fond d'une action et il y a en même temps des moments où elles se résolvent en une image de désir et de regard sur soi. Miroir d'un ensemble d'engagements que le spectateur est susceptible de reconnaître, mais auxquels il est incapable de s'identifier. Réflexion sur les stratégies de quelqu'un d'autre, toujours rendu autre par sa constante critique de la stabilité esthétique. Les lieux décrits par ces structures sont clairement non-fonctionnels et contribuent au contraire à l'évocation d'une série de transitions temporelles tout en mettant en jeu des relations entre objets, généralement éludées par des formes plus didactiques et super-subjectives. Car il ne s'agit pas ici d'une pratique super-subjective. La super-subjectivité appartient aux formes artistiques dominantes de notre époque. Elle combine présentation de l'abject ou du rejeté et modes de production spontanés à l'ironie super-réflexive. Une forme expressive de production artistique qui entre en tension avec des modes de production théoriquement plus « responsables » ou socialement plus pédagogiques. Le super-subjectif en art n'est pas non plus sans potentiel, bien qu'il n'ait jamais réussi à être à l'origine de nouveaux modèles de résistance et de critique. Pour commencer, il s'allie à des modèles de résistance subjective à la culture dominante, en particulier lorsqu'ils impliquent des interprétations sans détour de modèles sociaux et politiques progressistes : il expose le rejet de la résistance logique. Deuxièmement, il est lié à des formes de refus dans la culture imbriquées dans des mouvements sous-culturels et des ensembles de réflexions qui sont difficiles à saisir, à contrôler ou à analyser. L'une des choses à la fois intéressantes et cruciales dans la production de Lothar Hempel, c'est qu'il n'invalide pas le potentiel de la position culturelle super-subjective dans la société, bien qu'il envisage une telle approche stratifiée de la culture avec un degré d'autoréflexivité qui stratifie lui-même un nouvel ensemble de complications au-dessus de l'intuition et de la super-subjectivité. Hempel a produit une quantité d'esthétiques et de techniques qui ne sont jamais simplement personnelles et sans profondeur.

Il a généré de multiples moments de réflexion et de potentiel. Il y a une étrange immobilité dans l'œuvre. Un sens des choses mises en situation et présentées. Il y a là une prolifération de différences et une révélation du potentiel de l'agencement plutôt

que de la présentation. Même lorsque l'œuvre est en deux dimensions, chaque élément est maintenu en place grâce à une matrice de points de références qui met chaque moment graphique en tension avec tous les autres auxquels nous sommes susceptibles d'être confrontés. Ce que l'on nous montre, c'est un mélange d'artifice et de réalité. L'univers d'un geste suspendu que l'on soumet à de multiples poses, quelque chose qui tient de la sensation que l'on éprouve lorsque l'on feuillette les images de représentations et d'accrochages du début du 20ème siècle. L'image aplatie d'une complète alternative, où tout défie le quotidien et où le potentiel documentaire de l'art comme de la production culturelle reste encore à clarifier. Alors que l'on découvre une chaussure cirée sortant de sous un pourpoint gris graphique, il ne s'agit que de rappeler que l'on traite ici de représentation à chaque instant. Il n'y a pas de vérité autonome dans une œuvre de Lothar Hempel. On y trouve toujours une construction de potentiels stratifiés et de décisions verrouillées. Le cortège de l'agit-prop. Le décor produit au tout début du Bauhaus. Et rien de tout cela à la fois.

A chaque instant et dans chaque œuvre, on est amené à comprendre que Hempel a pris une décision précise pour chaque élément qui entre dans la réalisation d'une structure, mais dans bien des cas il ne se préoccupe ni d'expliquer pourquoi ni de tracer des pistes praticables pour l'analyse. C'est vrai même lorsqu'il crée un scénario où l'on peut trouver une compréhension complète de ce que la structure dans son ensemble vise. Il y a là une affirmation du doute, quelque chose qu'il a en commun avec les meilleurs œuvres d'art venues de Cologne ces trente dernières années. Un mélange d'instants choisis pour le jeu esthétique et de cette conscience que l'artiste est obligé d'éviter la parodie, l'autodérision et la dislocation sans toutefois jamais nier le fait que l'art est une série de fins de parties. Il y a un rejet de l'idée selon laquelle nous sommes forcés de nous conformer à des dispositifs puritains venus d'autres domaines que celui de l'art et de les utiliser comme cadre pour travailler, l'idée selon laquelle la seule présentation des preuves documentaires des « autres » suffira à créer une nouvelle représentation de comportement et d'action. Hempel est clairement l'un des pionniers d'un art qui a fait un bon en arrière par-delà les discours d'après-guerre dominant notre époque et qui a tenté de se pencher sur des esthétiques antérieures du refus et de la révolution sans pour autant tomber dans l'ironie et le néo-conservatisme. Son esthétique a creusé dans les débuts de l'art révolutionnaire en Union Soviétique, le théâtre communiste allemand, l'art graphique d'Amérique du Sud, le cinéma scandinave et le cinéma français. Mais elle prend aussi en considération la trivialité discordante des modalités créatives (quoique implosées et à la spontanéité complexe) de la mode, des comportements et de la consommation propres à la jeunesse. Sans oublier la complexité improvisée de la culture de la nuit telle qu'on la voit transpirer à travers tout le champ social. Pourtant, il ne s'agit pas d'un art qui s'approprie ou documente les acteurs sociaux en question. Il fait partie d'un courant de théories esthétiques qui accepte le potentiel de modèles construits ainsi que les nouveaux scénarios, y compris lorsqu'il se montre particulièrement sceptique quant à une telle possibilité. Ces gestes sont partie intégrante d'une histoire esthétique qui repose sur l'idée qu'il est possible d'envisager certains aspects de la culture créative qui nous entoure comme une exploitation des singularités qui en résultent destinée à la création

d'un ensemble parallèle de potentiels esthétiques, mais qui ne singent ni ne reflètent simplement les structures de la culture dominante telles qu'elles apparaissent en négatif dans le miroir de la rue qui a pris conscience d'elle-même. C'est un projet en cours qui s'accomplit sans chercher à éviter les esthétiques implosées et complexes de la fabrique urbaine striée, faite de multiples moi joués et représentés. Une célébration de la masse sociale consciente et toujours mobile au moment où celle-ci prend forme, se débarrasse de la logique et passe à une autre constellation de potentiels. Une forme mobile qui échappe à l'écrasante logique de la culture dominante.

Drunken Masters
Lothar Hempel and the Resistant Street

Liam Gillick

We are faced by a sequence of things that operate collectively within a strange series of spaces. These are territories of artistic practice that are neither completely narrative nor primarily formal. Over time, Lothar Hempel has refined his practice to a particular point where it operates in a new set of non-spaces. He has developed a sequence of locales that operate in a zone of temporal freedom. These are aesthetic spaces dominated by phantoms of particular pasts. Yet there is no point at which you could argue that his work is nostalgic. His achievement is to bring together corrupted new logics from a world of new images and formal complexity toward the creation of a new set of unstable relationships that are deeply rooted in resistance and coquetry. These are territories unhinged from the implicated recent past and near present, yet he has created images and objects that always defy the present in terms of what is accepted and rejected by the mainstream culture. Hempel's work generates a sequence of significations toward a community of self-referentiality that at the same time demonstrates a super-self-consciousness about the power and potential that results from a combination of intuition, desire, and critique. At any moment, within his production, we are confronted by a projection of potential filtered through pasts, presents, and futures. A stylized critique of the presented self-filtered through a distorted mirror. This is an allusive art practice that is rooted in a continual observation and distillation of collective social presentation, poise, and implosion. Hempel creates a series of mises-en-scène that both assert and deny the potential of unique behavior and vision simultaneously. This is clearly the work of someone with a singular relationship to the constructed images that surround us, but it is also a self-conscious critique of such a position. The work is completely "presented" to the point where it is, in essence, the presentation of the presented. Each structure is both its support and its content. There are extremely self-aware gestures here about the potential of art practice—a clear desire to discover new forms of representation without resorting to formal art languages alone. This is all in order to ensure the continuation of rather refined notions of developed (post)modern critical trails. Lothar Hempel creates images and structures that are populated with desire, resignation, and collapse. A continual layering of self-consciousness toward a new vocabulary of potential within an (art) terrain of images and structures that reflect those things that are resistant to analysis within our culture but remain poised and confrontational at the interface of new models of behavior, presentation, and denial. A poised and continually agitated language that draws on no specific artistic precedents, appearing to be locked into a set of circling phantoms from the past, while refusing to become instrumentalized by other more agitated didactic discourses or completely subsumed within a fey collection of minor gestures.

So what are we faced with in an exhibition of works by Lothar Hempel? Quite clearly there is a graphic sensibility here—a sequence of flat works that operate at the interstitial spaces between fraught graphic battles of our present and loaded past. The work settles and reanimates at will. It occupies rejected zones, reactivates, and then collapses them. The work has no time. It is permanently located in an agitated no-time. It is an art practice that squeezes into the small spaces between other more clearly defined set-ups in order to play havoc with micro-sensibilities and collapse precise readings. Lothar Hempel creates structures that stand in a room. Flattened, prodded, and tweaked. These are sets of a sort. Settings for a series of loaded aesthetic and intellectual operations. Each structure is both a semi-autonomous thing in its own right and a series of pictures locked into place via a series of props, both literal and deliberately loaded. There are moments when his object collections could be read as a backdrop for action, and there are simultaneous moments when they resolve into an image of desire and self-regard. A mirror of a set of engagements that the viewer can recognize but never identify with. A reflection of someone else's strategies, permanently othered by his constant critique of aesthetic stability. The locations described by these structures are clearly not functional in any direct sense, but rather work to evoke a sequence of temporal transitions while setting into play a number of object relationships that are normally skipped over by more didactic and super-subjective forms. For this is not a super-subjective practice. Super-subjectivity is one of the dominant art forms of our time. It combines the presentation of the abject or the rejected alongside intuitive and super-self-conscious ironic modes of production. It is an expressive form of art production that operates in tension with notionally more "responsible" or socially pedagogical modes of production. The super-subjective in art has some key potentials, while permanently failing to create new models of resistance and critique. Firstly, it allies itself with subjective models of resistance to the dominant culture, especially where those involve straightforward interpretations of progressive social and political models—it exhibits a rejection of logical resistance. Secondly, it is connected to forms of refusal in the culture that are intertwined with sub-cultural movements and sequences of reflections that are hard to pin down, control, or analyze. One of the interesting and crucial things about Lothar Hempel's production is that he doesn't reject the potential of the super-subjective cultural position within society, however he treats such a layered approach to the culture with a degree of self-consciousness that builds a new set of complications on top of intuition and super-subjectivity. Hempel has produced a multiplicity of aesthetics and techniques that are never merely personal and non-profound.

He has generated multiple moments of reflection and potential. There is a strange stillness to the work. A sense of things placed into position and presented. There is a proliferation of differences here and a revelation of the potential of placement versus presentation. Each element, even when the work is flat, is held in place by a matrix of reference points that hold each graphic moment in tension with every other one we are likely to face. We are presented with a mélange of artifice and actuality. This is a world of suspended action that is placed in multiple poses; there is something akin to the sense you get when flicking past images of early 20th-century performance and

presentation. A flattened image of a complete alternative, where everything defeats the quotidian, and the potential of documentary within art and cultural production has yet to clarify itself. While we may spot a shined shoe poking out from beneath a smocked graphic jerkin, this is merely a moment of reminder that we are dealing with presentation at every moment. There is no autonomous truth in a Lothar Hempel work. There is always a construction of layered potentials and locked-in decisions. It is the agit-prop train. It is the set produced at the early Bauhaus. It is also none of these things.

Every moment in every work leads you to the understanding that Hempel has made a precise decision about each element that goes to make up a structure, but in many cases he doesn't care to explain why or create stable trails of analysis. This is true even where he creates a scenario where there can be a complete understanding of what the overall structure is leading toward. There is an assertion of doubt here, something he has in common with the best art from Cologne in the last 30 years. A combination of resolute moments of aesthetic play with a sense that the artist is obliged to avoid parody, self-absorption, and collapse while never denying the fact that art is a sequence of endgames. There is a rejection of the idea that we must be forced to adopt puritanical devices from other areas alongside art and use them as a framework in order to proceed, that merely presenting the documentary evidence of "others" will suffice to create a new image of behavior and agency. Hempel was clearly one of the pioneers of an art that jumps backward over the dominant post-war discourses of our time and attempts to address earlier aesthetics of refusal and revolution without dropping into irony and neo-conservatism. His aesthetic has mined early revolutionary art from the Soviet Union, German Communist theater, and graphics from South America, Scandinavia, and French cinema. The discordant factuality of creative yet imploded and complex, intuitive, youth modes of fashion, behavior, and consumption is also acknowledged. All this alongside the improvised complexity of bar culture as it leaks through into the social frame. Yet this is not an art that appropriates or documents the implicated social player. It is part of a string of aesthetic theories that accepts the potential of constructed models and new scenarios even while demonstrating a complete scepticism about the possibility of such a thing. These gestures are part of an aesthetic history that is predicated on the idea that it is possible to regard aspects of the creative culture that surround us in terms of a harnessing of the resultant peculiarities toward the creation of a parallel set of aesthetic potentials that neither ape nor merely reflect the structures of the dominant culture as they appear in the negative mirror of the self-conscious street. This is an ongoing project that is achieved without avoiding the complex and imploded aesthetics of the striated urban fabric, made up of multiple performed and presented selves. It is a celebration of a conscious and continually mobile social mass as it finds form, drops logic, and proceeds to the next potential constellation. It is a mobile form that evades the crushing logic of the dominant culture.

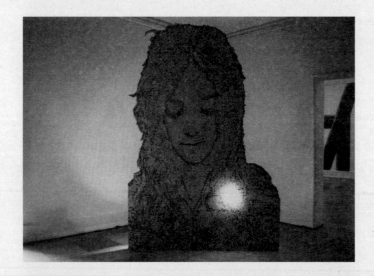

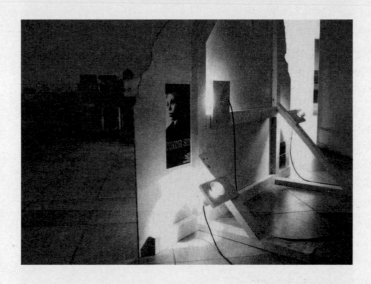

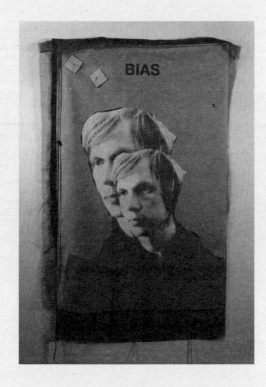

Bias, 2003

Kristalla, 2005

Le marquis, le saint et la concubine, 2001

Plakat III (Die grosse Illusion), 2006

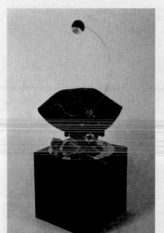

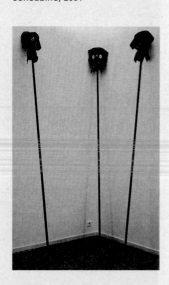

Lothar Hempel

Lili Reynaud Dewar

We were driving by along a street bounded by a high dark wall. Over the top of the wall, I suddenly caught sight of an ornamental cross. "Good God!" I said. "Are you taking me to the cemetery?"

The Baron merely smiled. We had stopped; having arrived, it seemed, at the blackest corner of the night. I stumbled over something, and the Baron obligingly took my arm. He seemed to have been there before. We passed through an archway and into the courtyard. There was light here from several windows, and snatches of gramophone music and laughter. A silhouette head and shoulders leant out of one of the windows, shouted: "Prosit Neujahr!" and spat vigorously. The spittle landed with a soft splash on the paving stone just beside my foot. Other heads emerged from other windows. "Is that you Paul, you sow?" someone shouted. "Red Front!" yelled a voice, and a louder splash followed. This time, I think, a beer mug had been emptied.

Here one of the anaesthetic periods of my evening supervened. How the Baron got me upstairs, I don't know. It was quite painless. We were in a room full of people dancing, shouting, singing, drinking, shaking our hands, and thumping us on the back. There was an immense ornamental gasolier, converted to hold electric bulbs and enmeshed in paper festoons. My glance reeled about the room, picking out large or minute objects, a bowl of claret-cup in which floated an empty match-box, a broken bead from a necklace, a bust of Bismarck on the top of a Gothic dresser—holding them for an instant, then losing them again in general colored chaos. In this manner I caught a sudden startling glimpse over Arthur's head, its mouth open, the wig jammed down its left eye. I stumbled about looking for the body and collapsed comfortably onto a sofa, holding the upper half of a girl. My face was buried in dusty-smelling lace cushions. The noise of the party burst over me in thundering waves, like the sea. It was strangely soothing. "Don't go to sleep, darling!" said the girl I was holding. "No, of course I won't," I replied, and sat up, tidying my hair. I felt suddenly quite sober.

Opposite me, in a big armchair, sat Arthur, with a thin, dark, sulky looking girl on his lap. He had taken off his coat and waistcoat and looked most domestic. He wore gaudily-striped braces. His shirtsleeves were looped up with elastic bands. Except for a little hair round the base of the skull, he was perfectly bald. "What on earth have you done with it?" I exclaimed. "You'll catch cold."

"The idea was not mine, William. Rather a graceful tribute, don't you think, to the Iron Chancellor?"[1]

Ne pas savoir, ou presque, d'où arrivent les personnages d'un récit, où ils vont, en fait des figures esthétiques, des symboles. L'isolement du reste de la fiction opère une sorte de nivellement égalitaire : on ignore s'ils sont secondaires ou pivots du texte dont ils sont extraits. On apprend autant de choses sur eux que sur le décor à l'intérieur duquel ils se manifestent, et qui ressemble d'ailleurs à une scène, avec ses objets, ses lumières, ses portions de décor. Réduits à des apparitions, ils défilent un instant, exécutent leur figure spéciale pour cette courte parade, déposent à vos pieds leurs caractéristiques momentanées, un tour sur eux-mêmes, et hop !, terminé.

Cette dimension performative, à la fois gratuite et énigmatique, procède de la citation, qui assigne les éléments d'une histoire à des propositions fugaces. C'est aussi le motif prédominant des *Berlin Stories*. Plusieurs années après leur publication, Isherwood les décrivait comme un « conte de fées »[2] cruel sur une véritable ville

1 — Christopher Isherwood, *Mr Norris Changes Train*, Hogarth Press, Londres, 1935. *The Berlin Novels*, Vintage Classics, Londres, 1999, p. 31–32 pour la présente édition.

2 — « Fairy story », le terme *fairy*, signifiant aussi tapette, en anglais, signalant la réappropriation ironique d'un terme péjoratif par l'auteur, destinée à revendiquer son identité homosexuelle (de la même manière que le terme *queer*, par exemple, à l'origine insultant, est aujourd'hui porté en en étendard par la communauté gay).

dans laquelle les êtres en détresse souffraient de la violence politique et mouraient quasiment de faim ; il n'aurait fait que « passer gaiement devant ces scènes de désolation, en donnant de fausses interprétations afin de satisfaire son imagination puérile »[3]. Par ce déni, typique de sa tendance à l'autodépréciation, Isherwood exprimait ses difficultés à assumer un texte dont l'ambiguïté n'est nullement le fait de son positionnement politique[4], mais bien le sujet, à savoir « le pouvoir nouveau du fantasme et de l'artifice dans la société européenne des années 1930 »[5] et son utilisation à des fins politiques terrifiantes. Exacerbant et esthétisant les rôles qui se jouent sous le regard de leur narrateur, ces nouvelles retournent silencieusement contre le Pouvoir ses propres armes : le fantasme et l'artifice. L'usage qu'il fit des concepts de scène, de spectacle et de performance[6] dans ses textes consiste à désigner les moyens usurpés par l'ennemi puis à se les réapproprier afin d'échapper à son emprise. Confisqués par le projet Nazi, « le spectacle, la théâtralité, certaines formes de célébration »[7], voire « le théâtre, l'art vulgaire, les manifestations grand guignol »[8] imprègnent la toile de fond des *Berlin Stories* (comme en témoigne l'exergue du présent texte). Le Nazisme aurait ainsi tout à la fois usurpé et caricaturé l'esthétisation du monde, mais à la différence du *Camp*, qui consisterait à percevoir le monde comme un phénomène esthétique, sans négociation de valeurs et sans instrumentalisation, le Nazisme a forcé cette esthétisation à des fins totalitaires. Et c'est justement en adoptant un regard *Camp* (bien que la notion n'ait pas encore été cernée à l'époque), c'est-à-dire totalement subjectif (s'opposant à la collectivité totalisante du Nazisme), décadent (radicalement rétif aux mensonges *progressistes* du Nazisme) et apparemment dégagé de tout jugement, en consignant ce qui autour de lui relève du *Camp* et échappe par ce biais à l'uniformisation et à l'oppression, ce qui excède ses armes, les déborde, les détourne, les dévie, qu'Isherwood esquisse un espoir idéologique. Il avance des formes d'esthétisation productives, capables de proposer, de façon plus ou moins délibérée, les conditions d'une résistance. « C'est au travers de leurs conceptions dissidentes de la *performance* que ces nouvelles suggèrent des manières dont l'esthétisation peut contribuer à ébranler à la fois les limitations d'une vie bourgeoise étriquée et la disparition totalitaire du réel. »[9]

Cette stratégie d'esthétisation à des fins libératrices me paraît être la force motrice de l'art de Lothar Hempel. On y retrouve, de manière plus ou moins directe, un attachement à différentes formes de performance résistant à leur appropriation par la culture dominante, nichées dans des poches idéologiques en retrait, non domestiquées, déviantes. Lothar Hempel se réfère souvent à des types de divertissement populaire, des formes artistiques issues d'un folklore européen contemporain, comme les « arts déclinants (*dying arts*) : artistes du vaudeville, équilibristes, gens de cirque. »[10]. J'ajouterais le théâtre de marionnettes, le cabaret, le cinéma muet : des performances qui exacerbent, au travers d'une série d'actions souvent muettes, ou d'un genre de *challenge* physique ou moral, les qualités immédiates d'un acteur ou d'un performeur en dehors de toute entreprise scénaristique et de toute construction linéaire. Les figures qui peuplent ses œuvres ne sont donc pas les personnages d'une fiction, elles sont des forces vives qui échappent à la normalisation, elles incarnent des principes ou des concepts plutôt que des personnalités ou des caractères, et sont à considérer sur le même plan que les parties ornementales, de décor et les

3 — *Exhumations, Stories, Articles, Verses*, Simon and Schuster, New York, 1966, p. 86-87. Cité par Anthony Shuttleworth dans « In a Populous City, Isherwood in the Thirties », James J.Berg, Chris Freeman (éd.), *The Isherwood Century, Essays on the Life and the Work of Christopher Isherwood*, The University of Wisconsin Press, Madison, 2001, p. 151. Traduction de l'auteur.

4 — Pendant son séjour berlinois, Isherwood rejoint les troupes communistes et lutte à leurs côtés contre les forces nazies, puis l'American Friends Service Committee, et combat aux côtés des forces américaines pendant la guerre.

5 — Anthony Shuttleworth, *op. cit.*, p. 151.

6 — Entendre le terme « performance » dans le sens de célébration, mais aussi dans le sens de « show » et de représentation, et noter que l'une des *Berlin Stories*, intitulée « Sally Bowles », fut adaptée pour faire l'un des succès de Broadway dans les années 1950, puis pour le cinéma dans les années 1970, avec le film *Cabaret*.

7 — Anthony Shuttleworth, *op. cit.*, p. 150.

8 — Modris Ekstein, *Rites of Spring : The Great War and the Birth of the Modern Age*, Doubleday, New York, 1990, p. 312. Cité par Anthony Shuttleworth, *op. cit.*, p. 152.

9 — Anthony Shuttleworth, *op. cit.*, p. 157.

10 — « Lothar Hempel. Interview with Emma Stern », *Umbrella*, Anton Kern Gallery, New York, 2006. Traduction de l'auteur.

objets environnants. « J'ai intégré des objets inchangés, comme le masque ou une image de magazine, à l'intérieur de mon propre contexte. J'ai soudain commencé à réaliser que, potentiellement, tout pouvait circuler dans mon travail et être porté à parler à l'intérieur de ce contexte. Le côté ordinaire de ces choses a quelque chose de presque libératoire, d'une façon réconfortante. Elles sont comme des acteurs amateurs, innocents et vides. Sans rapport avec quoi que ce soit, elles apparaissent magiques. »[11]

Personnification de principes, équivalence entre objet et personne, syncrétisme formel, intégration de l'objet commun dans un ensemble métaphorique... On retrouve ces procédures et cette disparité prodigue à l'intérieur des croyances constituées en marge des systèmes religieux principaux, et pour lesquelles la dimension performative est cruciale. Dans le vaudou, constitué comme un détournement de la religion imposée par l'oppression du système esclavagiste, un moyen de résistance à ce système, un lieu libéré pour la pensée, les *loa*, ou les *Invisibles*, sont des principes immatériels qui s'incarnent physiquement au travers de leurs chevaux, les humains possédés. « Ces principes, qui ont été abstraits du phénomène dans lequel ils sont manifestes, ne sont pas moins réels que le phénomène, mais seulement immatériels et invisibles, et ceci pourrait éclairer le concept *vaudoun* des *Invisibles* en tant que réel. Néanmoins, puisque les forces en question – qu'elles soient entendues comme des principes ou comme les *Invisibles* – ne peuvent être perçues que lorsqu'elles se manifestent à travers la matière, le serviteur s'adresse à des objets et des phénomènes matériels. »[12] Les *loa* sont personnifiés pour circuler dans le contexte de la pratique vaudou, ce qui n'en fait pas pour autant des personnes humaines. « Puissances supérieures et invisibles, ils sont nés dans le monde. Ils peuvent avoir été des personnages importants qui ont marqué l'histoire de leur clan, des animaux ou bien encore des éléments tels le tonnerre ou la tempête. »[13] Les personnages parfois partiellement démembrés et représentés de profil dans les grandes peintures d'Hempel (*Jason, Medea, Kindl, Richard Wright, Kreuzberg Night, Golden Triangle, Butterfly, Iron Butterfly, The Avantgardist*...) seraient donc les membres concrets d'une famille de symboles pléthorique, comme le sont les *loa* Papa Legba, Ogou le Rouge, Ogou Feray, Brave Gédé, Dambal Wédo, Cousin Azaka, Grande Brigitte. Ils ont en commun cet artifice : avoir prosaïquement pris forme humaine pour diffuser une mythologie. « Tenant pour constant que l'homme de la société bourgeoise est à chaque instant plongé dans une fausse Nature, [la mythologie] tente de retrouver sous les innocences de la vie relationnelle la plus naïve, l'aliénation profonde que ces innocences ont à charge de faire passer. Le dévoilement qu'elle opère est donc un acte politique : fondée sur une idée responsable du langage, elle en postule par là même la liberté. »[14] Le pragmatisme, voire le sens pratique, de cette prétendue innocence, est « à la fois intelligence du réel et complicité avec lui »[15]. C'est encore une fois, le moyen pour l'art de Hempel de se réapproprier le réel, de le refaire circuler à l'intérieur d'un contexte libéré des obligations de lisibilité, des limitations de la cohérence, bref, libéré de l'autorité et de la norme.

Et puis, il y a les *zombies*, hagards, vivants mais morts, dont les agissements sont guidés par un autre, et dont la *mnam* (l'âme) est confisquée, prisonnière d'une volonté extérieure. S'il existe un endroit à partir duquel le travail de Lothar

11 — Lothar Hempel, Rainald Schumacher, « Narrative Machines – A Conversation via E-Mail with Lothar Hempel, August 2005 », Ingvild Goetz (éd.), *Imagination Becomes Reality – Part II. Painting Surface Space*, Sammlung Goetz, Munich / ZKM Museum für Neue Kunst, Karlsruhe, p.78. Traduction de l'auteur.

12 — Maya Deren, *Divine Horsemen, The Living Gods of Haiti*, Thames and Hudson, London and New York, 1953. *Documentext*, Mc Pherson & Company, 2004, pour la présente édition, p. 88. Traduction de l'auteur.

13 — Laënnec Hurbon, *Mystères du Vaudou*, Découvertes Religions, Gallimard, Paris, 1993, p. 67.

14 — Roland Barthes, *Mythologies*, Editions du Seuil, Paris, 1957. Collection Points, 1970, pour la présente édition, p. 230.

15 — Roland Barthes, *op. cit.*, p. 230.

Hempel « semble décrire l'âme comme morte »[16], alors les *zombies* auraient leur place dans cette zone intermédiaire, cette dimension parallèle et étrangement concrète. Car ils sont « comme des acteurs amateurs, innocents et vides »[17], des silhouettes rigides, des *hyper* présences fugitives, des somnambules pugnaces, les fantômes d'un rêve cinématique et surréel, à l'image des individus à la fois absents et persistants des films en noir et blanc de l'artiste. Le vaudou, et ses *zombies*, fut un sujet de prédilection des premiers films d'horreur. Inspiré de *Magic Island* (1929) de William Buehler Seabrook, « voyageur et homme de lettres qui manifestait un penchant pour les choses bizarres et un grand intérêt pour la magie »[18] (Leiris disait de ses livres qu'ils reflétaient « l'esprit d'esthète bohème américain de la façon la plus ignoble »[19]), le film *White Zombie* (1932) inverse les rôles (le *zombie* serait généralement un homme noir) et met en scène une zombie blanche. Dans le même mouvement de transfert de l'imaginaire cinématographique américain sur la culture haïtienne, le film de Jacques Tourneur, *I Walked with a Zombie* (1942), raconte des histoires de *zombies* blanches emmenées par un *zombie* noir. Le slogan de l'affiche « She's Alive... Yet Dead! She's Dead... Yet Alive! This Strange Strange Story » ne dit pas, malgré son sensationnalisme direct, l'inquiétante étrangeté qui parcourt ces films populaires de part en part. « Le genre en question semble répondre à une nécessité sociale, en tant qu'il permet l'expression des domaines refoulés, détachés ou réprimés, dans une société où triomphe la représentation rationaliste du monde. »[20] Avec leurs *zombies* blancs, les films de Lothar Hempel, qui s'affranchissent de toute circonscription temporelle (entre film expérimental et film muet, imagerie d'Epinal et texture fantastique contemporaine, ils sont impossibles à dater) ou narrative (il s'agit plus d'une succession de tableaux encodés par une atmosphère obsessionnelle), occupent une telle fonction de libération de l'imaginaire – du « refoulé, du détaché, du réprimé », libération propre à la *méthode* surréaliste.

C'est bien sûr la manière associative qui rapproche les combinaisons d'Hempel du surréalisme, mais aussi leur rapport à une certaine ethnologie. On sait l'attention que portèrent les surréalistes à l'art primitif. On a vu Lothar Hempel s'approprier des masques, s'inspirer du théâtre Kabuki, fabriquer des genres de totems. « J'ai intégré des objets inchangés, comme le masque. [...] Le côté ordinaire de ces choses a quelque chose de presque libératoire. [...] Sans rapport avec quoi que ce soit, elles apparaissent magiques. »[21] A la fois « ordinaires » et « magiques », ces objets à l'identité culturelle ambiguë (ce ne sont pas des masques authentiquement primitifs mais des artefacts pour célébrations populaires ; les totems semblent issus d'une prophétie de science-fiction) revêtiraient un rôle équivalent à celui décrit par André Breton et décrypté par Rosalind Krauss au sujet de la recherche de Giacometti pour l'*Objet invisible*. « Giacometti et Breton se rendent au marché aux Puces, où chacun d'entre eux se trouve retenu par un objet apparemment dépourvu d'usage qu'il faut absolument, comme contre son propre gré, acquérir. Giacometti acheta une sorte de masque de guerrier aux formes acérées dont il ne pouvait, pas plus que Breton, déterminer exactement la fonction première. Ce qui importe dans le récit de Breton est la destination ultime, et non initiale de cet objet [...] » qui se trouvait être « un prototype d'un masque de protection en fer conçu par le corps médical lors la première guerre mondiale »[22]. Cette indétermination quant à la fonction initiale de l'objet a son

16 — « Interview with Toby Webster », Emma Stern (éd.), *Lothar Hempel. Propaganda*, ICA – Institute of Contemporary Arts, Londres, 2002, non paginé. Traduction de l'auteur.

17 — Lothar Hempel, Rainald Schumacher, *op. cit.*

18 — Ulrike Sulikowski, *Sprung im Spiegel, Filmisches Wahrnehmen zwischen Fiktion und Wirklichkeit*, Christina Bluminger, Vienne, 1990. Cité par Laënnec Hurbon, *op. cit.*, p. 158.

19 — Michel Leiris, *L'Afrique fantôme*, Gallimard, Paris, 1934. *Miroir de l'Afrique*, Quarto Gallimard, 1996, pour la présente édition, p. 381.

20 — Ulrike Sulikowski, *op. cit.*, p.159.

21 — Lothar Hempel, Rainald Schumacher, *op. cit*, p.78.

22 — Rosalind Krauss, *No More Play, Primitivism in 20th Century Art : the Affinity of the Tribal and the Modern*, The Museum of Modern Art, New York, 1984. Reproduit dans *L'originalité de l'avant-garde et autres mythes modernistes*, Macula, Paris, 1993, p. 214 – 215.

importance, quoiqu'en dise Rosalind Krauss, car elle questionne bien sûr son inscription culturelle et la notion d'authenticité. Lorsque Hempel agence *primitivement* des formes et des matériaux issus d'une culture occidentale contemporaine, il ne se situe pas dans une recherche formelle néo-primitiviste, mais suggère au contraire une impossibilité à partitionner ce qui est au monde selon une grille de lecture ordonnée et exclusive, et épouse la nature chaotique et pléthorique du monde contemporain. Quant à la dimension « libératoire » de l'objet, elle est, à nouveau, primordiale, mais pas dans le sens où l'entendait Breton : « L'intervention du masque semblait avoir pour but d'aider Giacometti à vaincre son indécision. La trouvaille d'objet remplit ici rigoureusement le même office que le rêve, en ce sens qu'elle libère l'individu de scrupules affectifs paralysants, le réconforte et lui fait comprendre que l'obstacle qu'il pouvait croire insurmontable est franchi. »[23]. Dans le cas de Lothar Hempel, il ne s'agit pas de s'adjoindre un objet pour résoudre un conflit formel, mais d'adjoindre des objets à l'audience pour lui permettre de se détacher de ses propres conflits d'interprétation.

En outre, Hempel convoque le surréalisme avec deux intentions distinctes. D'une part, il reprend à son compte le rapprochement opéré par Michael Fried entre art minimal et surréalisme : « cette affinité peut être résumée en disant que la sensibilité surréaliste et la sensibilité littéraliste sont toutes deux théâtrales »[24]. Confirmant l'idée de Toby Webster selon laquelle le travail de l'artiste procède d'un collage entre « perceptions psychologiques et sculpture formelle »[25], cette contraction entre art minimal et surréalisme accentue doublement sa dimension théâtrale. D'autre part, il fait circuler, dans le contexte de son travail, une utopie sociale, une avant-garde fondée sur le déni du rationalisme et de la logique, sur l'idée que « l'existence est ailleurs »[26] et, ce faisant, propose non pas une réitération du *programme* surréaliste, mais son interprétation théâtrale et provisoire, liée au temps de l'œuvre.

Cette interprétation, mue par une certaine sophistication intellectuelle, plutôt byzantine, éventuellement décadente, ne serait ni parodique, ni dramatique, ni nostalgique, mais parfaitement allégorique. *Rejouer*, aujourd'hui, des attitudes et des courants artistiques a priori emprisonnés dans l'époque et le contexte qui les ont engendrés n'a pas le même effet que les citer ou s'en approprier les productions. De la même manière que l'on a vu que les *loa*, parfaitement allégoriques eux aussi, en s'incarnant au travers de leurs *chevaux* humains deviennent, dans le contexte du rituel, partie intégrante de la réalité, alors cette allégorie *performative* aurait des effets concrets dans le contexte du travail de l'artiste. Car dans cette interprétation, dans ce théâtre, il existe une « dimension jouée » (en l'occurrence, celle de la distanciation historique) et une « dimension vécue » (celle qui préside à la production d'une œuvre nouvelle), continuellement entremêlées, ainsi que l'a montré Leiris[27]. C'est même cette indissociabilité qui rend cette allégorie performative, *productive* d'une réalité autre ; c'est le vécu conscient d'être le double d'un autre vécu. L'allégorie, omniprésente de maintes manières dans le travail magnifiquement hétérogène de Hempel : par « la confusion du verbal et du visuel », « des genres », « des frontières esthétiques », par la « combinaison ostensible de médiums artistiques auparavant distincts »[28], serait ainsi poussée à son paroxysme, sa dimension ultime ; le dernier volet d'une œuvre formant une sorte de cosmogonie complète, avec ses figures, ses objets, ses environnements : le paradoxe de l'interprétation et du jeu.

23 — André Breton, *L'Amour fou*, Gallimard, Paris, 1937. Cité par Rosalind Krauss, *op. cit.*

24 — Michael Fried, « Art and Objecthood », in *Artforum*, New York, 1967. Reproduit dans Charles Harrisson & Paul Wood, *Art In Theory 1900–2000*, 2nd edition, 2002, p. 834. Traduction de l'auteur.

25 — « Interview with Toby Webster », Emma Stern (éd.), *Lothar Hempel. Propaganda*, ICA – Institute of Contemporary Arts, Londres, 2002, non paginé. Traduction de l'auteur.

26 — André Breton, *Manifeste du Surréalisme*, Paris, 1924.

27 — Michel Leiris, *La Possession et ses aspects théâtraux chez les Ethiopiens de Gondar*, Gallimard, Paris, 1958. Reproduit dans *Miroir de l'Afrique*, *op. cit.*, p. 979.

28 — Craig Owens, « The Allegorical Impulse : Toward a Theory of Postmodernism », in *October*, vol. 12, Spring, 1980, p. 67–86. Reproduit dans Charles Harrisson & Paul Wood, *Art In Theory 1900–2000*, 2nd edition, 2002, p. 1052. Traduction de l'auteur.

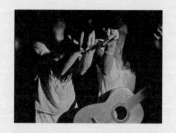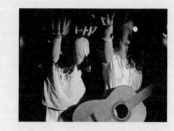

IKARUS

Ikarus, 2002

Lothar Hempel

Lili Reynaud Dewar

We were driving by along a street bounded by a high dark wall. Over the top of the wall, I suddenly caught sight of an ornamental cross. "Good God!" I said. "Are you taking me to the cemetery?"

The Baron merely smiled. We had stopped; having arrived, it seemed, at the blackest corner of the night. I stumbled over something, and the Baron obligingly took my arm. He seemed to have been there before. We passed through an archway and into the courtyard. There was light here from several windows, and snatches of gramophone music and laughter. A silhouette head and shoulders leant out of one of the windows, shouted: "Prosit Neujahr!" and spat vigorously. The spittle landed with a soft splash on the paving stone just beside my foot. Other heads emerged from other windows. "Is that you Paul, you sow?" someone shouted. "Red Front!" yelled a voice, and a louder splash followed. This time, I think, a beer mug had been emptied.

Here one of the anaesthetic periods of my evening supervened. How the Baron got me upstairs, I don't know. It was quite painless. We were in a room full of people dancing, shouting, singing, drinking, shaking our hands, and thumping us on the back. There was an immense ornamental gasolier, converted to hold electric bulbs and enmeshed in paper festoons. My glance reeled about the room, picking out large or minute objects, a bowl of claret-cup in which floated an empty match-box, a broken bead from a necklace, a bust of Bismarck on the top of a Gothic dress-er—holding them for an instant, then losing them again in general colored chaos. In this manner I caught a sudden startling glimpse over Arthur's head, its mouth open, the wig jammed down its left eye. I stumbled about looking for the body and col-lapsed comfortably onto a sofa, holding the upper half of a girl. My face was buried in dusty-smelling lace cushions. The noise of the party burst over me in thundering waves, like the sea. It was strangely soothing. "Don't go to sleep, darling!" said the girl I was holding. "No, of course I won't," I replied, and sat up, tidying my hair. I felt suddenly quite sober.

Opposite me, in a big armchair, sat Arthur, with a thin, dark, sulky looking girl on his lap. He had taken off his coat and waistcoat and looked most domestic. He wore gaudily-striped braces. His shirtsleeves were looped up with elastic bands. Except for a little hair round the base of the skull, he was perfectly bald. "What on earth have you done with it?" I exclaimed. "You'll catch cold."

"The idea was not mine, William. Rather a graceful tribute, don't you think, to the Iron Chancellor?"[1]

Not knowing, or almost not knowing, where the characters in a story come from, where they are going, turns them into aesthetic figures, symbols. Their isolation from the remainder of the narrative operates a kind of egalitarian leveling: we are unaware of whether they are secondary figures or pivotal to the text from which they are taken. We learn as much about them as we do about the setting within which they turn up which, moreover, resembles a stage set with its props, lights, and bits of scenery. Reduced to appearances, they show up for an instant, carry out their special appear-ance for this short parade, lay their momentary characteristics at our feet, execute a pirouette, and that's it!

This performative dimension, which is both gratuitous and enigmatic, derives from quotation, which attributes the elements of a story to fleeting remarks. It is also the predominant motif in *The Berlin Stories*. Several years after they had been

1 — Christopher Isherwood, *Mr Norris Changes Train*, Hogarth Press, London 1935. Reprinted in *The Berlin Novels*, Vintage Classics, London 1999, p. 31–32.

published, Isherwood described them as a "a heartless fairy story"[2] about a real city in which human beings were suffering the miseries of political violence and near-starvation; all he had done was "pass gaily through these scenes of desolation, misinterpreting them to suit his childish fantasies."[3] Through this disclaimer, typical of his tendency to be self-deprecatory, Isherwood was expressing the difficulties he had in claiming ownership of a text, the ambiguity of which in no way derives from his political stance,[4] but is in fact its subject, specifically "the new role and power of fantasy, and of artifice, in European society of the 1930s,"[5] and its use for terrifying political purposes. Heightening and aestheticizing the roles that are being played out under the eyes of the person narrating them, these stories silently use their own weapons—fantasy and artifice—to attack Power. The use he made of the concepts of the stage set, spectacle, and performance[6] in these texts consists of pointing out the means usurped by the enemy, then reappropriating them for himself in order to escape the enemy's grasp. Confiscated by the Nazi project, "the spectacle, the theatricality, and a certain kind of performance,"[7] indeed "the theater, vulgar 'art,' the *grand guignol* productions,"[8] are imbedded in the backdrop of the *Berlin Stories* (as the quotation introducing this text demonstrates). Thus Nazism has apparently both usurped and caricatured the aestheticization of the world, but unlike Camp, which seems to consist of perceiving the world as an aesthetic phenomenon, without any negotiation of values or instrumentalization, Nazism has forced that aestheticization for totalitarian purposes. And it is precisely by adopting a Camp view of things (though the concept had not yet been defined at that period)—i.e. a totally subjective (in opposition to the all-embracing collectivity of Nazism), decadent (radically resistant to the "progressive" lies of Nazism), and seemingly completely non-judgmental—and by recording everything around him that has Camp overtones and thereby escaping the pressure toward uniformity and oppression (what is beyond his weapons, outstrips them, deflects them, and diverts them) that Isherwood sketches an ideological hope. He puts forward productive forms of aestheticization capable of offering, in a more or less deliberate way, the conditions for resistance. "It is through different ideas of performance that the novel suggests ways in which aestheticism may work to undermine both the strictures of bourgeois life and the totalitarian disappearance of the real."[9]

This strategy of aestheticization for emancipatory purposes seems to me to be the motive force behind Lothar Hempel's art. In it we find, either more or less directly, an attachment to different forms of performance resistant to being appropriated by the dominant culture, nestling in untamed, deviant ideological pockets in the background. Lothar Hempel often makes references to types of popular entertainment, artistic forms derived from contemporary European folklore, like the "dying arts [...] vaudeville artists, rope-walkers, circus people."[10] I would add puppet theater, cabaret, and silent films: performances that through a series of often silent actions, or a kind of physical or moral challenge, heighten the immediate qualities of an actor or performer irrespective of any attempt at stage setting or any linear construction. Thus the figures that populate his works are not characters in a piece of fiction, they are living forces that escape normalization, they embody principles or concepts rather than personalities or characters, and are to be considered on the same level as the ornamental,

2 — "Fairy story": the term *fairy* is used to indicate the author's ironic reappropriation of a pejorative term with the intention of asserting his homosexual identity (just as the term "queer," for example, which was originally insulting, is now used as a banner by the gay community).

3 — Isherwood, *Exhumations: Stories, Articles, Verses*, Simon and Schuster, New York 1966, p. 86–87. Quoted by Anthony Shuttleworth in "In a Populous City, Isherwood in the Thirties," James J. Berg, Chris Freeman (ed.), *The Isherwood Century, Essays on the Life and the Work of Christopher Isherwood*, The University of Wisconsin Press, Madison 2001, p. 151.

4 — During his time in Berlin, Isherwood joined the Communist troops and fought alongside them against the Nazi forces; he subsequently joined the American Friends Service Committee and fought alongside the American forces during WWII.

5 — Shuttleworth, "In a Populous City," p. 151.

6 — The term "performance" should be understood in the sense of a celebration, but also in the sense of a "show," and it should be noted that one of the *Berlin Stories*, "Sally Bowles," was adapted and turned into a Broadway success in the 1950s, then again for the cinema in the 1970s, with the film *Cabaret*.

7 — Shuttleworth, "In a Populous City," p. 150.

8 — Modris Ekstein, *Rites of Spring: The Great War and the Birth of the Modern Age*, Doubleday, New York, 1990, p. 312. Quoted by Shuttleworth, "In a Populous City," p. 152.

9 — Shuttleworth, "In a Populous City," p. 157.

10 — "Lothar Hempel. Interview with Emma Stern," *Umbrella*, Anton Kern Gallery, New York 2006.

decorative parts and the surrounding objects. "I have put objects like the mask or the magazine photo unchanged into my context. Being able to do that was an important experience for me. I suddenly began to realize that, potentially, everything can flow into my work and be made to speak in the context. As I suggested earlier, it is the ordinariness of these things that has something almost comfortingly liberating. They are like amateur actors, innocent and empty. Unrelated to anything, they appear magical."[11]

The personification of principles, the equivalence between the object and the person, formal syncretism, the integration of common objects into a metaphorical whole ... We find these procedures and this prodigal disparity within the beliefs existing on the margins of the main religious systems, for which the performative dimension is crucial. In voodoo—set up as a diversion of the religion imposed by the oppression of the slavery system, a means of resisting that system, a place freed for thought—the *loa*, or *Les Invisibles* (*The Invisible Ones*), are immaterial principles that are embodied physically through their horses, possessed human beings. "These principles, which have been abstracted from the phenomena in which they are manifest, are not less real than the phenomena, but merely non-physical and invisible; and this fact may illuminate the concept of *Les Invisibles* as real [...] However, since the forces in question—whether understood as principles or as *Les Invisibles*—can be perceived only when manifest in matter, the servitor addresses himself to material objects and phenomena."[12] The *loa* are personified so that they can move around in the context of the voodoo practice, but this does not turn them into human beings. "They are superior invisible Powers, born in the world. They may have been important people who have left their mark on the history of their clan, animals, or perhaps even elements such as thunder or storms."[13] The characters, sometimes partly dismembered and depicted in profile in Hempel's large paintings (*Jason*, *Medea*, *Kindl*, *Richard Wright*, *Kreuzberg Night*, *Golden Triangle*, *Butterfly*, *Iron Butterfly*, *The Avantgardist*, for example), would accordingly be the concrete members of a superabundant family of symbols, as are the loa Papa Legba, Ogou le Rouge, Ogou Feray, Brave Gédé, Dambal Wédo, Cousin Azaka, and Grande Brigitte. What they have in common is the trick of having prosaically taken on human form in order to disseminate a mythology. "Taking it as a constant that man in a bourgeois society is at every turn plunged into a false Nature, [the mythology] attempts to rediscover under the innocent appearance of the most unsophisticated relationships the deep alienation that this innocence has the task of transmitting. The unveiling it effects is thus a political act: based on a responsible idea of language, in that very process it postulates language's freedom."[14] The pragmatism, indeed the practical sense of this supposed innocence, is "simultaneously an understanding of reality and complicity with it."[15] Yet again it is the means by which Hempel's art can reappropriate reality, cause it to circulate again within a context freed of the obligations of intelligibility, the limitations of coherence, in short freed from authority and norms.

Then there are the haggard zombies, living yet dead, whose actions are guided by someone else and whose *mnam* (soul) has been confiscated, held prisoner by an external will. If there is a place from which Lothar Hempel's work seems "to describe the soul as dead,"[16] then the zombies would be at home in that intermediate

11 — Lothar Hempel, Rainald Schumacher, "Narrative Machines—A Conversation via email with Lothar Hempel, August 2005," Ingvild Goetz (ed.), *Imagination Becomes Reality—Part II*. Painting Surface Space, Goetz Collection, Munich/ZKM Museum für Neue Kunst, Karlsruhe 2005, p.78.

12 — Maya Deren, *Divine Horsemen, The Living Gods of Haiti*, Thames and Hudson, London and New York 1953. Reprinted in *Documentext*, McPherson & Company 2004, p. 88.

13 — Laënnec Hurbon, *Mystères du Vaudou* (Découvertes Religions), Gallimard, Paris 1993, p. 67.

14 — Roland Barthes, *Mythologies*, Editions du Seuil, Paris 1957. Reprinted in 1970, p. 230.

15 — Barthes, *Mythologies*, 1970, p. 230.

16 — "Interview with Toby Webster," Emma Stern (ed.), *Lothar Hempel. Propaganda*, ICA – Institute of Contemporary Arts, London 2002, unpaginated.

zone, that parallel and strangely concrete dimension. For they are "like amateur actors, innocent and empty,"[17] stiff silhouettes, fleeting hyper-presences, pugnacious sleepwalkers, the phantoms of a cinematic, surreal dream, like the simultaneously absent yet tenacious individuals in the artist's black and white films. Voodoo with its zombies was a favorite subject of the first horror films. Inspired by *Magic Island* (1929) by William Buehler Seabrook, "a traveler and literary man who showed a liking for strange things and a great interest in magic"[18] (Leiris said of his books that they reflected "the spirit of a bohemian American aesthete in the most ignoble way"[19]), the film *White Zombie* (1932) reverses the roles (the zombie was generally a black man) and features a white female zombie. In the same process of transferring the imaginary world of the American cinema onto Haitian culture, Jacques Tourneur's film, *I Walked with a Zombie* (1942), tells stories of white female zombies led away by a black male zombie. In spite of its direct sensationalism, the slogan on the poster, "She's Alive … Yet Dead! She's Dead … Yet Alive! This Strange Strange Story," gives no hint of the uncanny atmosphere that pervades these popular films. "The genre in question seems to answer a social need insofar as it allows inhibited, alienated, or repressed fields to be expressed in a society where the rationalist representation of the world prevails."[20] With their white zombies, Lothar Hempel's films, which are free of any temporal circumscription (lying somewhere between experimental films and silent films, scrapbook images, and a fanciful contemporary texture, they are impossible to date) or narrative circumscription (they are more a succession of pictures encoded by an obsessive atmosphere), occupy just such a function of liberating the imaginary—the "inhibited, alienated, or repressed": a liberation peculiar to the Surrealist method.

Of course it is his use of association that brings Hempel's composite works close to Surrealism, but also their relationship to a kind of ethnology. The attention the Surrealists paid to primitive art is well known, and Lothar Hempel has been seen to appropriate masks, draw inspiration from Kabuki Theater, make kinds of totems. "I have put objects like the mask or the magazine photo unchanged into my context […] it is the ordinariness of these things that has something almost comfortingly liberating […] unrelated to anything, they appear magical."[21] These simultaneously "ordinary" yet "magical" objects with their ambiguous cultural identity (they are not genuine primitive masks but artifacts made for popular celebrations; the totems appear to have come from some science-fiction prophecy) seem to fulfill a role equivalent to that described by André Breton and decoded by Rosalind Krauss with regard to Giacometti's search for the *Objet invisible* [Invisible Object]. "Giacometti and Breton went to the flea market where the attention of each was arrested by an object that was seemingly completely useless but which they absolutely had to buy, as if despite themselves. Giacometti bought a sort of warrior's mask with sharp, pointed shapes, the original function of which he was unable to determine precisely, any more than Breton. What matters in Breton's account is the ultimate purpose of the object rather than its initial one," which turned out to be "a prototype for a protective iron mask designed by the medical corps during the First World War."[22] Whatever Rosalind Krauss may say, that indeterminacy as to the original function of the object has its importance, because it questions the object's cultural identity and the notion of authenticity. When Hempel arranges forms and materials that have emerged from

17 — Hempel, Schumacher, "Narrative Machines."

18 — Ulrike Sulikowski, *Sprung im Spiegel, Filmisches Wahrnehmen zwischen Fiktion und Wirklichkeit*, Christina Bluminger, Vienna 1990. Quoted by Hurbon, *Mystères du Vaudou*, p. 158.

19 — Michel Leiris, *L'Afrique fantôme*, Gallimard, Paris,1934. Reprinted in *Miroir de l'Afrique*, Quarto Gallimard, Paris 1996, p. 381.

20 — Sulikowski, *Sprung im Spiegel*, p.159.

21 — Hempel, Schumacher, "Narrative Machines," p.78.

22 — Rosalind Krauss, *No More Play, Primitivism in 20th Century Art: the Affinity of the Tribal and the Modern*, The Museum of Modern Art, New York 1984.

contemporary Western culture *in a primitive manner*, he is not positioning himself in a formal search for neo-primitivism: on the contrary he is suggesting that it is impossible to compartmentalize what exists in the world according to an ordered, exclusive reading grid, and espousing the chaotic, super-abundant nature of the contemporary world. As for the object's "liberatory" dimension, it is once again crucial, but not in the sense meant by Breton. "The intervention of the mask seemed to have the aim of helping Giacometti overcome his indecision. The finding of an object here serves strictly the same purpose as the dream, in the sense that it liberates the individual from paralyzing emotional scruples, reassures him, and makes him understand that the obstacle he may have believed was insurmountable has been overcome."[23] In the case of Lothar Hempel, it is not a question of annexing an object in order to resolve a formal conflict, but of connecting objects to viewers to allow them to become detached from their own conflicts of interpretation.

Furthermore, Hempel conjures up Surrealism with two distinct intentions in mind. On the one hand, he adopts on his own behalf the connection Michael Fried makes between Minimal art and Surrealism. "This affinity can be summed up by saying that Surrealist sensibility, as manifested in the work of certain artists, and literalist sensibility are both *theatrical*."[24] Confirming Toby Webster's idea that the artist works with "psychological perceptions collaged with formal sculpture,"[25] this contraction linking Minimal art and Surrealism doubly emphasizes its theatrical dimension. On the other hand, in the context of his work, he sets in motion a social utopia, an avant-garde based on the rejection of rationalism and logic, on the idea that "existence is elsewhere,"[26] and in doing so offers not a reiteration of the Surrealist *program*, but his own theatrical interim interpretation, linked to the time of the work.

That interpretation, driven by a certain rather Byzantine, possibly decadent, intellectual sophistication, is apparently not parodic, dramatic, or nostalgic, but perfectly allegorical. *Re-enacting* artistic attitudes and trends that are a priori imprisoned in the period and context that engendered them does not have the same effect today as quoting them or appropriating what they produced. In the same way as we have seen the *loa*, which are also completely allegorical, becoming an integral part of reality in the context of ritual, by being embodied through their human *horses*, this *performance* allegory would have concrete effects in the context of the artist's work. For in that interpretation, that theater, there exists a continually intermingled "acted dimension" (in this case that of historical distancing) and an "experienced dimension" (the one that presides over the production of a new work), as Leiris has demonstrated.[27] It is even this indissociability that turns the allegory into performance, *productive* of a different reality; it is real-life experience conscious of being the double of a different real-life experience. Allegory, omnipresent in many ways in Hempel's magnificently heterogeneous work through "the confusion of the verbal and the visual," "of genres," "of aesthetic frontiers," through the "undisguised combination of artistic mediums that were previously distinct,"[28] would thus be pushed to its utmost extreme, its ultimate dimension; the last section of a body of work forming a sort of complete cosmogony, with its figures, objects, and environments: the paradox of interpretation and play.

23 — André Breton, *L'Amour fou*, Gallimard, Paris 1937. Quoted by Krauss, *No More Play*.

24 — Michael Fried, "Art and Objecthood," *Artforum*, New York, 1967. Reprinted in Charles Harrison & Paul Wood, *Art in Theory 1900–2000*, 2nd edition, Blackwell Publishing Professional, Oxford and London 2002, p. 834.

25 — *Lothar Hempel*, "Interview with Toby Webster."

26 — André Breton, *Manifeste du Surréalisme*, Paris 1924.

27 — Michel Leiris, *La Possession et ses aspects théâtraux chez les Ethiopiens de Gondar*, Gallimard, Paris 1958. Reproduced in *Miroir de l'Afrique*, p. 979.

28 — Craig Owens, "The Allegorical Impulse: Toward a Theory of Postmodernism," *October*, vol. 12, Spring 1980, p. 67–86. Reproduced in Harrison & Wood, *Art in Theory*, p. 1052.

Untitled, 1998

Lars Bang Larsen

INTRODUCTION Avoir l'attitude c'est connaître son potentiel. C'est cette manière caractéristique et recherchée avec laquelle on fait ce qu'on fait – ou c'est même parfois comme une arme. C'est une façon de peser et de mettre en scène son apparence, une façon de jouer ses intentions et de les faire résonner devant les autres. C'est déterminer le seuil de sa personnalité et la façon dont les autres doivent le percevoir. Une attitude au point, c'est un catalyseur dans les relations sociales – c'est un aimant pour le regard, un lieu de combat et d'exercice de la liberté. Parce qu'elle est disruptive, on pourrait dire de l'attitude qu'elle ébranle l'idéologie de la classe moyenne. Alors que la classe moyenne est tournée vers une normalité qui esquive la différence et ainsi toute possibilité d'articulation, l'attitude n'est de son côté ni défensive ni conformiste.

On la tient communément pour indiquer une clôture : « j'ai l'attitude ça veut dire que je suis un putain d'enculé de sa mère de la rue » pour citer, dans le texte, N.W.A. (Niggaz With Attitude). Dans un autre morceau rap, ils appuient leur message « Me faire une vie ou deux / Voilà mon truc putain / Si t'aimes pas comme je vis alors va te faire foutre ». En psychologie, l'attitude indique quelque chose comme une armure qui sert de bouclier au moi : une défense, une extériorité qui permet de ne pas avoir à gérer la vulnérabilité de sa psyché et qui mène du coup à une sorte de stagnation de la personnalité. Cela dit, la façon dont nous l'employons ici n'est pas nécessairement territoriale ou statique : quand on agit en ayant conscience que son attitude est lisible comme telle, elle devient au contraire une forme d'économie (ou elle devient lisible comme symptôme).

L'attitude énonce ce qu'on a choisi de faire à partir des attentes de la société conformément à un genre, à un corps, une ethnie, une classe, une sous-culture, une éducation, une sexualité, etc. Les groupes marginaux excellent en attitude : en général, les *queers*, les immigrés, les gitans, les gens de couleur et autres inventent leurs propres sous-cultures plutôt que de risquer de sombrer dans le grand public. Si tu n'aimes pas comme je vis, alors va te faire foutre... Si dans la sous-culture l'attitude est associée au style, elle n'en est en rien synonyme : contrairement au style, l'attitude n'est pas essentiellement visuelle, elle relève aussi d'une intelligence et de comportements sociaux (fierté, amour propre). Elle va au-delà des concepts qui organisent le style, tels que cohérence esthétique et rituel collectif – autrement dit, le style peut s'approprier, l'attitude non (si tu récupères une attitude, t'es un naze). En ce sens, la fonction de l'attitude est l'interprétation subjective de la révolte du style. Comme se lamentait, il y a quelques années, l'un de mes amis qui avait été punk dans les années 1970 : « Le punk ne veut plus rien dire. Aujourd'hui ça veut juste dire que t'es un pauv' type agressif. ». Un bon style n'est jamais la garantie d'une bonne attitude.

Dans l'œuvre de Lothar Hempel, l'attitude ne parle pas seulement d'impertinence ou d'apparence de soi, elle est examen de soi à travers la façon dont les

formes deviennent attitude. L'*art attitude* subvertit ce que l'on attend généralement d'un médium et de la situation d'une œuvre dans l'espace, y introduisant ainsi une dimension performative : elle assure une certaine intimité avec le spectateur et souligne – souvent avec force effets de manche – la singularité de chaque pièce vis-à-vis des autres œuvres d'art. Là-dessus, comme si ça ne suffisait pas, l'attitude est aussi, à l'intérieur de l'art, référence stratégique au rôle de l'artiste.

1. Quiconque réchappe à une catastrophe qui a emporté nombre de vies et où il aurait très bien pu laisser la sienne, se trouve confronté au drame d'avoir à survivre à sa propre survie. La vie humaine qui persiste contre vents et marées n'en est pas plus précieuse, elle devient un fait nu qui échappe à toute explication dès qu'on l'interroge. En octobre 1972, un avion de l'armée en route pour Buenos Aires avec à son bord les Old Christians, une équipe de rugby amateur de Montevideo en Uruguay, s'écrasait dans une tempête et glissait dans une vallée de la Cordillère des Andes. Au cours et à la suite du crash, 26 des 45 passagers périrent. Les secours furent rappelés en moins d'une semaine du fait de grosses chutes de neige et, alors que l'hiver s'installait, les survivants durent s'en remettre au cannibalisme. On dit que Pedro Algorta, l'un d'entre eux, l'interpréta comme une forme de communion possible : de la mort de leurs amis, les autres vivraient. Peu avant Noël, après avoir passé 70 jours dans les montagnes, ils furent finalement secourus.

L'année suivante, les survivants se rencontrèrent à New York à une soirée qu'ils organisèrent pour fêter le fait d'être resté en vie – mais n'était-ce pas pour se rappeler l'imminence de la mort et ce fait obscène qu'ils s'en étaient sortis ? Hempel a acheté, dans une agence photo d'Amsterdam, un cliché de l'un des survivants à cette soirée qu'il a inclus dans l'exposition organisée au Stedelijk Bureau d'Amsterdam en 1998 et intitulée *Kunstschnee will schmelzen (La neige artificielle veut fondre)*. Le survivant fait face à l'objectif, bardé d'innombrables crucifix et autres amulettes qui disent clairement « je n'aurais pas dû survivre ». Sa fâcheuse posture est une charade anthropophage, comme diraient les brésiliens : l'autre, qui est ton semblable, n'a permis ta survie que parce que tu l'as ingéré. Maintenant : tu as commencé par manger l'autre et sa mort violente. Montre-nous comment tu manges ta propre survie. Comment, puisque tu es cannibale, peux-tu en effet te manger toi-même ? Il semble presque impossible de pouvoir se débarrasser de la vieille croyance animiste selon laquelle on acquiert les propriétés de celui qu'on mange. Celui qui s'est fait cannibale pour échapper à la mort ne souffre ainsi d'aucun problème moral, mais il devient l'hôte d'un psychodrame où plus d'un acteur se bousculent la scène : il n'est plus lui-même – il est devenu autre ou plusieurs : un sale *Übermensch* [surhomme].

Ce n'est pas un moindre signe de l'attitude de Lothar Hempel que d'avoir décidé d'inclure une telle photo dans son exposition.

2. Lothar Hempel, à propos de son travail : « Un monument dédié à l'instant même de la capitulation du moi… Se laisser aller à accomplir quelque chose de grand. » La fille dans *Leave All the Rest Behind*, présentée d'abord dans *KAPUTT und die Folgen (Kaputt et les conséquences*, 1999), Robert Prime Gallery, Londres. Autre scène touchant à ce qui est hors maîtrise, tirée d'une photo de manifestation à Turin dans les

années 1970. L'idée selon laquelle l'inauguration d'une nouvelle société implique toujours un sacrifice... voir sa mort absorbée ou sublimée par une communauté. A la fin, ce sacrifice tourne autour de sa propre individualité et n'a plus grand-chose à voir avec la viabilité sociale de la cause ou de ladite communauté. Comme le dit Jean-Luc Nancy : « L'Individu n'est que le résidu de l'expérience de la dissolution de la communauté. Par nature – ainsi que son nom l'indique, c'est l'atome, l'indivisible – ce que l'individu révèle c'est qu'il est le résultat abstrait d'une décomposition. C'est une autre, et symétrique, figure de l'immanence : l'absolument détaché pour soi, pris comme origine et comme certitude. ». Quelque chose d'archaïque dérange notre lecture du motif de la jeune femme qui tourne la tête : ce n'est pas tant le sous-texte politique qui vient à l'esprit, que sa beauté resplendissante, dans un contexte effacé que l'on imagine être un violent soulèvement de rue. L'idole repose sur des perforations à la Cady Noland et au-dessus de sa tête flotte une sorte de halo (gaz lacrymogène ?). L'aspect mythique de l'installation aurait confiné à la propagande s'il n'y avait eu son support ineffable, sa couleur ternie et son message ambigu. Tel quel, le romantisme de l'œuvre livre toute entière la jeune activiste à sa singularité, le tout dans une image évoquant la transgression de l'astreinte à l'administration contemporaine du sexe.

Ne jamais faire de la politique les yeux fermés.

3. Dans un essai au titre anglais *What's happening, baby ?* (*Qu'est-ce qu'il se passe, bébé ?*, 1967), le journaliste, poète et romancier danois Hans-Jørgen Nielsen inventa l'expression d'attitude relative (« attituderelativisme »). Il s'en servit pour dérouler un scénario post-existentialiste dans lequel le sujet humain était susceptible d'assumer une multiplicité de rôles sans en privilégier aucun. A l'identité, argumente Nielsen, s'est substitué un spectre d'attitudes au sein duquel le sujet n'est plus défini par une individualité singulière mais à travers son agencement dans le champ social. Contrairement aux rôles clairsemés et rigides de la société bourgeoise, on se retrouve avec un arsenal de casquettes interchangeables qui, ensemble, constitueraient une garde-robe déterminant une « personnalité ». La perspective axiale de l'espace humaniste y est abandonnée au profit d'un relativisme des attitudes échappant à toute aliénation – dans la mesure où, dès le départ, il n'y a rien à perdre.

L'*attitude relative* de Nielsen lui fut inspirée par une vision structuraliste du monde et cherchait, d'un côté, la comparaison avec l'orthodoxie marxiste définissant l'individu relativement à son appartenance de classe et, de l'autre, la provocation des conventions bourgeoises qui, elles, prescrivaient stabilité, dépendance et tout ce qui va avec (plutôt que de changer de modes de vie comme on change de chemises). Au lieu de ça, il fallait avoir son truc à soi, comme disait le slogan, en restant conforme à l'obsession comportementale de l'époque. Plus encore, il s'agit d'une irréfutable description, l'une des premières, de la condition postmoderne – un point de départ précurseur des constructions à venir de nos individualités.

Mais ce relativisme ne pose-t-il pas un problème moral ? Non, nous dit Nielsen, il ne prive personne de son authenticité. Le sujet humain n'a pas d'essence, il est une série de stases dans un espace sans perspective : « pour un point de vue relativiste, il n'y a pas de système de valeurs, il y a en revanche des repères de valeurs au passage d'une situation à une autre, d'une attitude à l'autre ». Pour Nielsen, le relativisme

de l'attitude était une idée rebelle qui assurait la liberté du sujet en ceci que tout ce qu'il avait à faire, c'était continuer à jouer – il n'y avait pas de réalité au-delà du jeu. Dans ce scénario, l'art ne peut être salvateur (au sens où il instituerait une réalité seconde sur un horizon utopique): l'art ne peut que poursuivre et finir le jeu. «Finalement, ce n'est pas le jeu en tant que tel qui est réalité, mais le fait que le jeu existe bel et bien et que c'est un jeu» explique Nielsen. Au moment où l'on prend conscience d'être impliqué dans une série de situations ludiques et qu'il s'agit, en fait, de la seule réalité, on fait l'expérience d'une liberté nouvelle et précieuse.

Ian Curtis: un nom qui continue de jeter un froid. Son suicide n'avait rien du suicide de rock star classique – il ne fut pas le résultat incontournable de l'excès mais au contraire d'un calcul. Sorte de Joker qui a lui aussi joué le jeu jusqu'à en déterminer l'axiome final (seule manière de quitter la partie?). Lothar Hempel a donné à Curtis les yeux de David Bowie sur la photo *New Dawn Fades*, tirée du livre de la veuve de Curtis, *Touching from a Distance*. Elle fut d'abord exposée dans *The Song of the Bird Is Nonsense* (*Le chant de l'oiseau est absurde*) à la galerie Anton Kern de New York en 2003.

A l'occasion d'une conversation de comptoir, j'ai un jour exalté les vertus de Joy Division auprès d'un ami et déclaré, l'alcool aidant, qu'ils étaient bien meilleur que New Order. Mon ami, qui avait traversé toute la gamme qui va du punk au post-punk en passant par la new-wave, s'est écrié «mais qu'est-ce que tu racontes? J'ai failli me tuer quand Ian Curtis s'est suicidé. Alors quand New Order a sorti *Blue Monday* ça voulait dire qu'on était plus obligé de regarder ses pompes. ». Sauvé par le gong des attitudes relatives... la partie a continué.

4. *Vergeltung* (*Sous les bombes*), roman de 1956 écrit par Gert Ledig sur les raids al- liés au-dessus d'une ville allemande pendant la seconde guerre mondiale, commence ainsi: «Laissez venir à moi les petits enfants. Lorsque la première bombe est tombée, la pression de l'air a catapulté les enfants morts contre le mur. Ils sont morts avant- hier, asphyxiés dans une cave. On les a déposés au cimetière parce que leurs pères étaient au front et qu'il nous fallait d'abord aller chercher leurs mères. Nous n'en avons trouvé qu'une seule. Mais elle était écrasée sous les débris de l'explosion. C'est à ça que ressemble la vengeance. ».

Abstract Socialism (2002) est un monument à l'utopie envisagée comme une collection de motifs un peu vagues. Il s'agit d'un jeu avec les dimensions, comme dans toute pensée utopique: une mise en application quantitative d'une réflexion qualitative. La ruine d'une ville miniature n'a rien de pittoresque – c'est une sculpture anti-sociale: toute culture est camelote, ainsi que le déclarait Adorno à la fin de la guerre mondiale. Dans le «monument» de Hempel, le projet moderne d'éducation esthétique de l'homme a lui aussi tourné à la dialectique négative, la lanterne des Lumières s'avérant impossible à réparer. Des tentatives ont pourtant été faites en ce sens mais elles n'ont vraiment rien changé aux derniers coups de la partie, et la base de la sculpture de continuer de tourner comme un accessoire sorti de ses gonds sur la scène d'une pièce historique. De Samuel Beckett et Tony Blair lequel est le plus absurde? Qui a créé les limbes les plus poignantes? Lénine: «Bien entendu, person- ne, pensons-nous, n'a jusqu'ici douté que la force du mouvement moderne venait de

l'éveil des masses (principalement du prolétariat industriel) et que sa faiblesse venait du manque de lucidité et d'esprit d'initiative parmi les chefs révolutionnaires. »

Montré pour la première fois dans l'exposition *Propaganda* à l'ICA de Londres en 2002.

5. D'après une légende du sud de l'Italie, la morsure mortelle de la tarentule ne peut se guérir que par une danse frénétique : la tarentelle. Lorsqu'une femme travaillant aux champs se faisait mordre, les hommes avaient coutume d'apporter mandolines et tambourins pour qu'on commence cette danse apparentée à une transe jusqu'à ce que le poison soit anéanti. En réalité, la tarentule est terrifiée par le contact des hommes et son venin n'a rien de particulièrement dangereux, par conséquent, certains historiens avancent que l'explication « médicale » de la tarentelle est une fable visant à passer outre la prohibition religieuse de la danse ou encore une manière pour les femmes d'exprimer leur sexualité à une époque où leur désir était assujetti à l'administration patriarcale. Ainsi, son but tenait-il de la subversion voire de l'hygiène sublimatoire.

Dans une peinture récente de Lothar Hempel (*Tarentella*, 2006), une danseuse de tarentelle pieds nus lève un tambourin au-dessus de sa tête sur un fond terne, alors que les couleurs de sa robe fouettent l'air autour d'elle comme les fragments d'un arlequin désarticulé. Un chiffon couleur chair en forme de serre, suspendu dans les airs, est tourné vers la danseuse évoquant la dent d'une araignée.

Au-dessus de ses pieds, un demi-cercle gris avec un point orange en son centre suggère un équilibre précaire : ou comment la liberté repose entre *self-control* et laisser-aller.

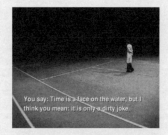

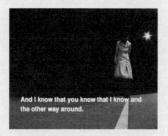

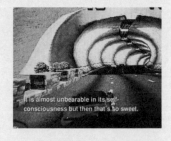

Where are you going.

You say: Time is a face on the water, but I think you mean: it is only a dirty joke.

And I know that you know that I know and the other way around.

It is almost unbearable in its self-consciousness but then that's so sweet.

It becomes a circle, a swindle, what have you got to prove?

moment.

they spread about us. Thank God that nobody besides us reads it.

I love it when you say: We are ghosts.

I love it when you say: We are ghosts.

and akin to shadows.

Arm in arm we stand in the middle of the middle, far ahead of time.

KAPUTT und die Folgen (Kaputt and the Consequences), 1999

The Facts
5 × Attitude in Lothar Hempel

Lars Bang Larsen

INTRODUCTION Attitude is seeing how far you can go. It is the characteristic and controlled manner in which you do the things you do, or it can even be a kind of weapon. It is the way you pace and perform your appearance, how your intentions are played out and resonate in other people. It means defining the threshold of your personality, and how this threshold is to be perceived by others. A good attitude is a catalyst in social processes—a magnet for the gaze, the site of a struggle, and an exercise of freedom. Because it is disruptive, you could say that attitude destabilizes middle-class ideology. Whereas the middle class is oriented toward a normality that bypasses difference, hence requiring no articulation, attitude is neither defensive nor conformist.

Attitude is commonly held to denote a closure: "I've got an attitude that's saying I'm a crazy motherfucker from the streets" to quote, exactly, N.W.A. (Niggaz With Attitude). In another rap they amplify their message "Taking a life or two / That's what the hell I do / If you don't like how I'm living well fuck you." In psychology, attitude denotes something like a protective armor that shields your self: a defense, an exteriority that allows you not to deal with the vulnerability of your psyche, and hence becomes a kind of stagnation of the personality. However, the way we use it here is not necessarily territorial or stagnant: when you act with the knowledge that your attitude is readable as such it becomes instead a negotiation (or it becomes readable as a symptom).

Attitude is stating what you have decided to do with what society expects you to be in relation to your gender, body, ethnicity, class or subculture, education, sexuality, etc. Marginal groups excel in attitude: queers, immigrants, gypsies, colored people, and other others typically create their own subcultures instead of allowing themselves to be sucked up in the mainstream. If you don't like how I'm living, well fuck you ... Through subculture, attitude is associated with style, but is by no means synonymous with it: unlike style, attitude isn't primarily visual, it is also determined by social intelligence and behavior (pride, self-respect). It goes beyond concepts that organize style, such as aesthetic coherence and collective ritual—in other words, style can be appropriated, attitude cannot (if you appropriate an attitude you are a fake). In this sense, the function of attitude is its subjective interpretation of the revolt of style. As a friend of mine who was a punk in the 1970s lamented a few years ago: "Punk doesn't mean anything anymore. Today it only means that you are an aggressive bum." Good style is no guarantee for a good attitude.

In Lothar Hempel's work, attitude is not just about sassiness or the appearance of the self, but also an examination of the self through the way forms become attitude. Art with an attitude confounds our expectations of the medium and location of the work's presentation, thereby conveying a performative dimension: it assures a certain intimacy with the beholder, and emphasizes—often in a gestural

way—the singularity of each piece vis-à-vis other artworks. And, to be sure, attitude is also an artistic strategy of how to relate to the role of the artist.

1. Whoever is not killed by a disaster that claims many lives, and that could easily have claimed theirs, is faced with the dilemma of surviving his or her survival. Human life that persists against all odds does not become more precious, but becomes a naked fact that recedes as you demand an explanation from it. In October 1972 a chartered military plane en route to Buenos Aires with a group of amateur rugby players from the Old Christians team of Montevideo, Uruguay, crashed in rough weather and slid into a valley in the Andes. In the crash and after, 26 out of the 45 passengers died. Search parties were called off within a week due to heavy snowfall, and as winter advanced the survivors had to resort to cannibalism. It is said that one survivor, Pedro Algorta, thought of it as a communion: from their friends' deaths, the others would live. Shortly before Christmas, after 70 days in the mountains, they were finally rescued.

The following year the survivors met again in New York City at a party they held to celebrate being alive—or maybe to remind themselves of their near death, and the obscene fact that they made it? Hempel bought a photograph of one of the survivors at the party from an Amsterdam photo agency, which was incorporated in the exhibition *Kunstschnee will schmelzen* (*Artificial Snow Wants to Melt*) at the Stedelijk Bureau in Amsterdam, 1998. The survivor stares back at us, covered with a number of crucifixes and amulets that clearly say, "I shouldn't have lived." His predicament is an anthropophagic riddle, as the Brazilians would put it: the other, who is like you, allowed for your survival by being ingested by you. Now, first you ate the other and his violent death. Let us see how you can eat your own survival. How, indeed, can you ingest yourself as a cannibal? The old animistic belief that you take over properties from the person you eat must be almost impossible to shake off. He who has become a cannibal due the risk of losing his life thus has not a moral problem, but is the host of a psychodrama with more players on a crowded stage: he is no longer himself—he has become other, or several: a dirty *Übermensch* (Superhuman).

It is indicative of Hempel's attitude that he decided to include a photograph with such a resonance in an exhibition.

2. Hempel writes about this work, "A monument for the moment of surrender of the self ... Letting yourself go to achieve something for the cause." Like the girl from *Leave All the Rest Behind*, first shown in *KAPUTT und die Folgen* (*Kaputt and the Consequences*, 1999), at the Robert Prime Gallery, London. Another scene for what cannot be mastered, made from a found photograph of a political demonstration in Turin in the 1970s. The idea that ushering in a new society demands sacrifice; to have your death absorbed or sublated in a community. In the end, this sacrifice revolves around your individuality and does little for the social viability of the cause or the community. As Jean-Luc Nancy puts it: "But the individual is merely the residue of the experience of the dissolution of community. By its nature—as its name indicates, it is the atom, the indivisible—the individual reveals that it is the abstract result of a decomposition. It is another, and symmetrical, figure of immanence: the absolutely detached for-itself,

taken as origin and as certainty." Something archaic disturbs our reading of the motif of the young woman turning her head: it isn't the political subtext that comes to mind, but her beauty and her rapture, in the midst of a context that has been erased and that you imagine is a full-blown street riot. The idol rests on Cady Noland-style perforations, and around her head hovers a kind of halo (tear gas?). The mythical air of the installation could have made it a propaganda piece, if it weren't for its flimsy support, bland color, and equivocal message. As it is, the romanticism of the work delivers the young activist to her singularity, resolved in an image suggestive of a transgression of today's extremely exacting administration of sex.

Never practice politics with your eyes closed.

3. In an essay with the English title "What's happening, baby?" (1967), the Danish journalist, poet, and novelist Hans-Jørgen Nielsen coined the term "attitude relativism" (attituderelativism). With this he unfolded a post-existentialist scenario in which the human subject could assume a plurality of roles without a focal point. Identity, Nielsen argued, is substituted by a spectrum of attitudes in which the subject is no longer defined by its unique individuality but through its agency in the social field. Unlike the few and rigidly defined roles of bourgeois society, you are in this way offered an arsenal of roles which you can slip in an out of as if they were a dress or a suit, and which together define your "personality." The central perspective of the humanist universe is lost, and so a relativism of attitudes is beyond alienation—because there is nothing to lose in the first place.

Nielsen's attitude relativism was inspired by a structuralist worldview and was on the one hand a showdown with Marxist orthodoxy that defines the individual in relation to class belonging, and on the other, a provocation in the face of bourgeois convention that prescribed stability, dependency, and all things in their place (rather than changing your lifestyle as frivolously as the color of a lipstick or the length of a skirt). Instead you had to do your own thing, as the slogan went, in accordance with the era's focus on behavior. More than that, it is an early and compelling description of the postmodern condition—a point zero awaiting the construction of ourselves.

But isn't this relativism a moral problem? No, Nielsen says, it doesn't deprive anybody of their authenticity. The human subject has no essence, it is a series of stations in a space with no perspective: "From a relativist point of view there are no value systems, but there are points of value from one situation to the next, from one attitude to the next." For Nielsen, attitude relativism was a rebellious idea that set the subject free in that all you can do is to play along—there is no reality beyond the game. In this scenario, art couldn't save the day (in terms of establishing another reality on a utopian horizon): art could only pursue and accomplish the game. "At the end of the day it is not the game in itself that is reality. But the fact that the game exists, and that it is a game," Nielsen clarifies. The moment you acknowledge that you are involved in a series of game situations, and that this is your only reality, you experience a new and valuable freedom.

Ian Curtis: a name that still sends a chill through you. His wasn't the classic rock'n'roll suicide—it was not the inevitable result of excess, but instead a calculation.

A kind of joker figure who also played the game until he defined the game's final axiom (the only way to leave the game?). Hempel has given Curtis Bowie eyes on the photograph *New Dawn Fades* which is taken from the book by Ian Curtis' widow, *Touching from a Distance*. It was first shown in *The Song of the Bird Is Nonsense*, at Anton Kern Gallery in New York in 2003.

In a bar conversation I once extolled the virtues of Joy Division to a friend of mine, and drunkenly called them a greater band than New Order. My friend, who had lived through the whole gamut of punk to post-punk and new wave went, "What are you talking about! I almost killed myself when Ian Curtis took his own life. But when New Order released *Blue Monday* it meant that you didn't have to be a shoe-gazer anymore." Saved by the bell by relative attitudes ... the game went on.

4. *Vergeltung (Payback),* Gert Ledig's novel from 1956 about an allied air raid on a nameless German city during the WWII, begins like this: "Let the little children come to me. When the first bomb fell, the air pressure catapulted the dead children against the wall. They died the day before yesterday, suffocated in a cellar. We took them to the cemetery because their fathers were at the front, and we had to first look for their mothers. We only found one. But she was crushed beneath the debris of the explosion. That is what revenge looks like."

Abstract Socialism (2002) is a monument to utopia as a collection of vague motifs. It is a play with dimensions, as any utopian thought is: quantitative implementation of qualitative thought. The ruin of a miniature city is not a picturesque one—it is rather an antisocial sculpture: all culture is rubbish, as Adorno declared after the end of the Second World War. Also in Hempel's "monument," modernity's project of man's aesthetic education has turned into a negative dialectics in which the lantern of enlightenment is beyond repair. Attempts at reparation have been made which clearly do not redeem the endgame, and the base of the sculpture keeps turning up as a debased prop in a history play. Samuel Beckett or Tony Blair—who is the most absurd? Who created the most poignant limbo? Lenin: "Indeed, no one, we think, has up to now doubted that the strength of the modern movement lies in the awakening of the masses (principally, the industrial proletariat), and that its weakness lies in the lack of consciousness and initiative among the revolutionary leaders."

First shown in *Propaganda*, ICA, London 2002.

5. According to southern Italian legend, the deadly bite of the tarantula could only be cured by frenetic dancing—the Tarantella. When a woman working in the field had been bitten, the men would get out their mandolins and tambourines and the trance-like dancing would begin until the poisoning had been cured. However, the tarantula is in fact terrified of human contact and its venom not particularly dangerous, so some historians suggest that the "medical" explanation of the Tarantella dance is a tall tale used to circumvent religious prohibition against dancing, or a way for women to express their sexuality in an era when women's desire was a matter of patriarchal administration. Hence its purpose was of a subversive or even hygienic-sublimatory kind.

In Hempel's painting from 2006, a barefoot Tarantella dancer raises the tambourine over her head on a drab background, while the colors of her dress whip around her like fragments of an exploded harlequin. A flesh-colored, claw-shaped rag, suspended in mid-air, is turned toward the dancer like the tooth of the spider.

Above her feet, a gray half-circle, centered by an orange dot, suggests a precarious balance: how freedom lies between self-control and letting go.

EXTREMA DURA Suddenly they break in over us. Leaving behind them burnt earth, they are insatiably hungry and armed with precious weapons. The crowd opens up and casts furtive glances. From mirrored wall to mirrored wall, tension fills the room. A glass slips from a hand and soundlessly shatters on the black and white marble floor. Its shards reflect their superhuman charm a thousand times over. The small gestures of superiority and the open display of recklessness are not to be missed. It is their sheer belief that only the absolute counts, that which we fear and desire. There is open provocation, naturally predicting the inevitable fight which erupts within the shortest time. You pull me into a side room just before a kneecap crushes a nose. Want to be alone with me amongst the others. Want to share this last moment with me before everything changes.

The Wespennest Times

ON THE OLYMPUS It always surprises me how few of us there are. Just a handful, two dozen, only a small crowd. The first hour of dawn on the roof of the multi-story parking lot, beneath us the eternal city. Sleepless demigods, standing against the light. Twisted silhouettes, damp from the morning dew. A declaration is flung from the roof with precision. Now it is growing wings. It becomes a law.

 "Everything corresponds with us. A fatal condition." Somebody next to me says quietly, as if talking to himself. Later a quarrel arises from a game—played without a hint of imagination—it turns serious right away. Beer rains down on us. Noses are bleeding and we are wide awake from exhaustion. Ice-cold revelation: everything is going to carry on like this forever. In any case, we can no longer turn back. Immature freedom. "Aren't you cold?" I asked vaguely. "Not anymore." You say with a laugh.

SHANGRI-LA Far above the city, circling helicopters render the whole scene: houses and streets covered in sticky black soot; turned-over cars, ruins and smoke. A drive-in restaurant in the east is burning. Windows shatter and plastic furniture melts. Liquids pour and spill onto floors drawing big puddles, trickling into cellars and finally down a sewer. From there further seeping into the pipes and deeper, arriving at the cool earth. Stones and quiet.

 Suddenly a glimmer of light and now voices behind a wall. And behind this wall: a restless gang, scraping feet in heavy boots, a razor-sharp gaze and stress. "We now cannot wait any longer!" has been said here for centuries. Hot currents flow through these heads until blood spurts from a nose. But also: gently flawed skin, hand-stitched uniforms, shared cigarettes.

 Baked into a lead mantra, the ever-same thoughts pound against the skull from inside until it hurts. The contract! The contract above all. Accepted in darkness. It is irrevocable, alienating. We mature down here. Our time will come. The finger points at us, and this morphs me into we, which is at the threshold of him. Diamonds.

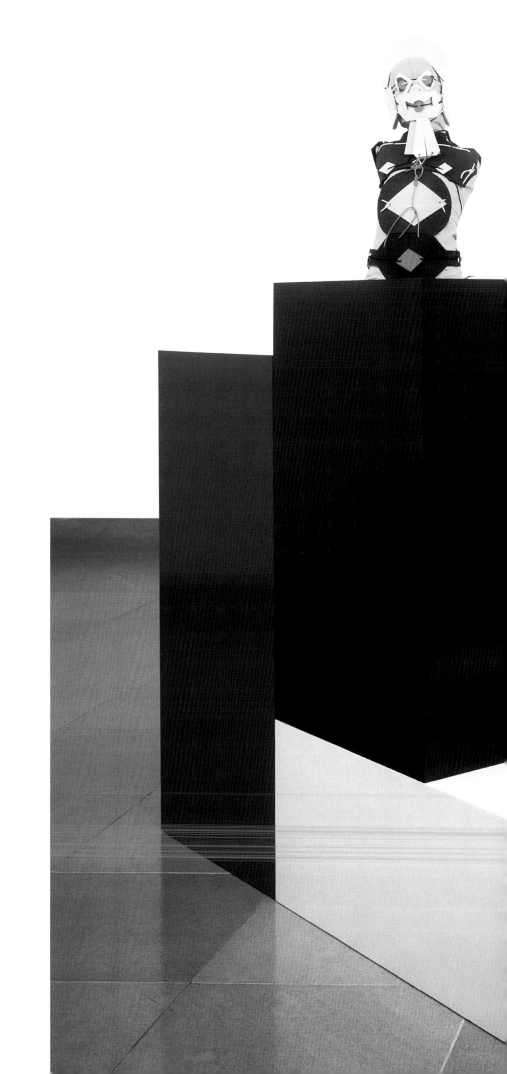

Wespennest (Wasp's Nest), 2000

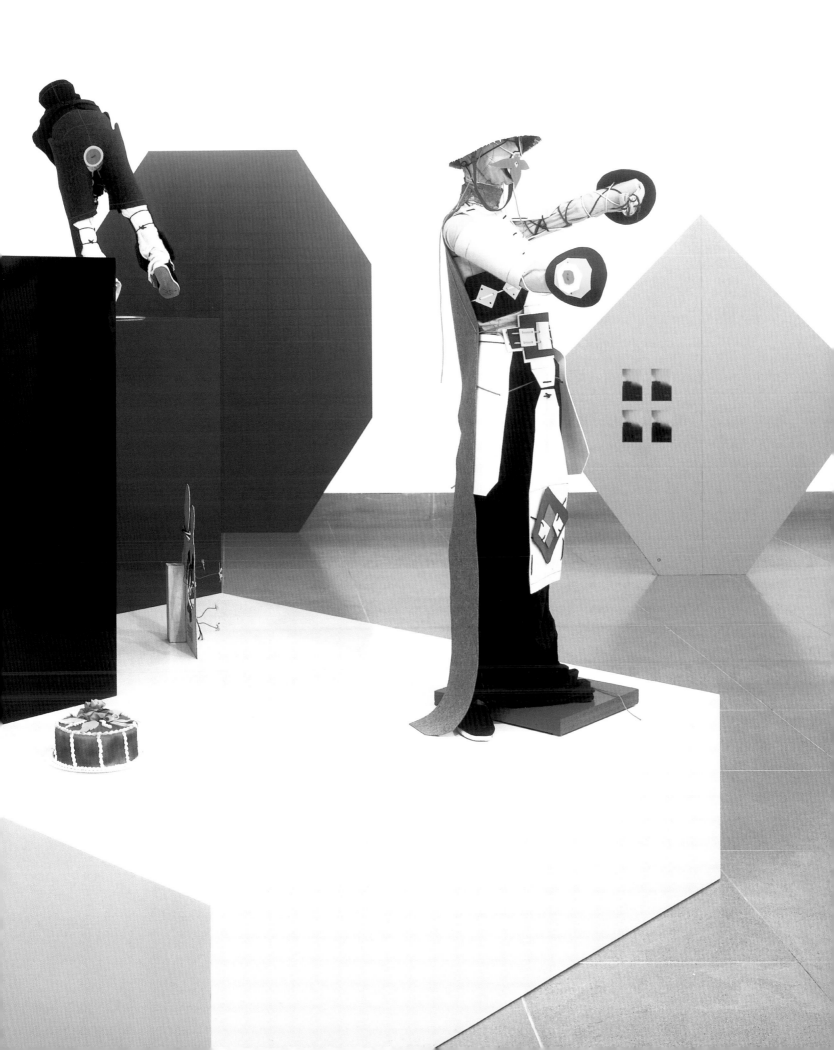

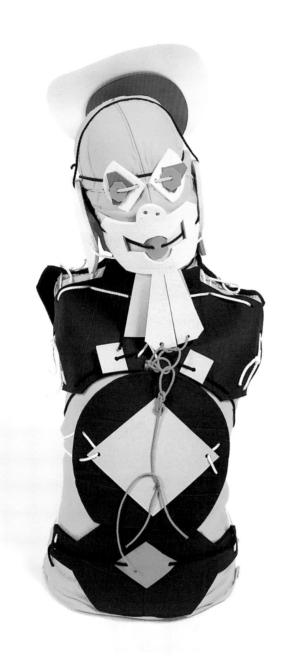

Dornenboy (The Boy of Thorns), 2000

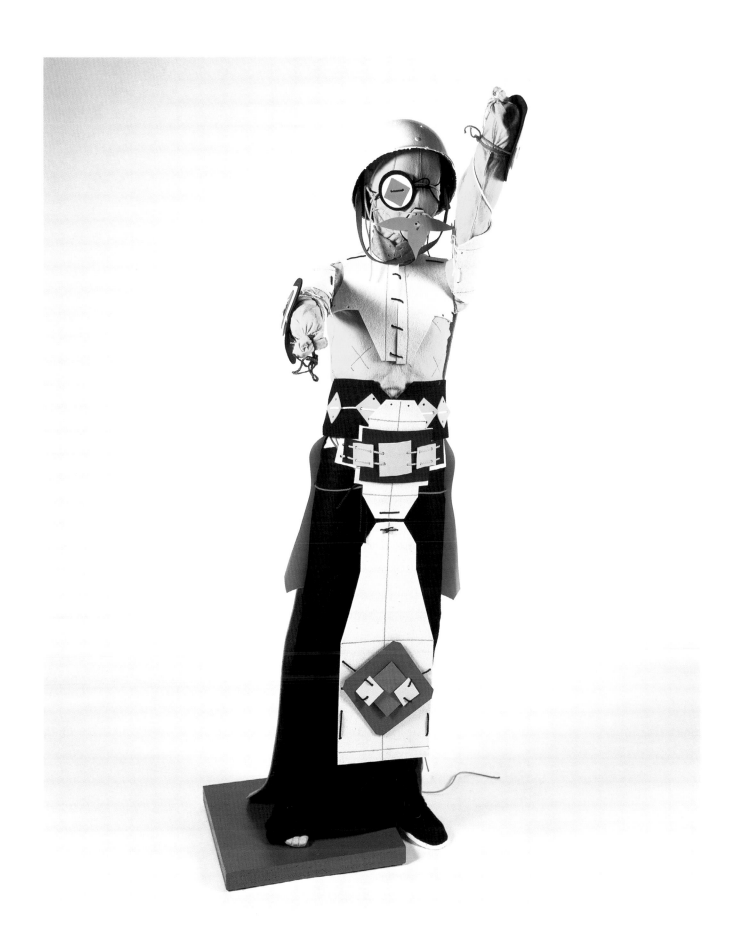

Tired God Says: I'll Fight Until the End, 2000

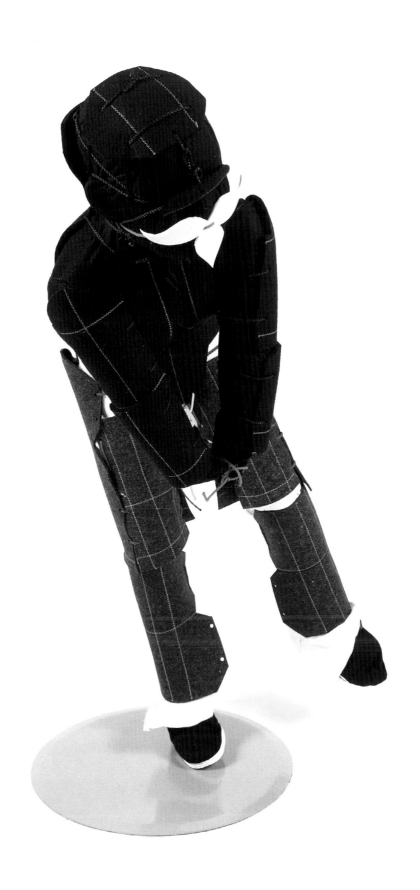

Zuckerloch (Sugarhole), 2000

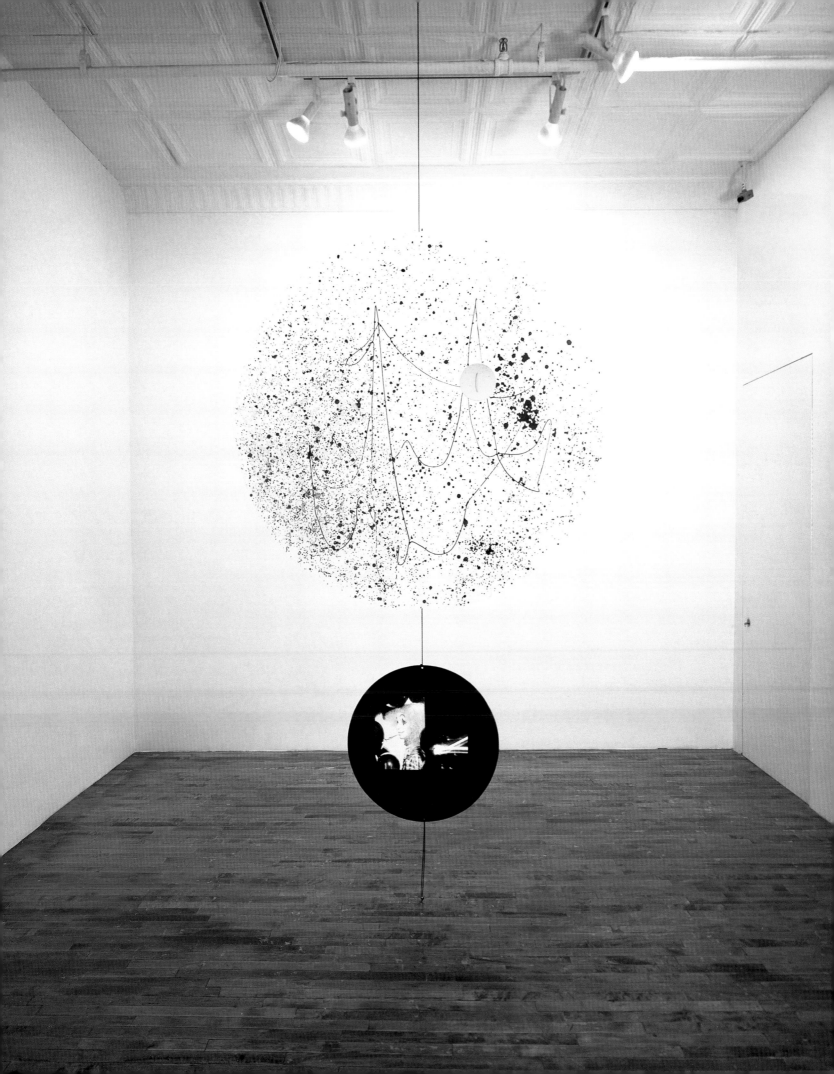

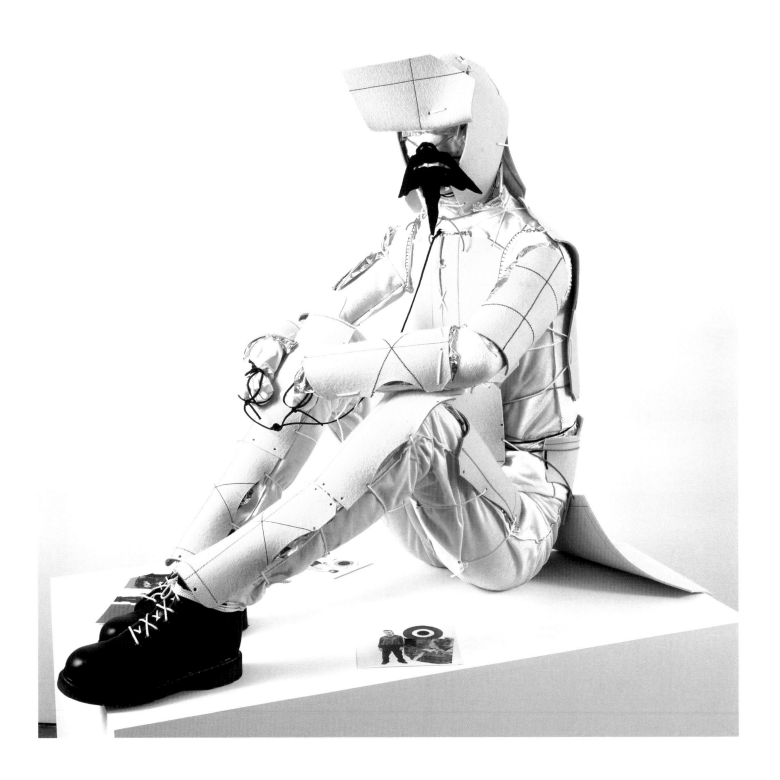

Jupiter, 2000

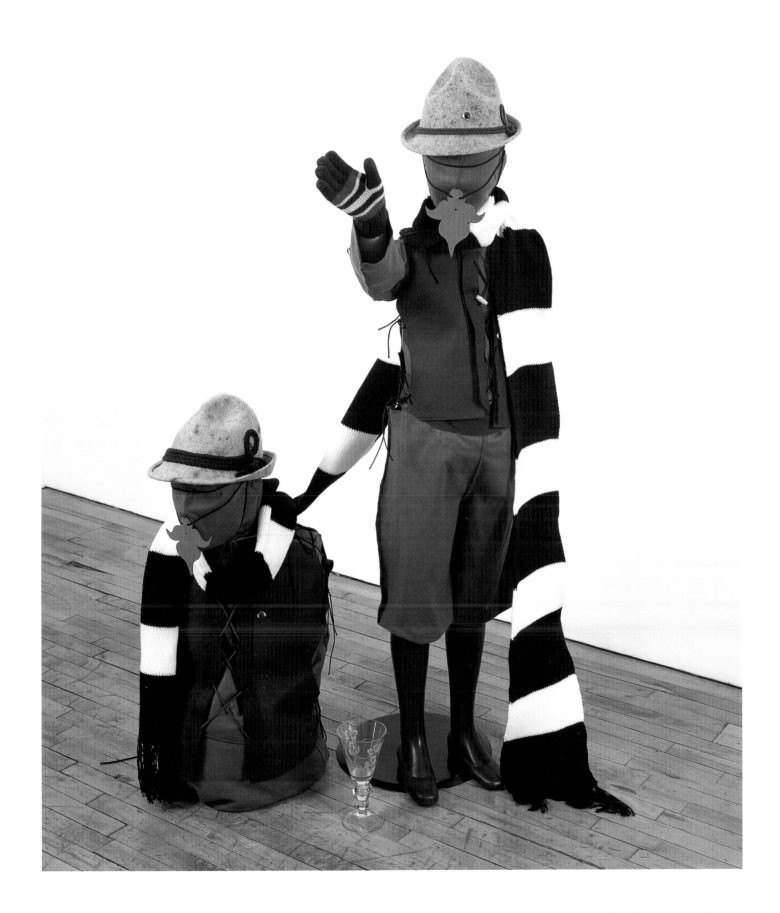

Ungeheuer (The Ogre), 2001

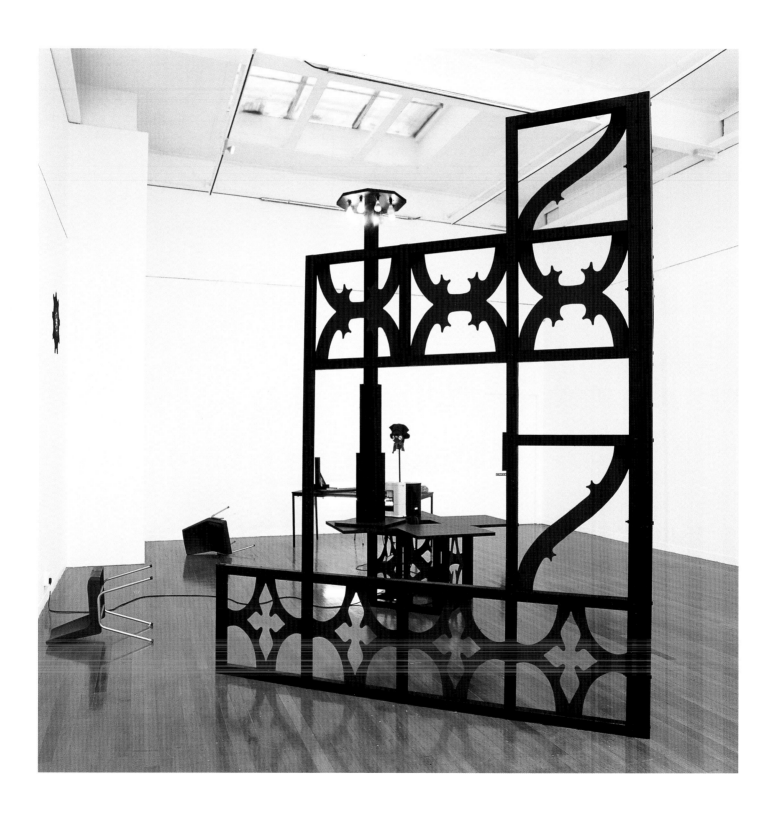

Streik (Strike), 2002

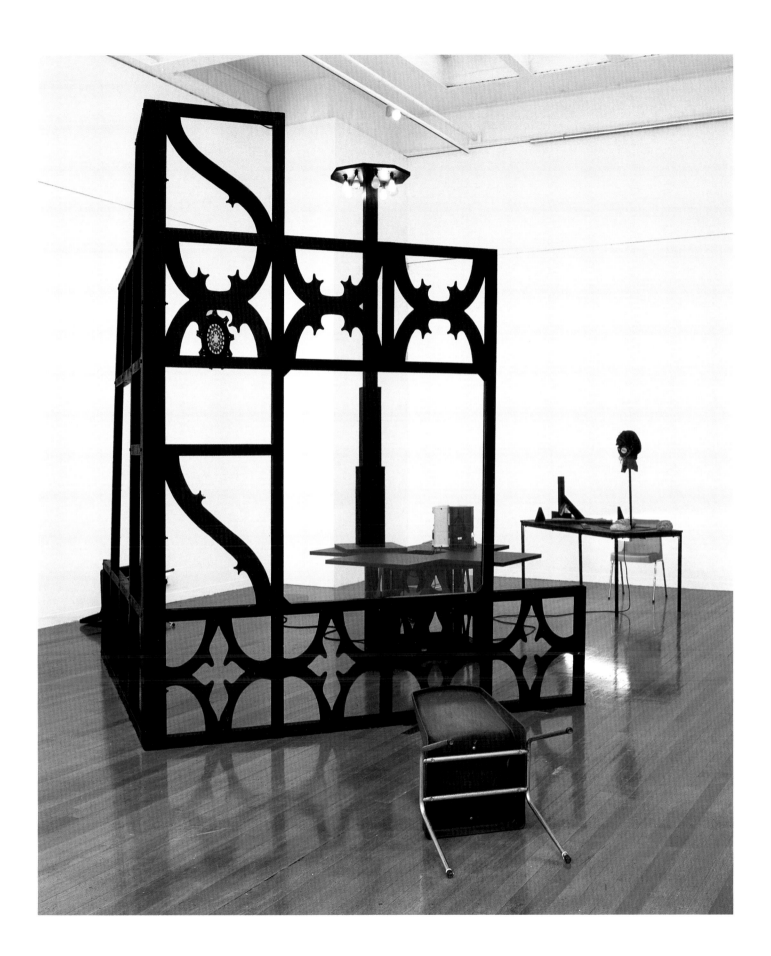

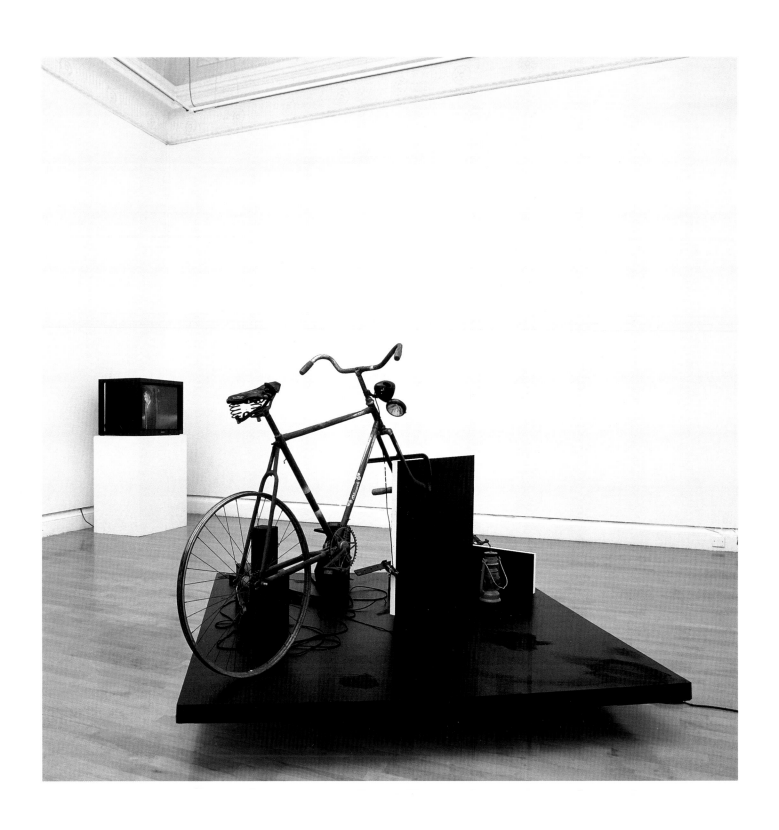

Abstrakter Sozialismus (Abstract Socialism), 2002

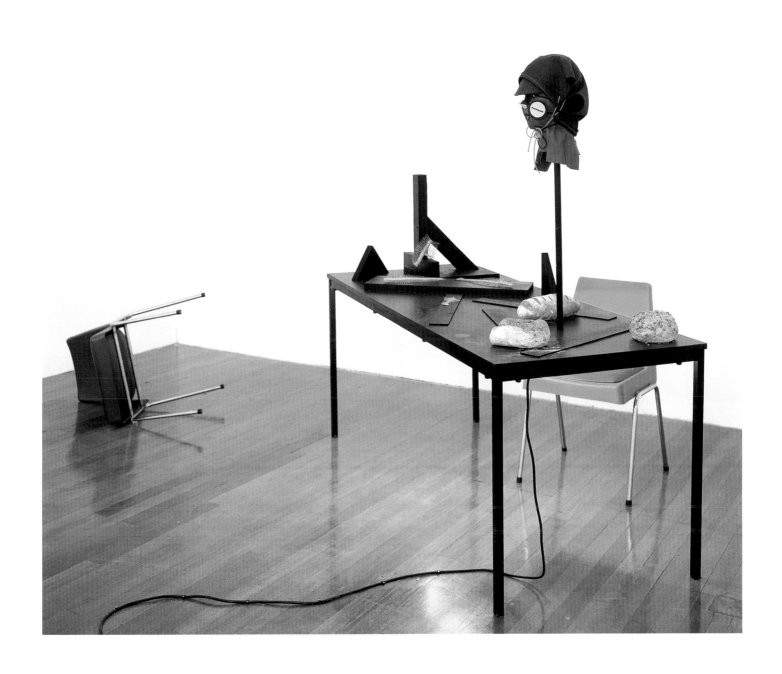

Streik (Strike), 2002 [détail]

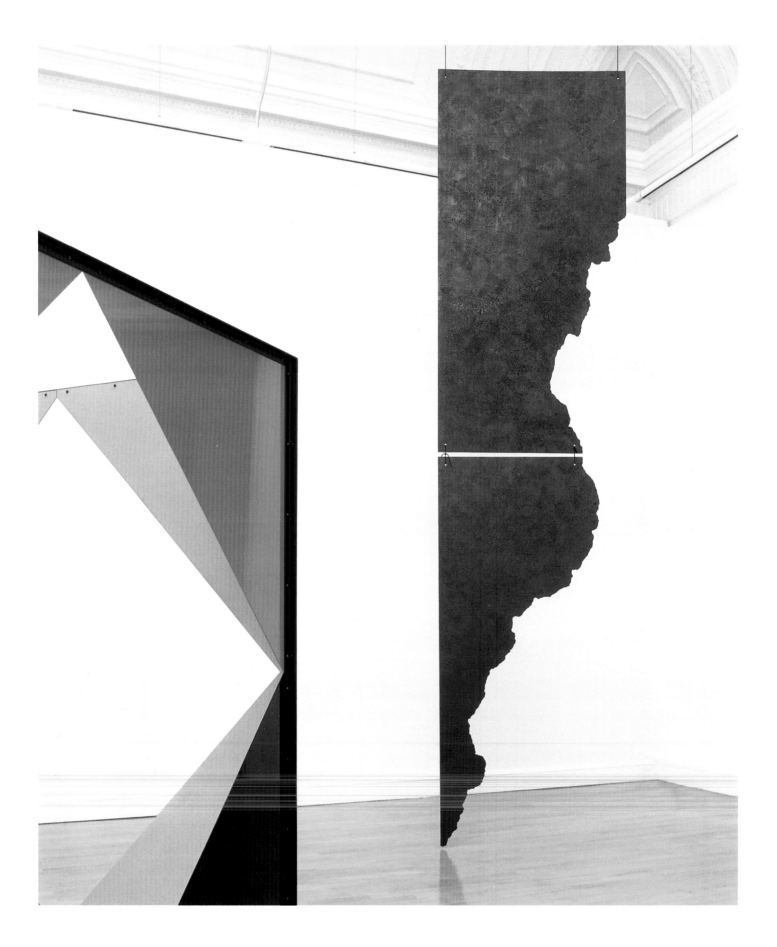

Lightning (Black), 2002

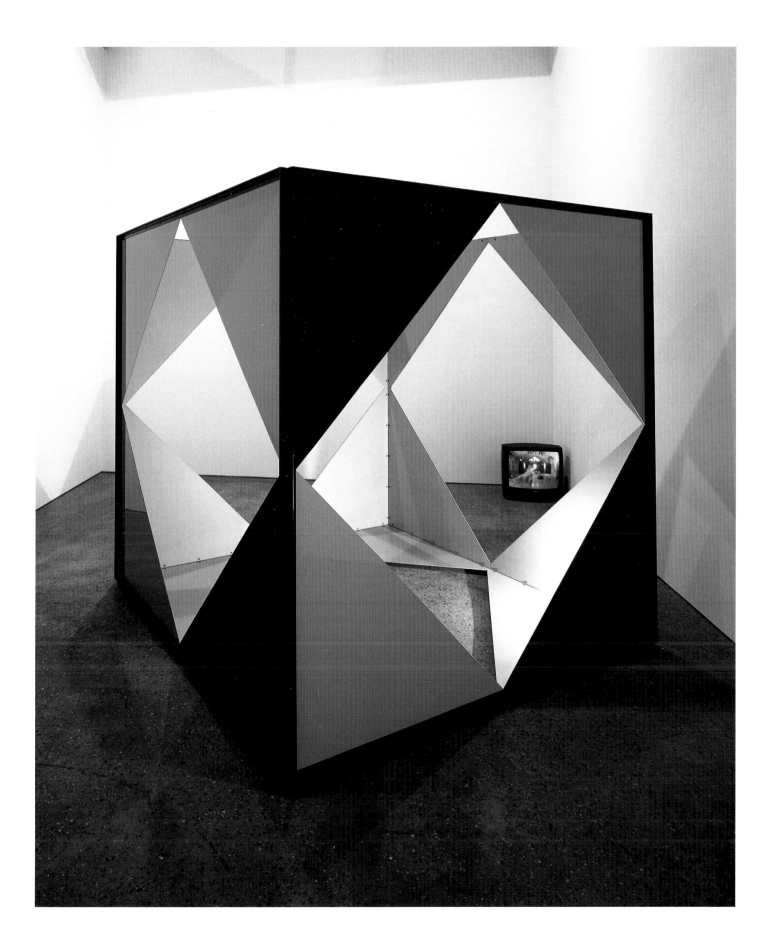

Maschinen Herz (Machine Heart), 2002

Diamanten
c/o – Atle Gerhardsen, Berlin
28.06 – 03.08.2002

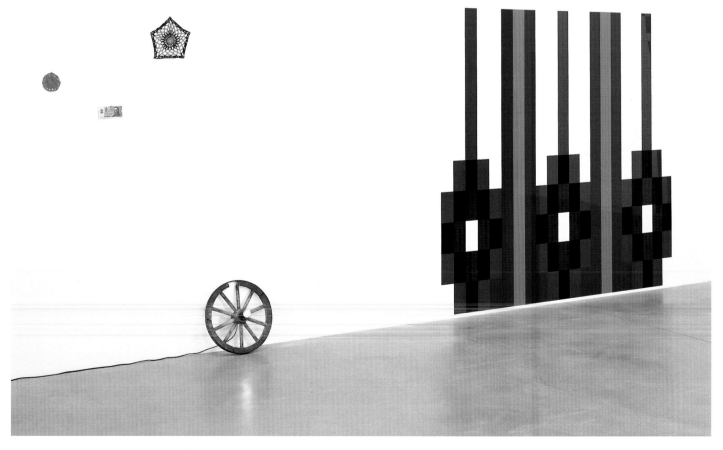

Roter Diamant (Red Diamond), 2002
Irrlicht, 2002
Franz Kafka Platz, 2002

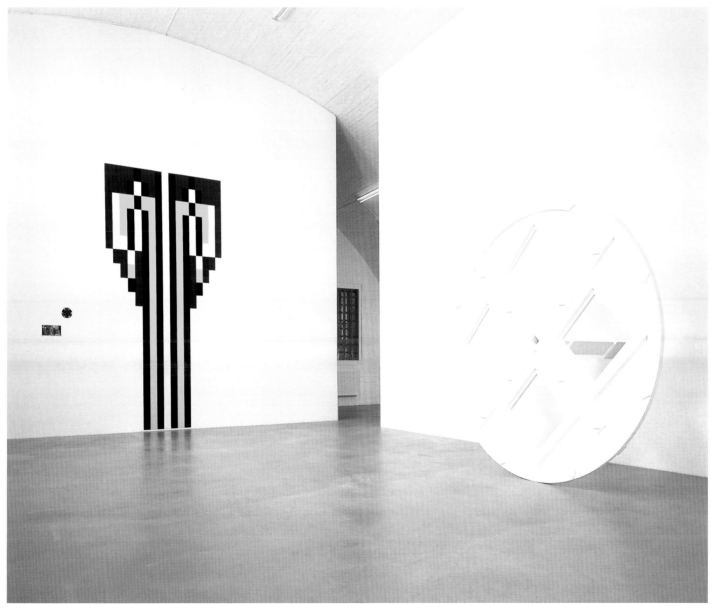

Grüner Diamant (Green Diamond), 2002
Rainer Werner Fassbinder Platz, 2002
Implosion, 2002

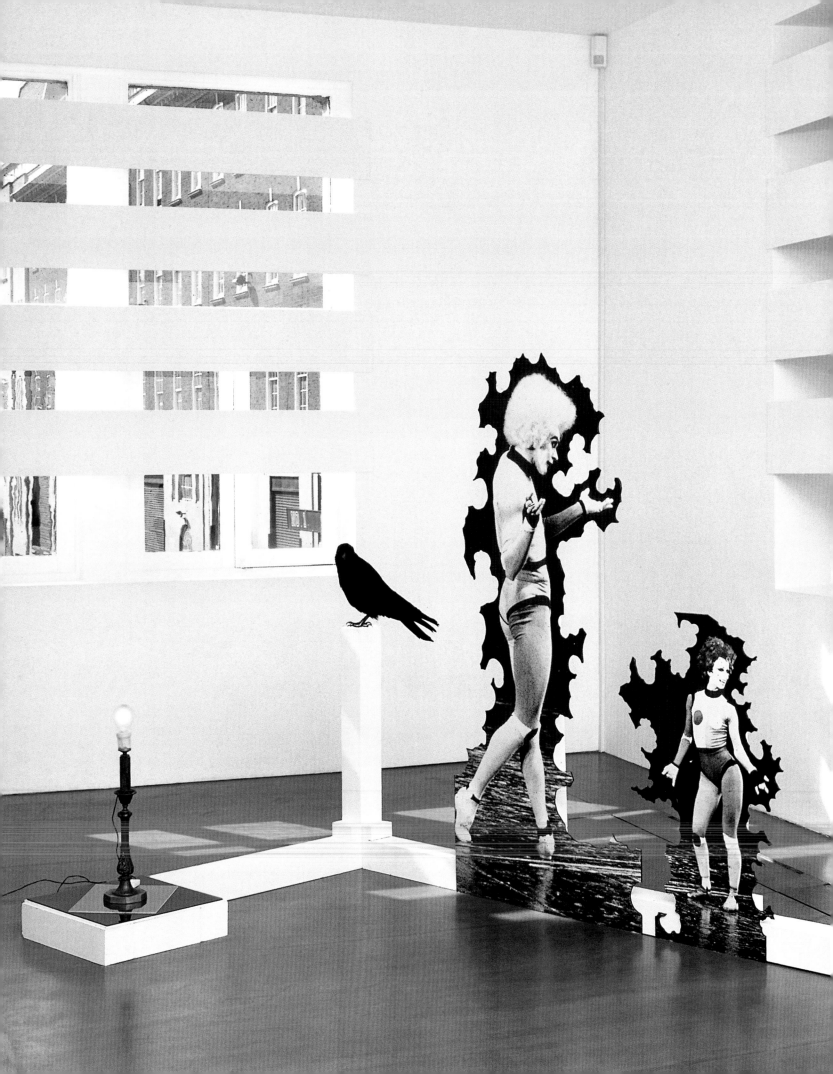

Fleisch : Maschine
Magnani, Londres
20.04 – 01.06.2002

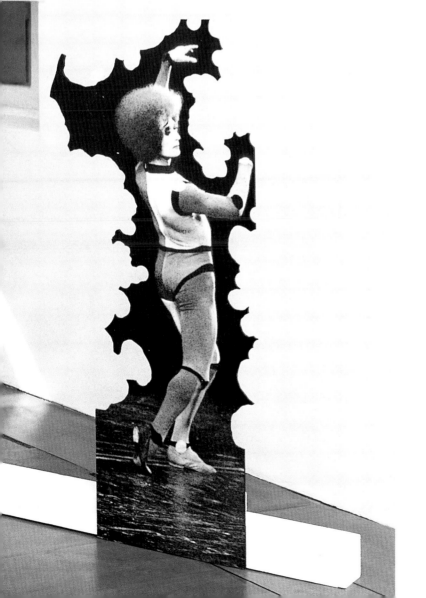

Laissez Faire, 2002

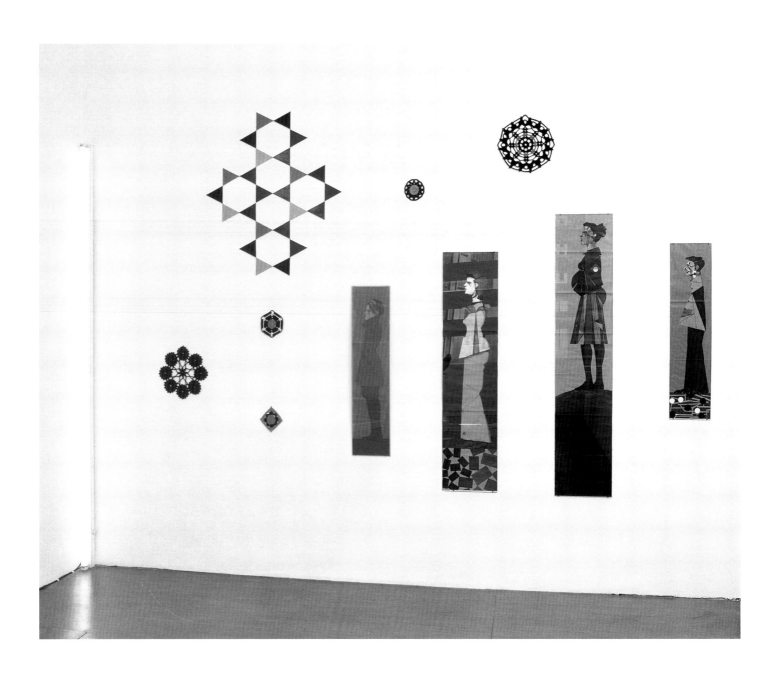

Vue d'installation, Magnani, Londres, 2002

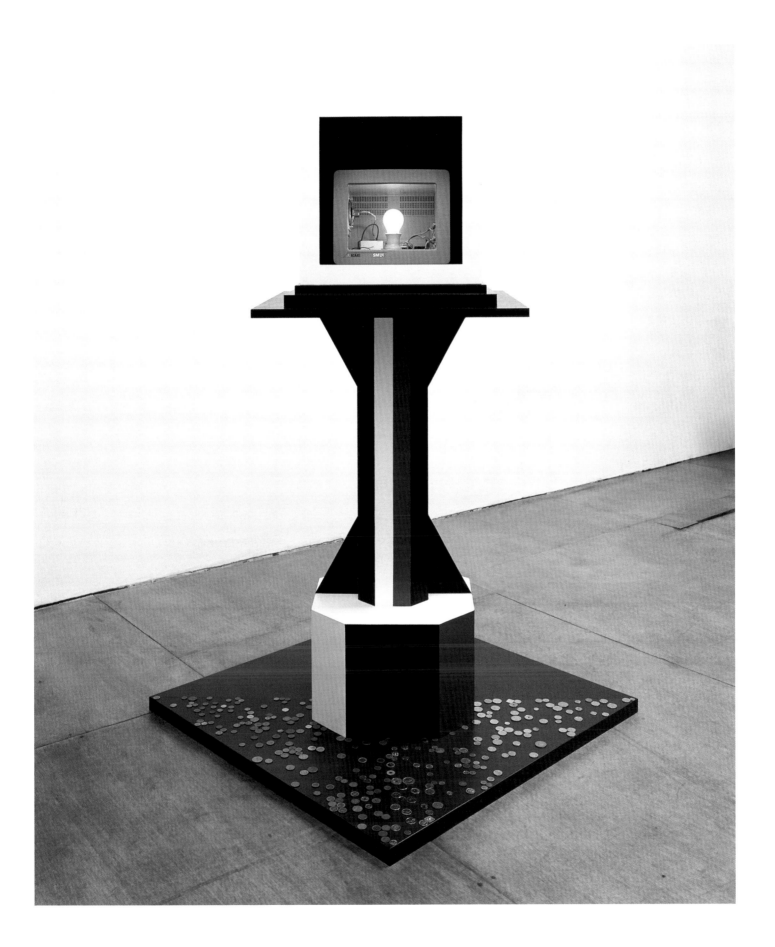

Vaterstaat, 2002

Der Gesang der Vögel ist sinnlos (The Song of the Bird Is Nonsense)
Anton Kern Gallery, New York
04.04 – 10.05.2003

thunder and lightning

you scream: "this is not right! you are still doing it wrong!" a
tear of disappointment rolls from your eye and leaves a clear
trace on your dusty skin. angrily you strike out at one of the
performers in pig costumes with your stick. "you damned
idiots!" silently and submissively everybody is trotting back to
their starting position. "la monstra," they call you, so i have
heard. it can take hours until everything behind the scenes is put
into order again. the street that you had built into this classical
horizon looks ridiculous. the artificial mountains that pile up
left and right look false. the costumes—a catastrophy. the sun is
almost at its zenith now. it is getting even hotter. i hear the
mediterranean sea. it roars from the nearby beach. eternal sea.
laughing sea. "it will never be the way you want it to be," i think
and i am astonished by my silent laugh, because i do love you in
your madness. then we hear a cry from afar. an extra has fallen
off one of the rocks and broken his leg. this is a sign! "take a
one-hour break, goddammit!" you are yelling and i follow you
calmly into our trailer. you close the shutters. shadows and dust
dance inside the room. i kiss your naked butt and honey flows
out of your asshole into my mouth. "this is where the pain lies
that i can't bear anymore! right here!" you whisper faintly,
pushing with your index finger deeply into the spot between
breast and stomach. then you fall into my arms, we slide down
onto the floor and i feel your hard cock through my clothes.
while we are fucking and clinging together in our sweat, i think
of the day that i saw you for the first time. a big nice lump of clay
filled with animal souls, i thought and i fell for you at once. how
you then told me drunkenly about your idea. every detail, every
motion, every fraction was already clear in your head back then.
you said: "if everything will turn out as i see it, i will finally turn
into a human being. into a real human being." when you turn
into a human being, then i will be gone, i think, and i feel you
coming inside of me.

[Extrait]

104

New Dawn Fades, 2003

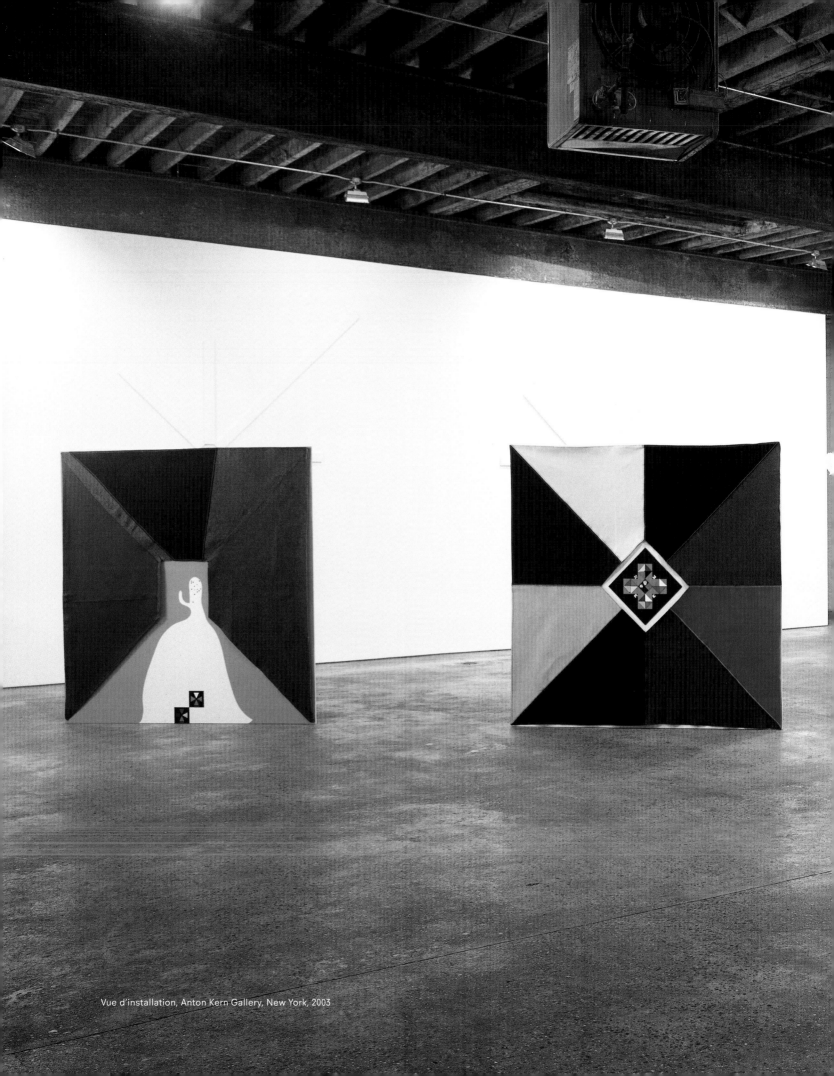

Vue d'installation, Anton Kern Gallery, New York, 2003

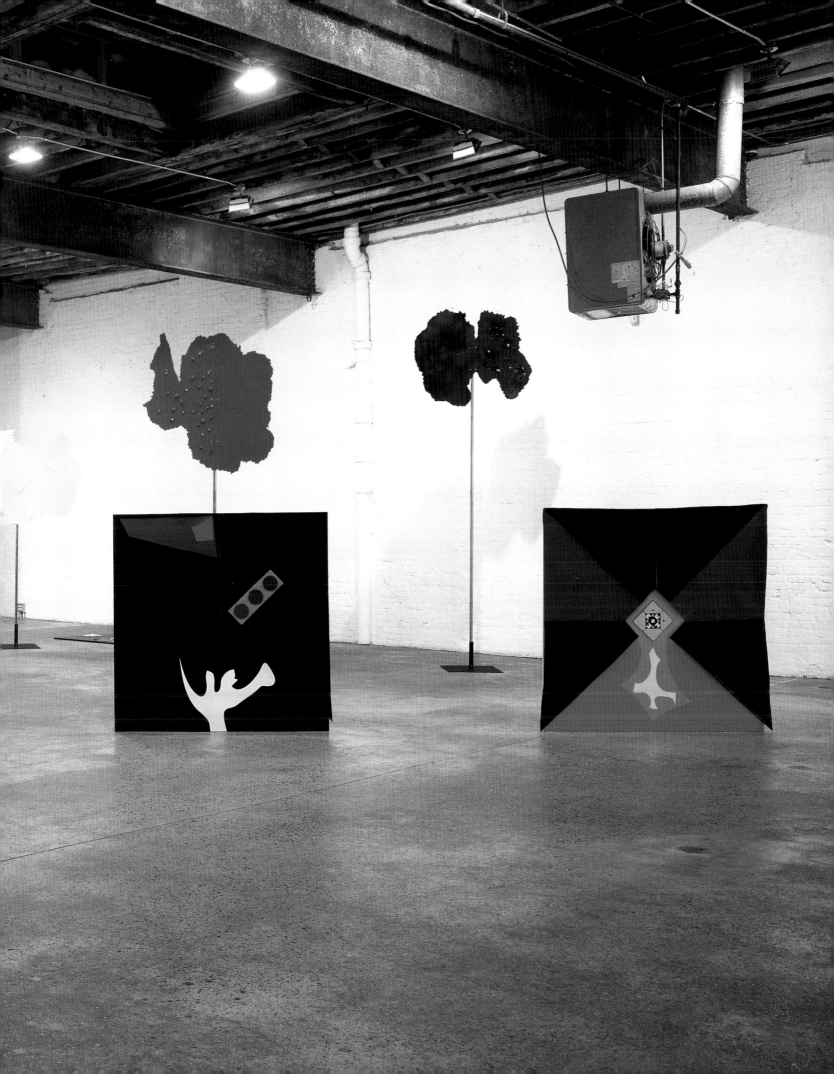

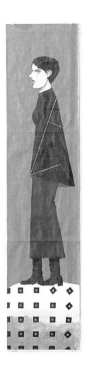 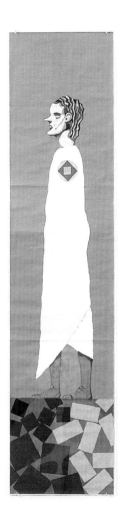 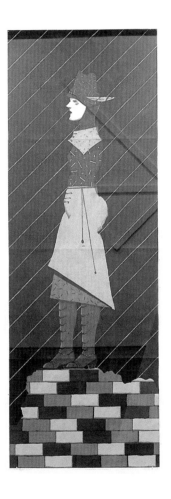

Kreuzberger Nacht (Kreuzberg Night), 2003
Jason, 2003
Kindl, 2003
Das Goldene Dreieck (The Golden Triangle), 2003
Medea, 2003
Richard Wright, 2003

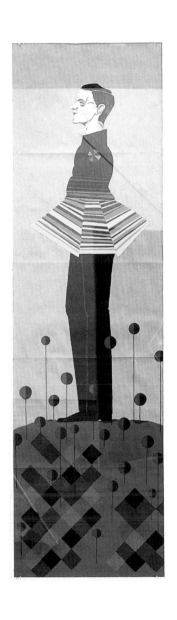
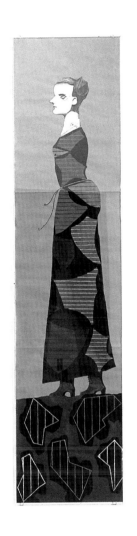
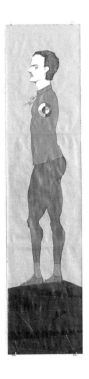

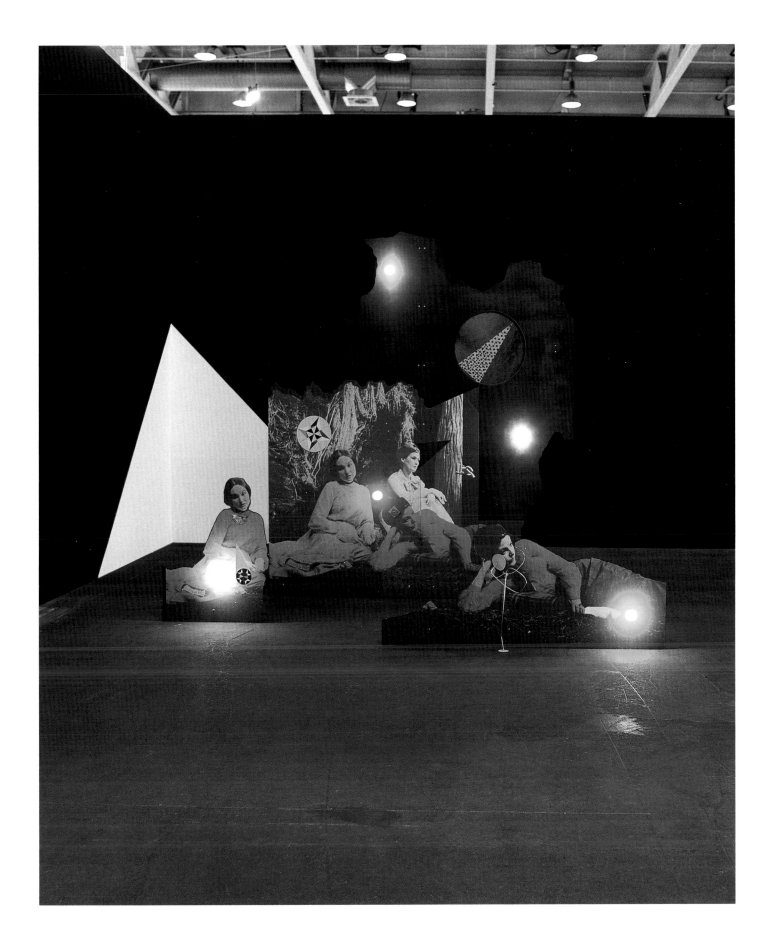

Die schwarze Stunde (The Black Hour), 2004

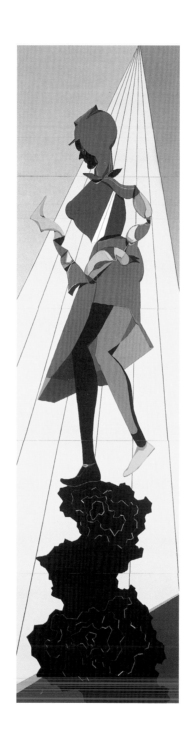

Gottesanbeterin (Praying Mantis), 2004

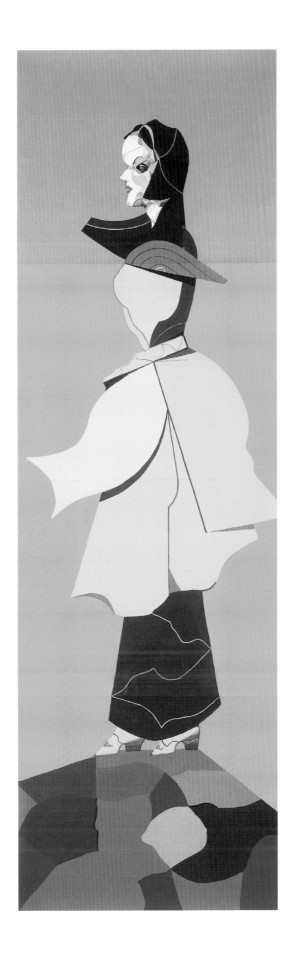

Sie hat den Film gesehen (She Saw that Movie), 2003

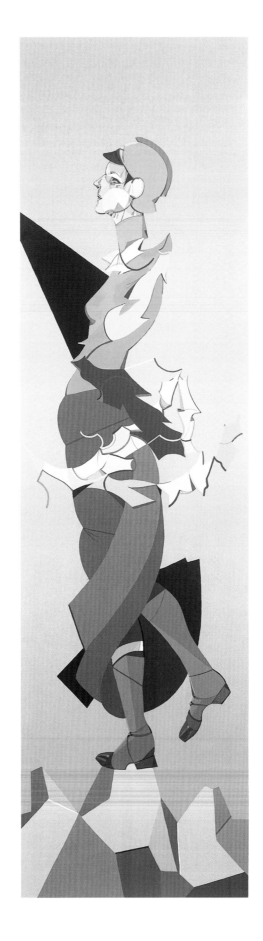

Hysteria Metallica, 2005

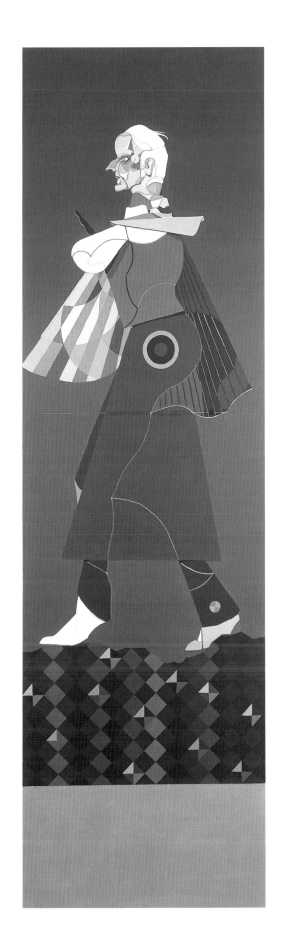

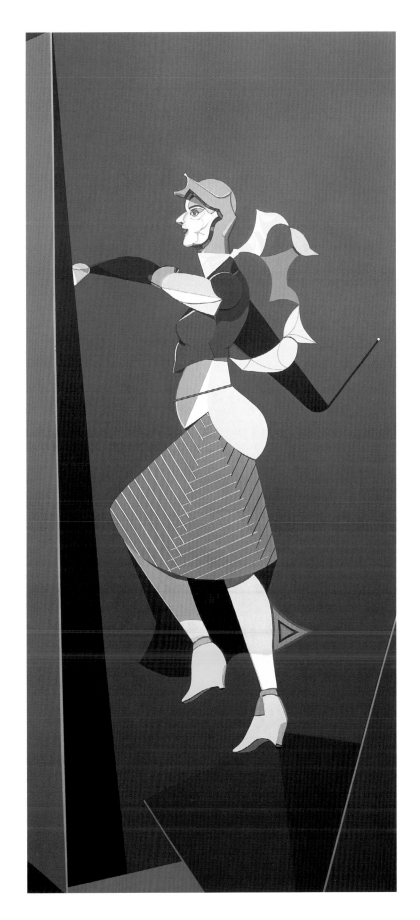

Max, du grauer Vogel (Max, You Gray Bird), 2004
Die gelben Schuhe (The Yellow Shoes), 2005

Vue d'installation, c/o – Atle Gerhardsen, Berlin, 2005

casa musica (extrema)
c/o – Atle Gerhardsen, Berlin
02.04 – 30.04.2005

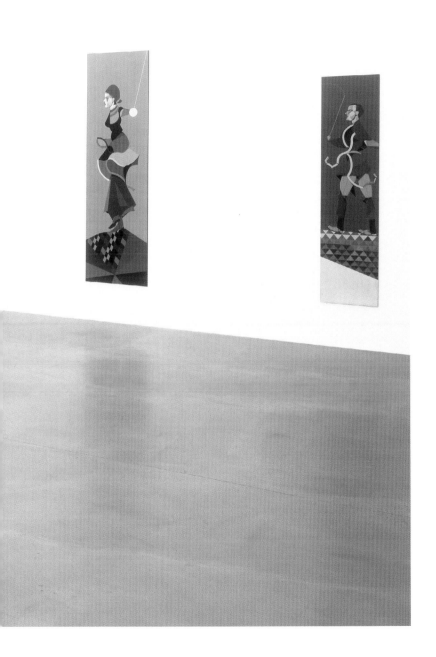

Plakat III, 2005

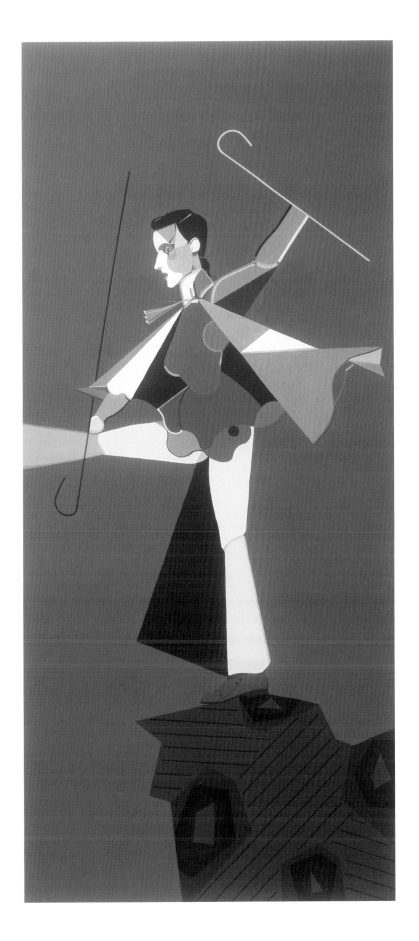

Nie wieder Krücken! (Crutches? Never Again!), 2005

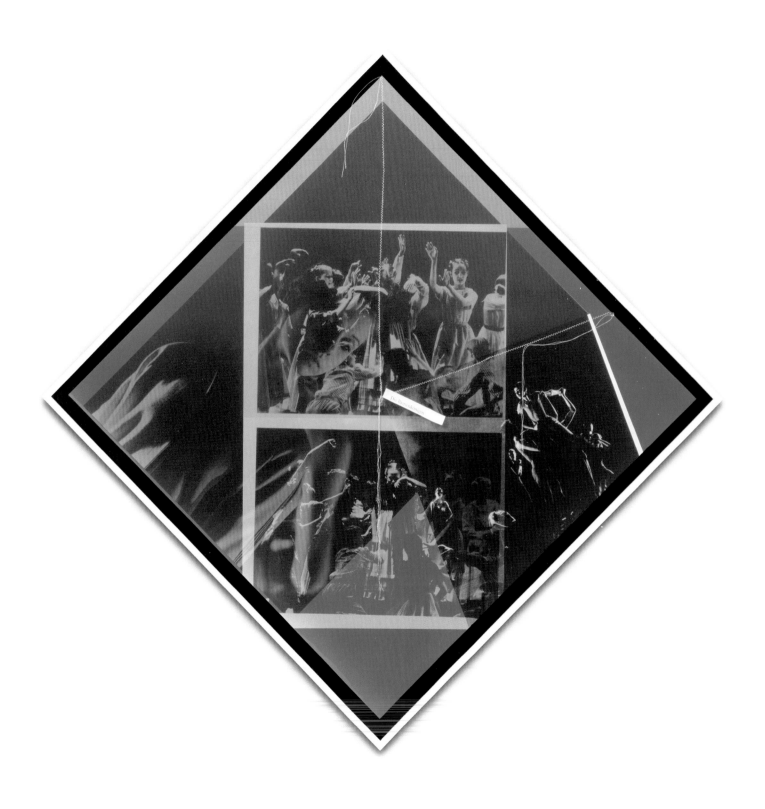

Plakat I (Die Bienenkönigin / The Bee Queen), 2005

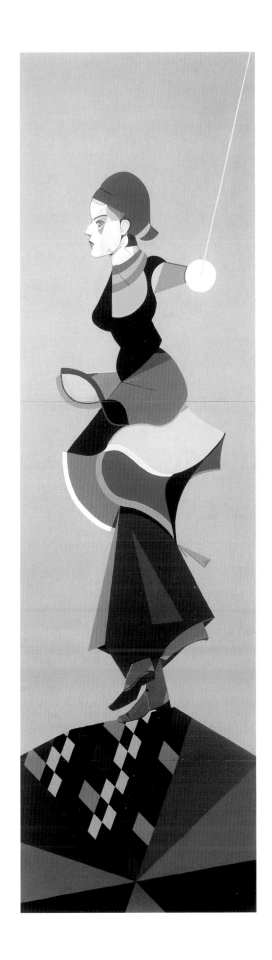

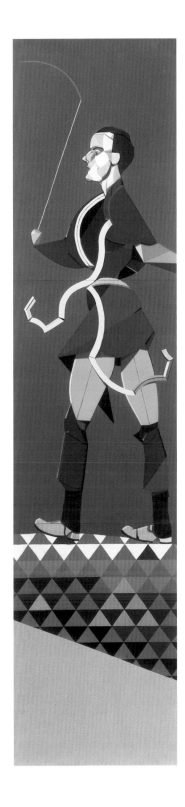

Sie will nur noch tanzen (She Only Wants to Dance), 2005

Das Uhrwerk (The Clockwork), 2005

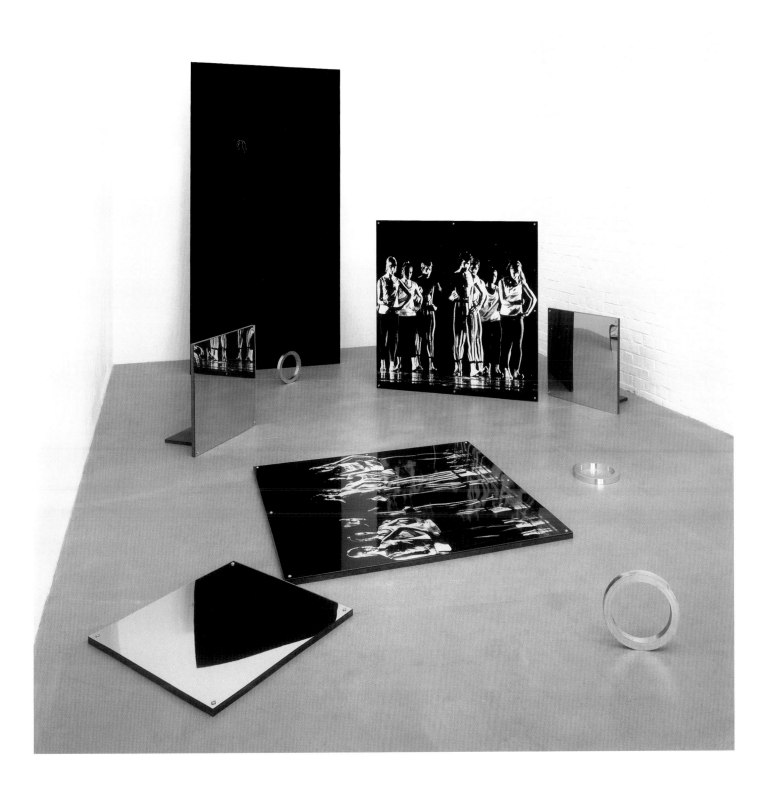

Akkord (Chord), 2005

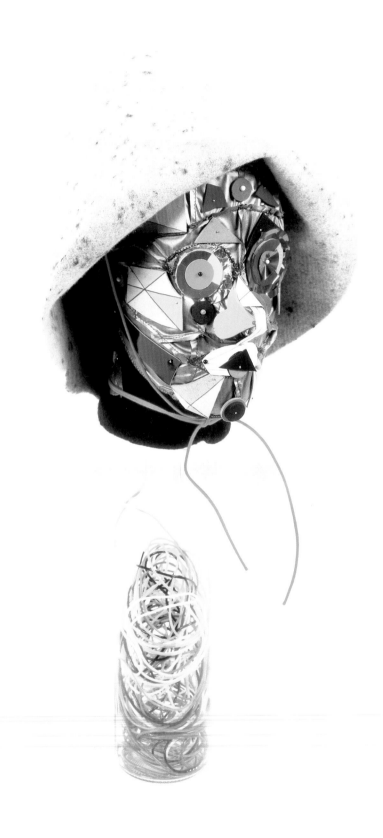

Single Child, 2005

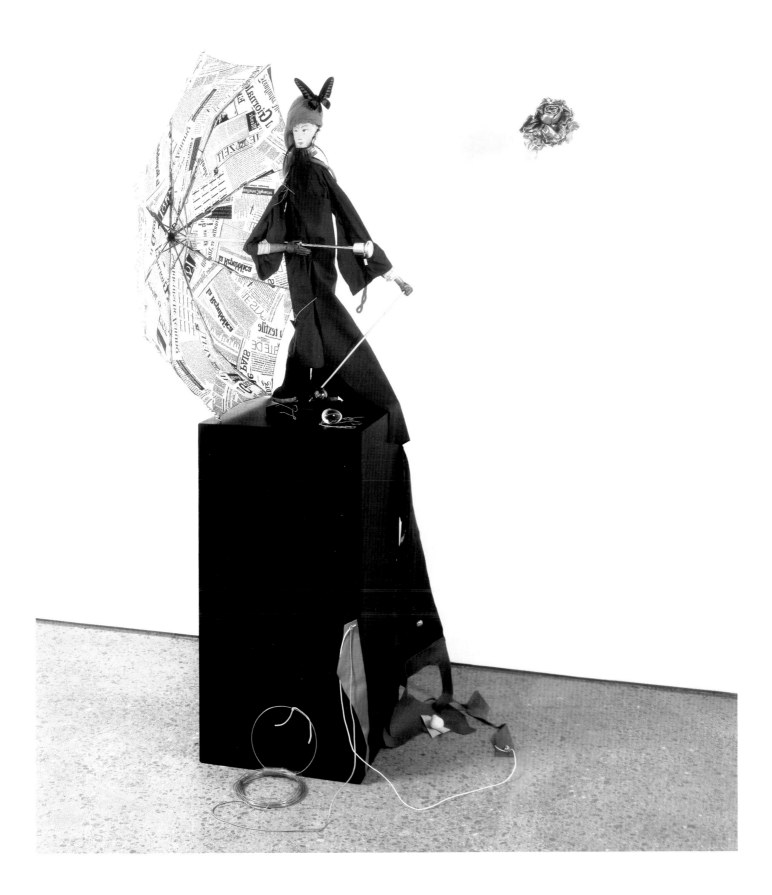

Morning Rain, 2005

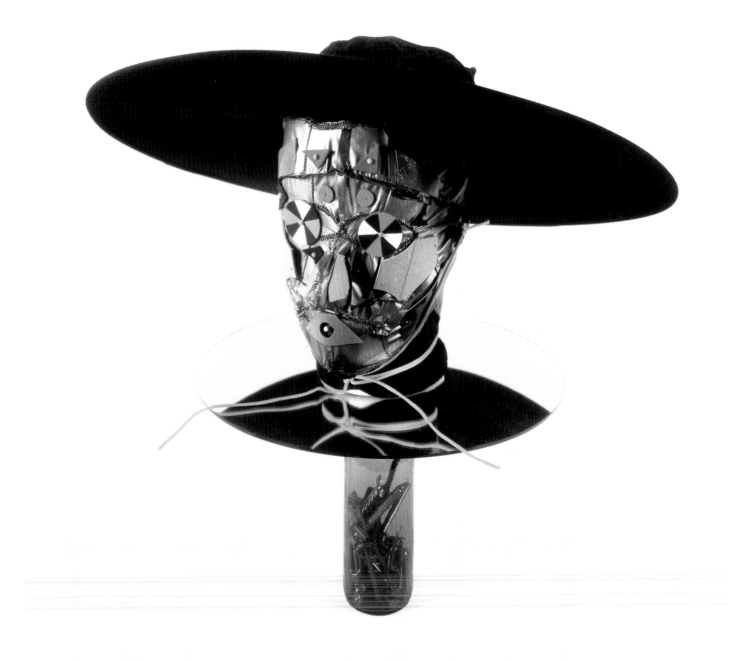

Einzelkind (Single Child), 2003

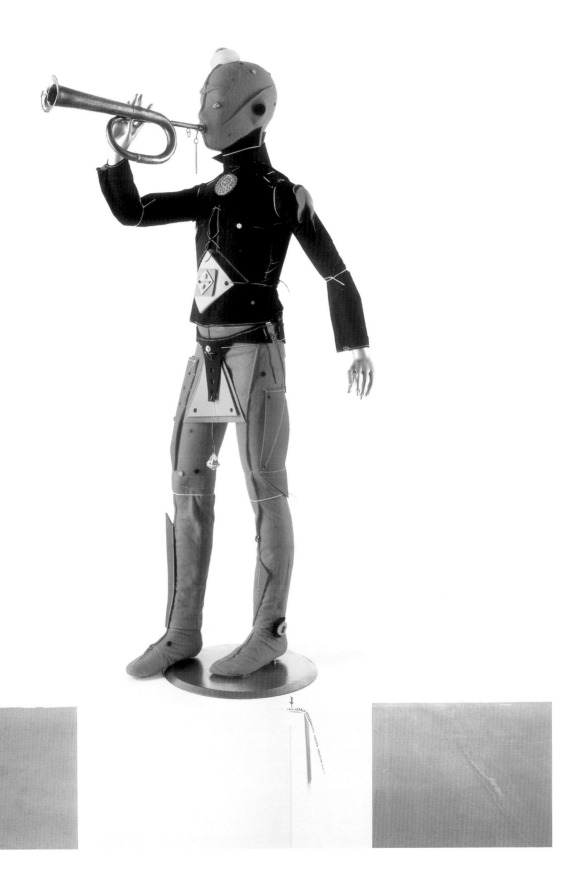

Niemand hört mich! (Nobody Hears Me!), 2006

Butterfly
c/o – Atle Gerhardsen, Art Nova, Art Basel Miami Beach, Miami
01 – 04.12.2005

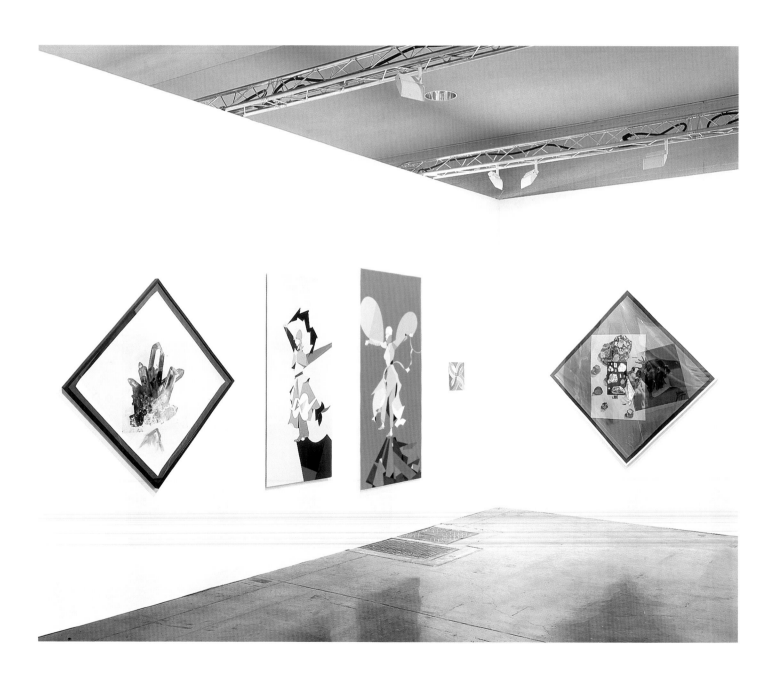

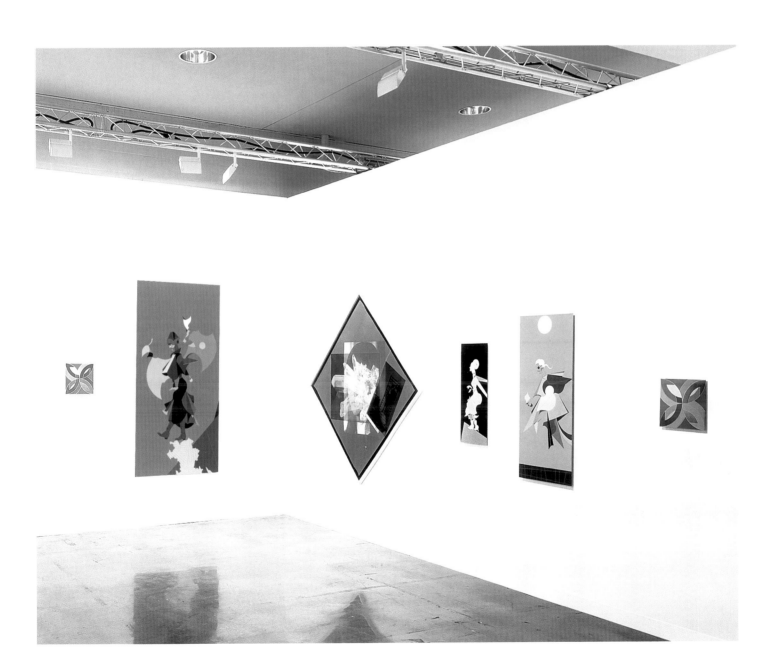

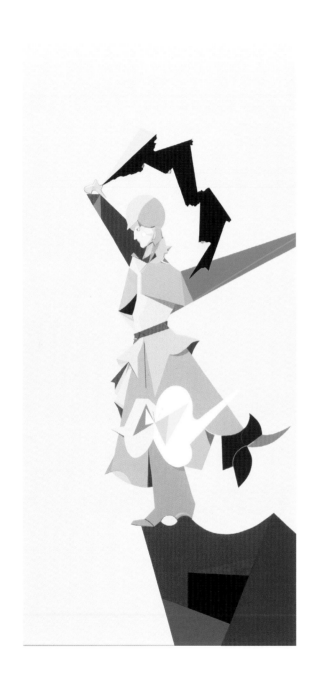

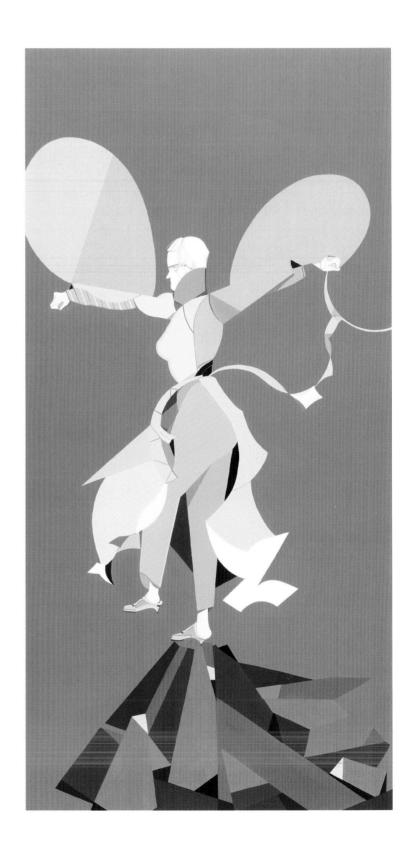

Schon wieder gefangen (Prisoner Again), 2005
Butterfly, 2005

Escape from Innen, 2005

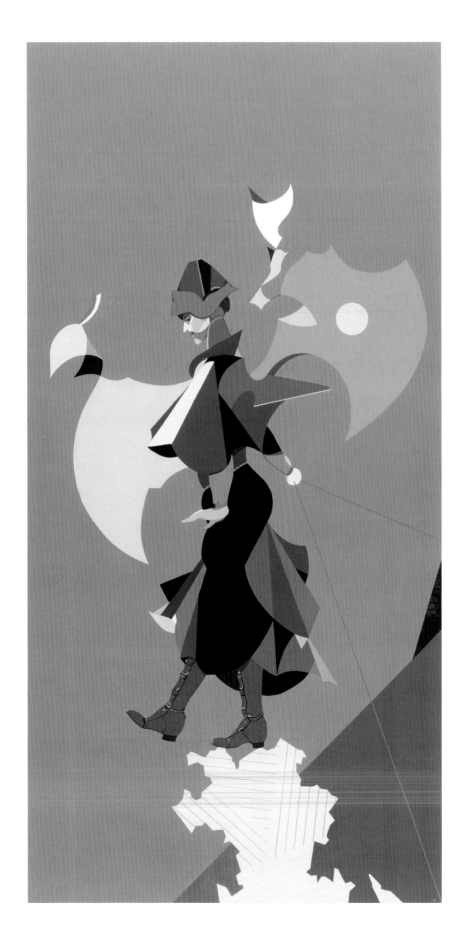

Iron Butterfly, 2005

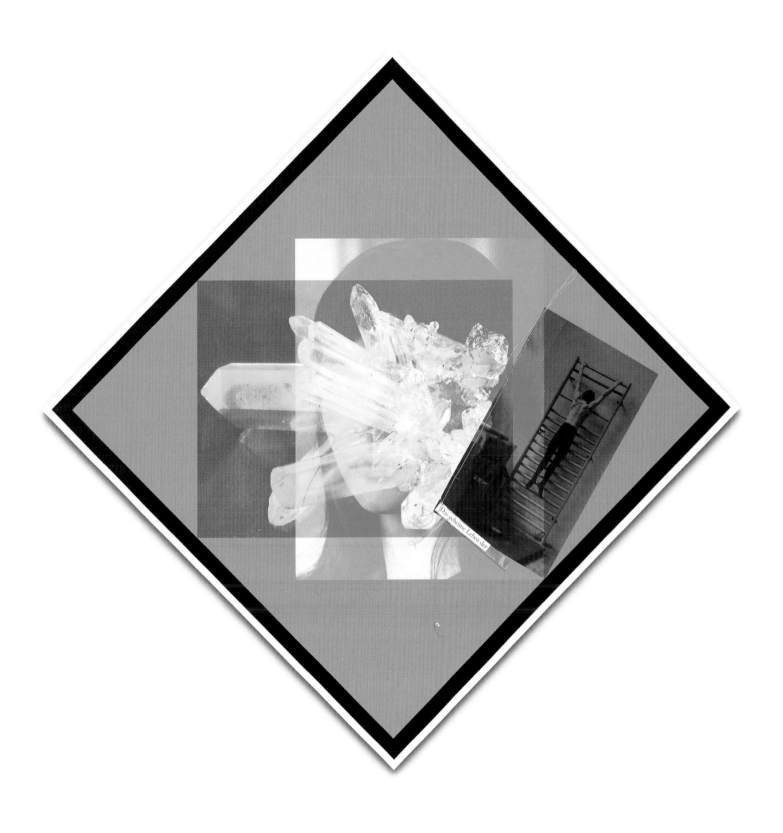

Escape from KRISTALL, 2005

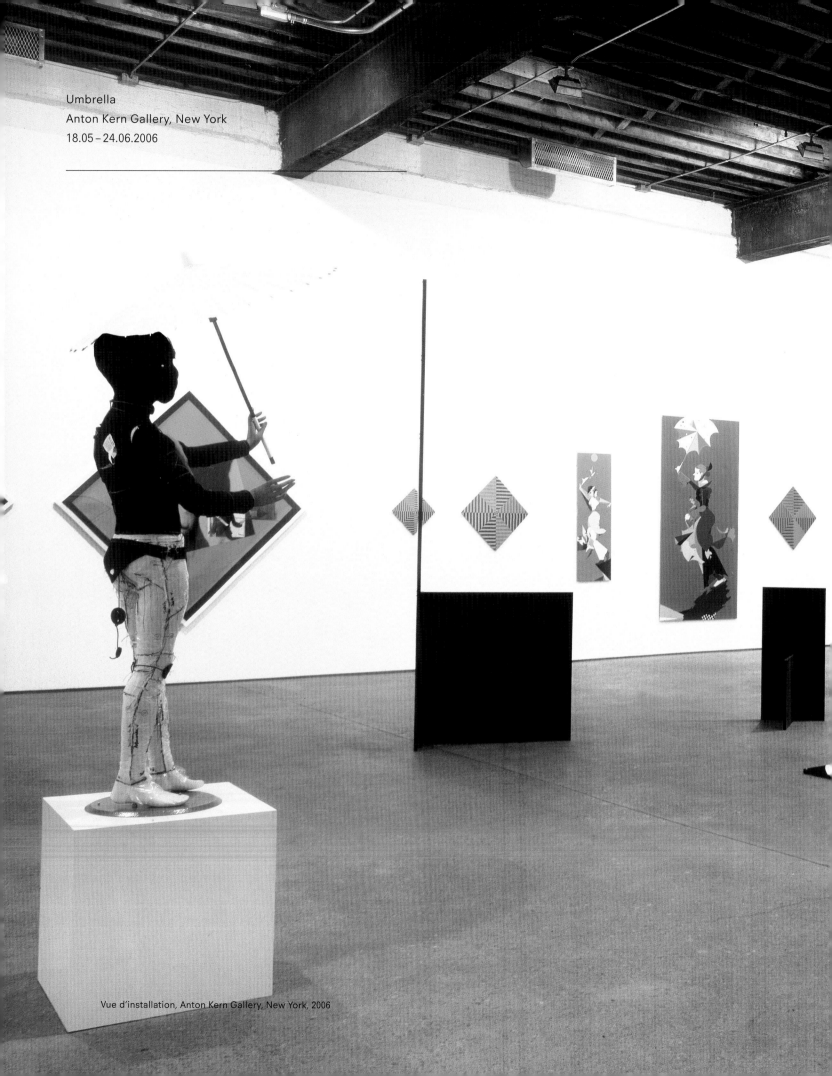

Vue d'installation, Anton Kern Gallery, New York, 2006

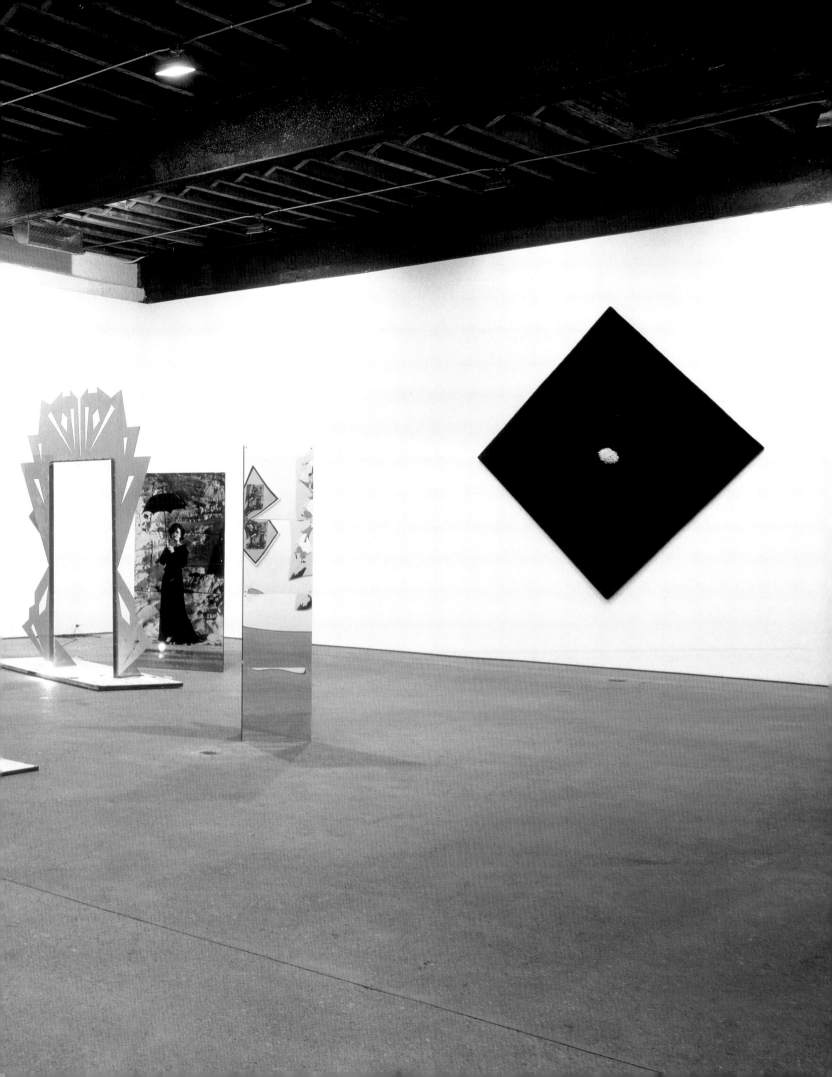

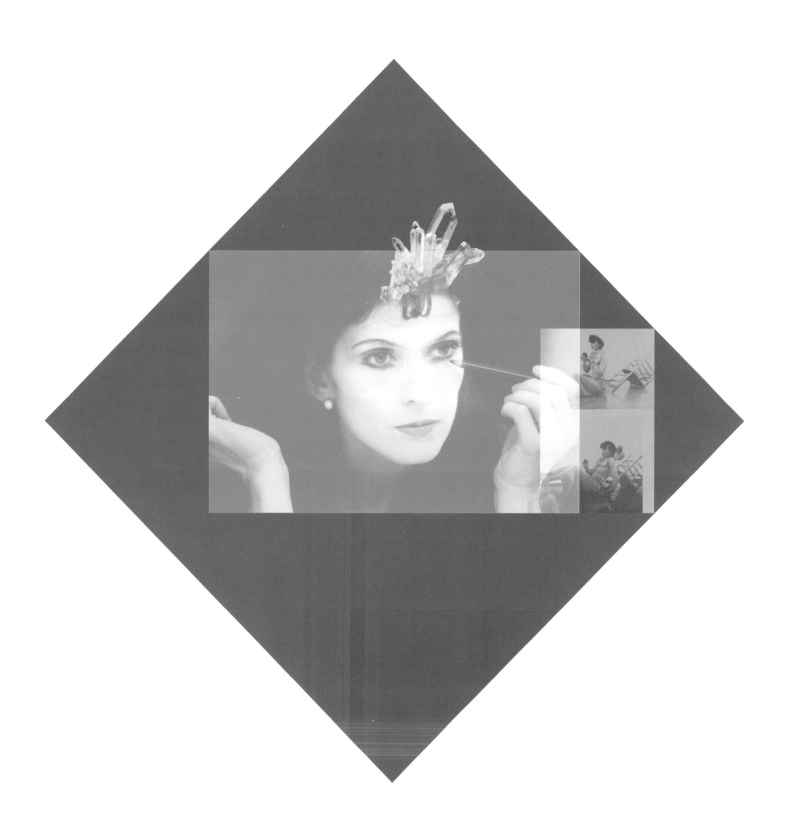

Plakat II (Make-up She), 2006

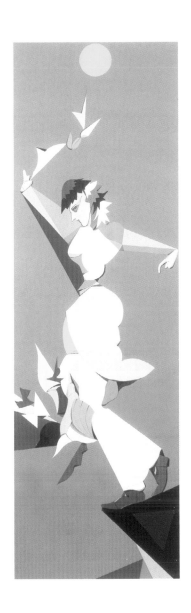

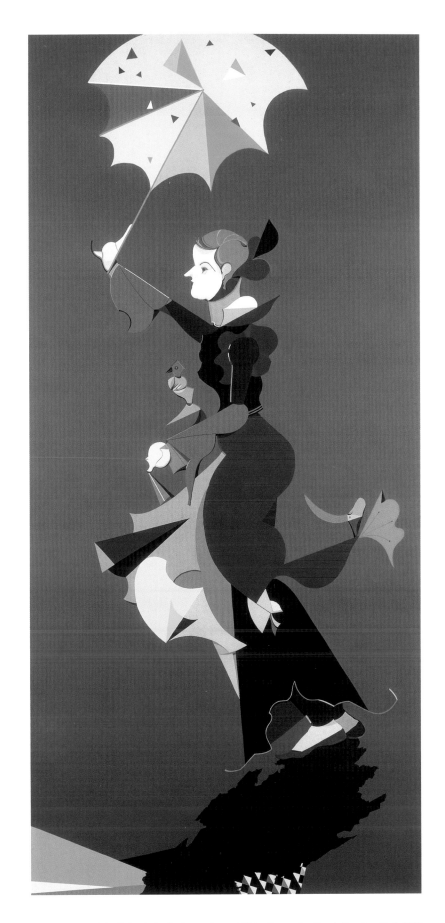

Bringt euch in Sicherheit, die Sonne kommt (Take Cover, the Sun Is Coming Out), 2006
Oh, wie ich die Sonne hasse (Oh, How I Hate the Sun), 2006

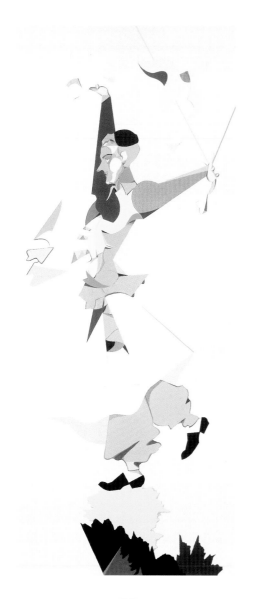

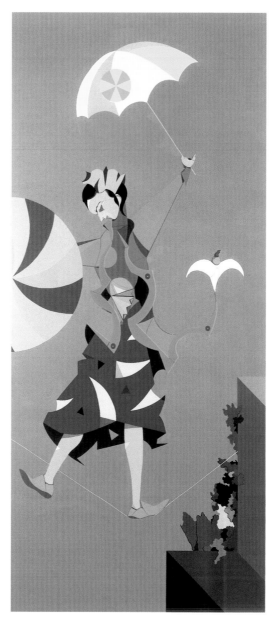

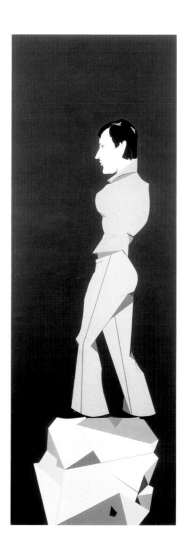

Auf und davon (Up and Away), 2006
Sei um Gottes Willen vorsichtig ! (Be Careful, for God's Sake !), 2006
Fox, 2006

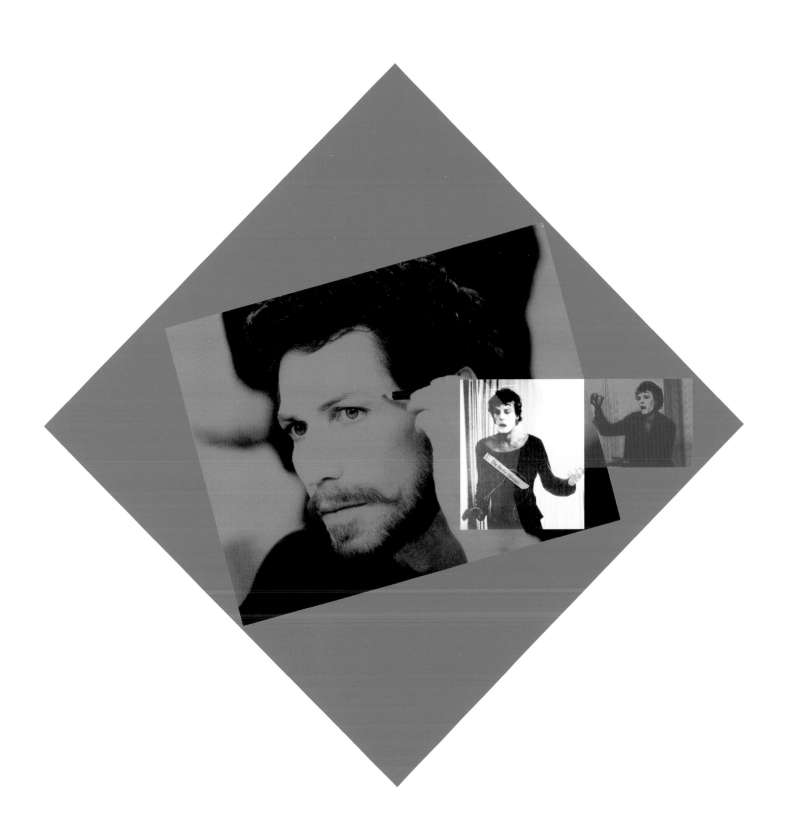

Plakat I (Die Bestie zähmen), 2006

Poison Beach

Slow fade-in. Hovering pastel colors, sand pebbles of crystal glass. A figure floats in from the right, as if pulled by invisible threads. She carries a tiger, an owl, and other animals on her body. It is a symbiosis. The creatures move breathlessly with contorted limbs, milk dripping from their mouths, sparks falling from their eyes. She, though, stands still and fast as in the grip of a drug. One wants to call out to her, maybe to make her laugh, but then one remembers it is just a movie. An artificial sun appears at the upper edge of the frame. The sky is black. Slowly, she opens a paper umbrella and in its shade she thinks: "I want to transform myself soon. I want scales and green skin. I will dig deep into the ground and I will eat stones. Will they cry for me? Will they avenge me? Oh, how much I hate the sun."

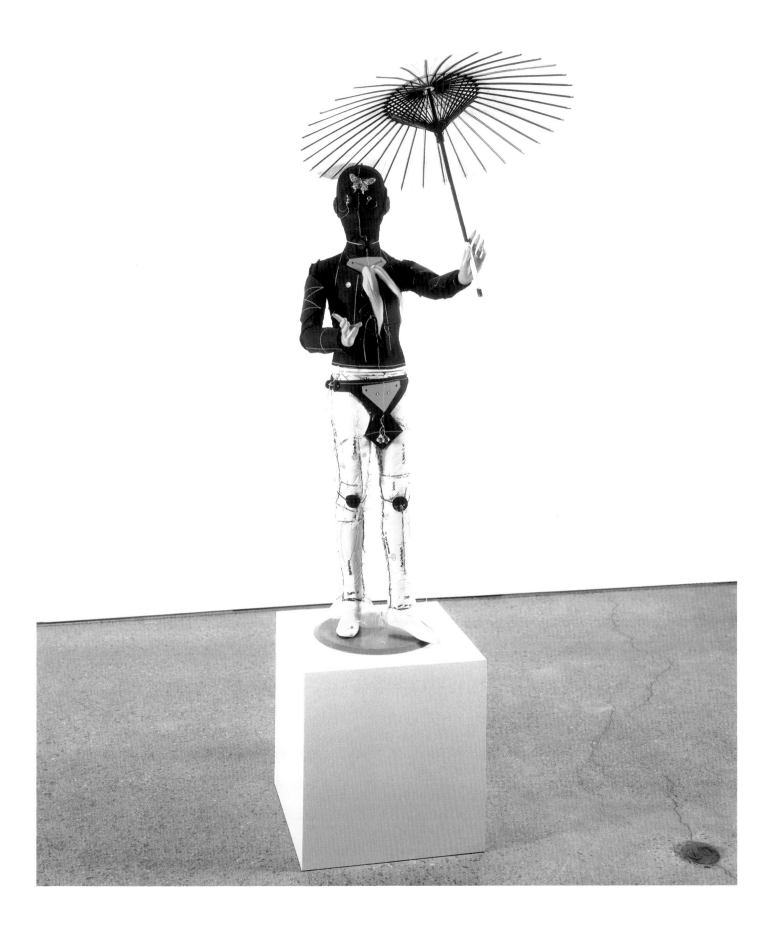

Rauschen zum Wachstum (Rustle for Growth), 2006

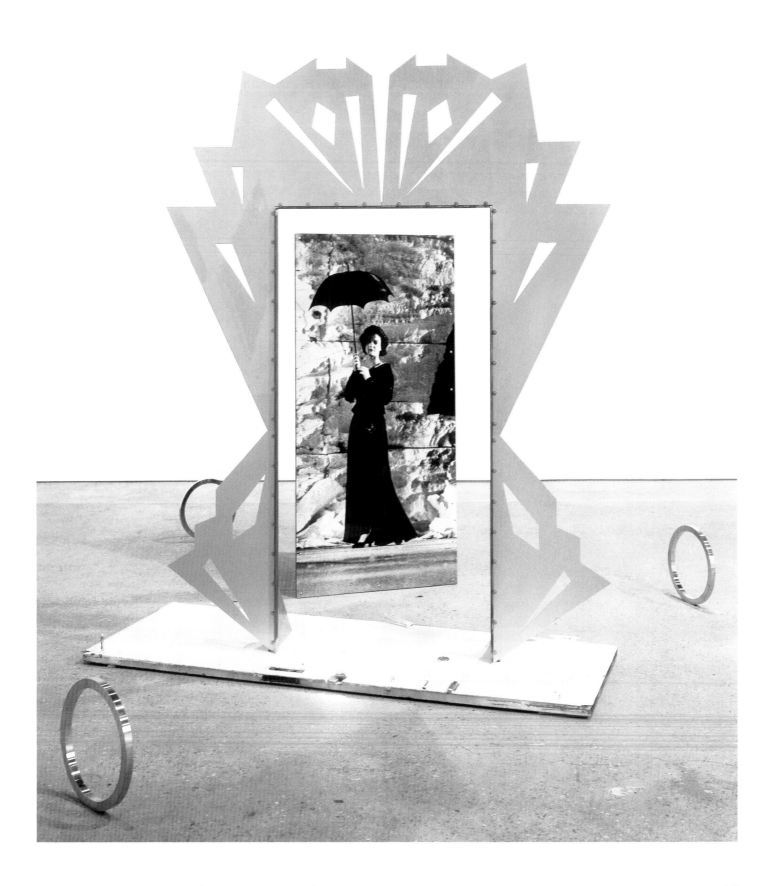

Der Kompass spielt verrückt (The Compass Goes Crazy), 2006

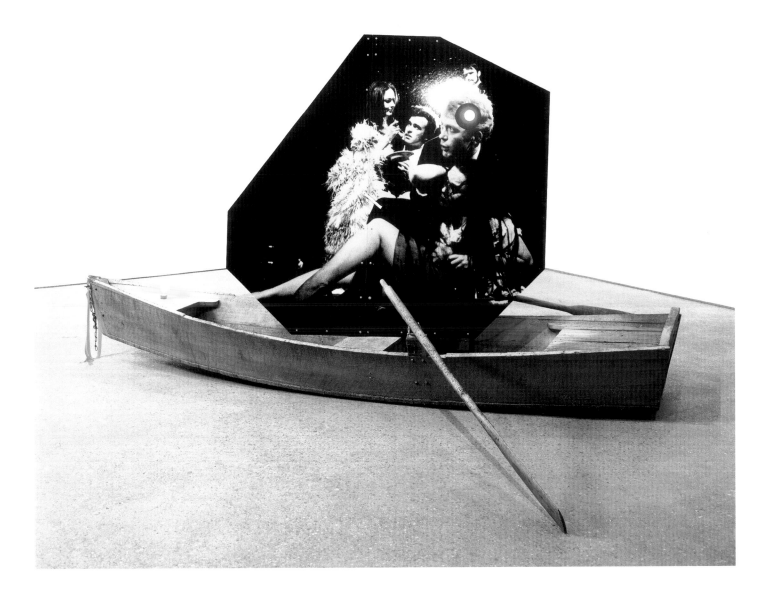

Endlose Reise (Endless Journey), 2006

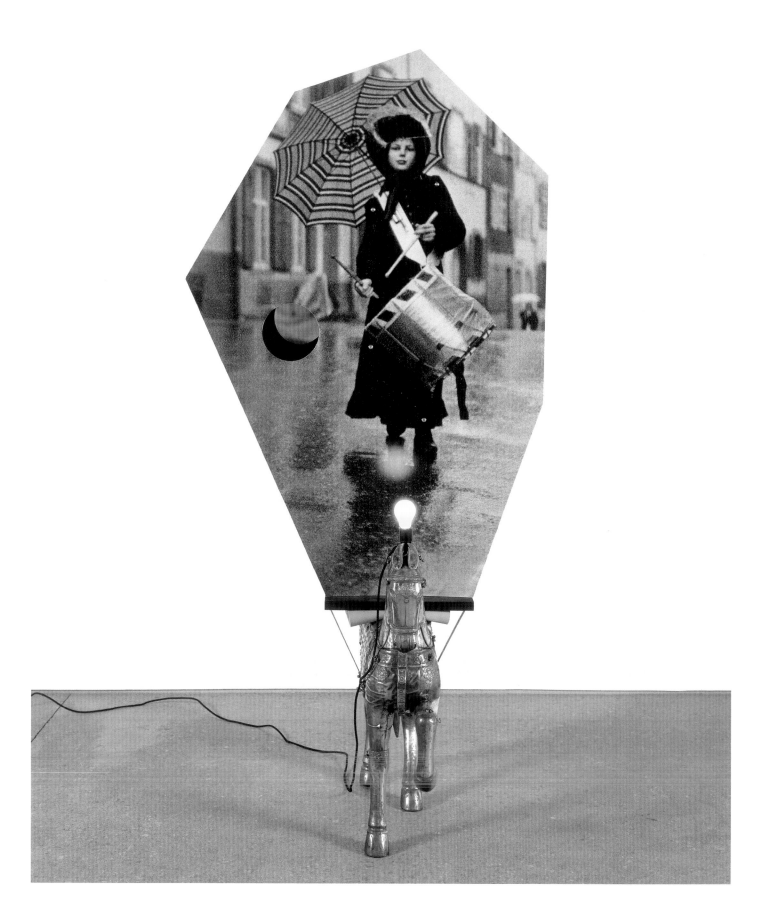

Vorwärts! (Forward!), 2006

Légendes

Captions

8	*Speaking to the Air*, 1996 Performance Courtoisie de l'artiste *Hilf mir durch die Nacht (Help Me Through the Night)*, 2004 Technique mixte ; 200 × 20 × 20 cm Collection privée, Grèce *Aether (Ether)*, 2004 Technique mixte ; dimensions variables Collection privée, Grèce		Collection Fondazione Sandretto Re Rebaudengo, Turin
12	Lothar Hempel, carton d'invitation Exposition *Fleisch : Maschine* Magnani, Londres, 2002 *Untitled #5*, 1999 Technique mixte sur papier ; 53 × 44 cm Courtoisie Anton Kern Gallery, New York *Untitled*, 1999 Technique mixte sur papier ; 30 × 20 cm Collection privée, Etats-Unis *Untitled (Police Man)*, 2000 Technique mixte sur papier ; 82 × 63,5 cm Courtoisie Anton Kern Gallery, New York *Untitled (Olymp)*, 2000 Technique mixte sur papier ; 53 × 44 cm Collection privée, Norvège	27	*Samstag Morgen, Zuckersumpf (A Clear, Almost Singing Voice)*, 1997 Matériaux divers ; dimensions variables Collection Fondazione Sandretto Re Rebaudengo, Turin
		28	*Samstag Morgen, Zuckersumpf (Schwellen / Treshold)*, 1997 *Gaze* ; 3 × (160 × 120 × 60 cm) Collection Fondazione Sandretto Re Rebaudengo, Turin
		29	*Samstag Morgen, Zuckersumpf (Das kalte Bild / The Cold Image)*, 1997 Technique mixte ; dimensions variables Collection Fondazione Sandretto Re Rebaudengo, Turin
17	*Eine blasse Kolonie (A Pale Colony)*, 1996 Technique mixte ; dimensions variables Vue d'installation, Ars Futura / Galerie Nicola von Senger, Zurich, 1997	30 – 31	*Ein Sandstrand voll Glas (A Beach Full of Glass)*, 1998 Technique mixte ; dimensions variables Courtoisie Anton Kern Gallery, New York *Den Kopf voller Ahnungen (A Head Full of Forbodings)*, 1999 Bois MDF, peinture, photocopies couleur, ampoule ; 12,7 × 5 × 28 cm Collection privée, Etats-Unis Stedelijk Museum Bureau Amsterdam, 1998
19	*Strom (Current)*, 1996 Technique mixte ; dimensions variables Courtoisie Anton Kern Gallery, New York		
21	*Gelbes Sonnenbrillenglas (Yellow Sunglass Lenses)*, 1997 Technique mixte ; dimensions variables Courtoisie Anton Kern Gallery, New York	32	*One Thousand Years Later*, 1997 Acrylique, encre, ampoules, bois, bois contreplaqué ; 240 × 300 cm Courtoisie c/o – Atle Gerhardsen, Berlin
22	*12:00 Uhr Morgens (Twelve O'Clock in the Morning)*, 1997 Technique mixte ; dimensions variables Collection privée, Etats-Unis	33 – 35	*Kunstschnee will schmelzen (Artificial Snow Wants to Melt)*, 1998 Technique mixte ; dimensions variables Vue d'installation, Stedelijk Museum Bureau Amsterdam, 1998
23	*Zuckersumpf (Sugar Swamp)*, 1997 Technique mixte ; dimensions variables Courtoisie Anton Kern Gallery, New York *Eine stolze Form von Trotz (A Proud Disguise for Spite)*, 1997 Technique mixte ; dimensions variables Courtoisie Anton Kern Gallery, New York	36 – 37	*Eine Falle schnappt fast zu (Autumn Leaves)*, 1998 Encre et acrylique sur bois contreplaqué, stroboscope ; dimensions variables Collection Erling Kagge, Oslo
		38 – 39	*Nur das Lächeln bleibt (Only the Smile Remains)*, 1999 Bois, peinture, verre, ampoules ; 190 × 200 × 160 cm Collection Hort Family
25 – 26	*Samstag Morgen, Zuckersumpf (Schwarze Ebbe, heiße Flut / Black Ebb, Hot Flow)*, 1997 Technique mixte ; dimensions variables	41	*A Simple Story*, 1999 Acrylique, MDF, feutre, photographies ; 231 × 142 × 71 cm Collection privée, Massachusetts, Etats-Unis

Implosion, 2002
Bois ; Ø 220 × 130 cm
Courtoisie c/o – Atle Gerhardsen, Berlin

100–01 *Laissez Faire*, 2001
Matériaux divers ; dimensions variables
Collection de Bruin-Heijn

102 Vue d'installation, Magnani, Londres, 2002

103 *Vaterstaat*, 2002
Technique mixte ; 168,5 × 100 × 100 cm
Collection privée, Londres

105 *New Dawn Fades*, 2003
Tirage C-type ; 180 × 120 cm
Courtoisie Stuart Shave/Modern Art, Londres

106–07 Vue d'installation, Anton Kern Gallery,
New York, 2003

108–09 *Kreuzberger Nacht (Kreuzberg Night)*, 2003
Acrylique sur papier ; 89 × 20,5 cm
Collection Saatchi, Londres
Jason, 2003
Acrylique sur papier ; 125 × 30 cm
Collection Saatchi, Londres
Kindl, 2003
Acrylique sur papier ; 119 × 41 cm
Collection Saatchi, Londres
Das Goldene Dreieck (The Golden Triangle),
2003
Acrylique sur papier ; 143 × 42 cm
Collection Saatchi, Londres
Medea, 2003
Acrylique sur papier ; 125 × 30 cm
Collection Saatchi, Londres
Richard Wright, 2003
Acrylique sur papier ; 89 × 244 cm
Collection Saatchi, Londres

110 *Die schwarze Stunde (The Black Hour)*, 2004
Bois MDF, plastique, aluminium, photogra-
phies, lampes, horloge électrique ; 279 cm ×
254 cm × 150 cm
Sammlung Goetz, Munich

111 *Gottesanbeterin (Praying Mantis)*, 2004
Acrylique sur papier sur carton ; 147 × 42 cm
Collection privée, New York

113 *Sie hat den Film gesehen (She Saw that
Movie)*, 2003
Acrylique sur papier ; 193 × 61 cm
Collection privée, Etats-Unis

114 *Hysteria Metallica*, 2005
Acrylique sur papier sur aluminium ;
183 × 51 cm
Collection privée, Etats-Unis

115 *Max, du grauer Vogel (Max, You Gray Bird)*,
2004
Acrylique sur papier sur carton sur bois ;
198,5 × 58,5 cm
Collection privée, New York
Die gelben Schuhe (The Yellow Shoes), 2005

Acrylique sur aluminium ; 200 × 89 cm
Collection de Bruin-Heijn

116–07 Vue d'installation, c/o – Atle Gerhardsen,
Berlin, 2005

118 *Plakat III*, 2005
Collage ; 141 × 141 cm
Collection BM, Dublin

119 *Nie wieder Krücken! (Crutches? Never
Again!)*, 2005
Acrylique sur aluminium ; 205 × 90 cm
Collection BM, Dublin

120 *Plakat I (Die Bienenkönigin/The Bee
Queen)*, 2005
Collage ; 141 × 141 cm
Collection BM, Dublin

121 *Sie will nur noch tanzen (She Only Wants to
Dance)*, 2005
Acrylique sur papier sur carton ; 205 × 58,4 cm
Collection Erling Kagge, Oslo
Das Uhrwerk (The Clockwork), 2005
Acrylique sur papier sur carton ; 172 × 42 cm
Collection Atle Gerhardsen, Berlin

123 *Akkord (Chord)*, 2005
Photographies noir & blanc, verre, bois,
tissus, bois MDF, cuivre ; dimensions
variables
Courtoisie c/o – Atle Gerhardsen, Berlin

124 *Single Child*, 2005
Polystyrène, plastique, punaises, nylon,
verre ; 58,5 × 30,5 × 30,5 cm
Collection Noel Frackman, Scarsdale, NY

125 *Morning Rain*, 2005
Technique mixte ; 168 × 109 × 107 cm
Collection Saatchi, Londres

126 *Einzelkind (Single Child)*, 2003
Technique mixte ; 49 × 48 × 46 cm
Collection Laura Steinberg et Bernardo
Nadal-Ginard, Etats-Unis

127 *Niemand hört mich! (Nobody Hears Me!)*, 2006
Technique mixte ; 140 × 80 × 80 cm
Collection Ebrahim Melamed/Honart
Museum, Téhéran

128–29 Vue d'installation, c/o – Atle Gerhardsen,
Art Nova, Art Basel Miami Beach, Miami, 2005

130 *Schon wieder gefangen (Prisoner Again)*, 2005
Acrylique sur aluminium ; 170 × 80 cm
Collection privée, San Francisco
Butterfly, 2005
Acrylique sur aluminium ; 200 × 100 cm
Collection Saatchi, Londres

131 *Escape from Innen*, 2005
Photographies, technique mixte ; 130 × 130 cm
Collection privée, Milan

132 *Iron Butterfly*, 2005
Acrylique sur aluminium ; 200 × 100 cm
Collection Erling Kagge, Oslo

Liste des œuvres exposées

List of exhibited works

Salle 1 *Untitled*, 1998
Photographie couleur ; 27 × 40 cm
Collection de l'artiste
Sternzeichen (Star Sign), 2000
Vernis sur Plexiglas, feutrine, tissues, nylon,
photographies ; 30,5 × 12,7 × 2 cm
Collection Michael Benevento, New York

Salle 2 *Wespennest (Bergversion), Wasp's Nest
(Mountain Version)*, 2007
200 × 200 × 50 cm (blanc), 200 × 50 × 150 cm
(marron), 50 × 100 × 150 cm (noir)
Production Le Magasin – Centre National
d'Art Contemporain de Grenoble
Tired God Says: I'll Fight Until the End, 2000
Mannequin, feutrine, caoutchouc, nylon,
casque, pantoufles, bois ; 165 × 63,5 × 61 cm
Collection Hall
Zuckerloch (Sugarhole), 2000
Mannequin, feutrine, caoutchouc, nylon,
pantoufles, métal ; 112 × 35,5 × 51 cm
Collection privée, New York
Dornenboy (The Boy of Thorns), 2000
Mannequin, feutrine, caoutchouc, nylon,
métal ; 58,5 × 25,5 × 23 cm
Collection Annie Camarda
Wasp's Nest (Wespennest), 2000
Technique mixte ; 53,5 × 30,5 × 15 cm
Courtoisie Anton Kern Gallery, New York
Angel Eyes, 2003 – 2007
Bois, peinture ; dimensions variables
Production Le Magasin – Centre National
d'Art Contemporain de Grenoble

Salle 3 *Jupiter*, 2000
Tissus, feutrine, mannequin, bois ;
104 × 63,5 × 84 cm
Collection Hort Family
*Abstrakter Sozialismus (Abstract
Socialism)*, 2002
Bois, peinture, métal, bicyclette, lanterne,
moniteur, vidéo (*Automaticon*, 4' 40''),
système de rotation ; dimensions variables
Courtoisie Anton Kern Gallery, New York
Musik ist ein Befehl (Music Is a Command),
2003
DVD, Pal, 2' 05''
Courtoisie Anton Kern Gallery, New York
Niemand hört mich ! (Nobody Hears Me !),
2006

Technique mixte ; 140 × 80 × 80 cm
Collection Ebrahim Melamed /
Honart Museum, Téhéran
New Dawn Fades, 2003
Tirage C-type ; 180 × 120 cm
Courtoisie Stuart Shave/Modern Art,
Londres

Salle 4 *Ikarus*, 2002
DVD, noir et blanc, son ; 2' 57''
Courtoisie Anton Kern Gallery, New York
Der Letzte seiner Art (The Last of His Sort),
2003
Feutrine, caoutchouc, styropore, métal,
corde, verre, plomb ; 50 × 35 × 35 cm
Collection Galerie Emmanuel Perrotin,
Paris / Miami
Mitten im Nichts (In the Middle of Nothing),
2004
Impression sur tissus ; 210 × 210 × 100 cm
Courtoisie Art:Concept, Paris
Gottesanbeterin (Praying Mantis), 2004
Acrylique sur papier sur carton ; 147 × 42 cm
Collection privée, New York
*Nie wieder Krücken ! (Crutches ? Never
again !)*, 2005
Acrylique sur aluminium ; 205 × 90 cm
Collection BM, Dublin
Das Uhrwerk (The Clockwork), 2005
Acrylique sur papier sur carton ; 172 × 42 cm
Collection Atle Gerhardsen, Berlin
Laissez Faire, 2002
Matériaux divers ; dimensions variables
Collection de Bruin-Heijn
Escape From S.O.U.L, 2005
Photographies, technique mixte ; 100 ×
100 cm
Courtoisie c/o – Atle Gerhardsen, Berlin
Escape From KRISTALL, 2005
Photographies, technique mixte ; 130 × 130 cm
Courtoisie c/o – Atle Gerhardsen, Berlin
*Plakat I (Die Bienenkönigin) / The Bee
Queen*, 2005
Collage ; 141 × 141 cm
Collection BM, Dublin
Plakat III, 2005
Collage ; 141 × 141 cm
Collection BM, Dublin
Trotzkopf, 2005
Feutrine, carton, papier, punaises, verre,

nylon ; 59 × 31 × 31 cm
Collection privée, New York
Endlose Reise (Endless Journey), 2006
Bateau, bois MDF, papier photographique,
lampes ; 203 × 114 × 325 cm
Courtoisie Anton Kern Gallery, New York
Der Kompass spielt verrückt
(The Compass Goes Crazy), 2006
Bois MDF, plastique, acier, alliage de
bronze
et aluminium, lampe, photographies ;
180 × 90 × 95 cm, 3 anneaux : Ø 36 cm
Collection Hort Family
Rauschen zum Wachstum (Rustle For
Growth), 2006
Plastique, feutrine, encre, peinture, feutre,
nylon, vêtements, ombrelle, fausse
fourrure, papillon ; 155 × 73,5 × 73,5 cm
Collection Amalia Dayan et Adam Lindemann
Sphinx, 2006
Acrylique sur aluminium ; 125 × 40 cm
Courtoisie c/o – Atle Gerhardsen, Berlin
Oh, wie ich die Sonne hasse (Oh, How
I Hate the Sun), 2006
Acrylique sur aluminium ; 209 × 100 cm
Collection Charlotte et Bill Ford
Jede Nacht derselbe Traum (Each Night
the Same Dream), 2006
Acrylique sur aluminium ; 200 × 100 cm
Collection Ebrahim Melamed / Honart
Museum, Téhéran
Plakat III (Die grosse Illusion), 2006
Collage ; 150 × 150 × 3,5 cm
Collection privée, New York
Stella Umbrella 1, 2006
Photographie sur aluminium ; 42 × 42 cm
Courtoisie Anton Kern Gallery, New York
Stella Umbrella 2, 2006
Photographie sur aluminium ; 42 × 42 cm
Courtoisie Anton Kern Gallery, New York
Stella Umbrella 3, 2006
Photographie sur aluminium ; 42 × 42 cm
Courtoisie Anton Kern Gallery, New York
Stella Umbrella 5, 2006
Photographie sur aluminium ; 71 × 71 cm
Courtoisie Anton Kern Gallery, New York
Stella Umbrella 7, 2006
Photographie sur aluminium ; 71 × 71 cm
Collection Amalia Dayan et Adam Lindemann
Wesen (Entity), 2006
Velour, bois, corail ; 282 × 282 cm
Collection Amalia Dayan et Adam Lindemann
ABC, 2007
Matériaux divers ; dimensions variables
Production Le Magasin – Centre National
d'Art Contemporain de Grenoble

Salle 5 *Akkord (Chord)*, 2005
Photographies noir & blanc, verre, bois,
tissus, bois MDF, cuivre ; dimensions
variables
Courtoisie c/o – Atle Gerhardsen, Berlin

Salle 6 *Samstag Morgen, Zuckersumpf (A Clear,*
Almost Singing Voice), 1997
Matériaux divers ; dimensions variables
Collection Fondazione Sandretto Re
Rebaudengo, Turin
Samstag Morgen, Zuckersumpf (Schwarze
Ebbe, heiße Flut / Black Ebb, Hot Flow), 1997
Technique mixte ; dimensions variables
Collection Fondazione Sandretto Re
Rebaudengo, Turin
Samstag Morgen, Zuckersumpf (Das kalte
Bild / The Cold Image), 1997
Technique mixte ; dimensions variables
Collection Fondazione Sandretto Re
Rebaudengo, Turin
Samstag Morgen, Zuckersumpf
(Schwellen / Treshold), 1997
Gaze ; 3 × (160 × 120 × 60 cm)
Collection Fondazione Sandretto Re
Rebaudengo, Turin

Salle 7 *Untitled*, 1999
Technique mixte sur papier ; 30 × 20 cm
Courtoisie Anton Kern Gallery, New York
Untitled, 1999
Technique mixte sur papier ; 30 × 20 cm
Courtoisie Anton Kern Gallery, New York
Untitled, 1999
Technique mixte sur papier ; 30 × 20 cm
Courtoisie Anton Kern Gallery, New York
Untitled, 1999
Technique mixte sur papier ; 30 × 20 cm
Courtoisie Anton Kern Gallery, New York
Untitled (Rocket), 2000
Technique mixte sur papier ; 82 × 63,5 cm
Courtoisie Anton Kern Gallery, New York
Untitled (Police Man), 2000
Technique mixte sur papier ; 82 × 63,5 cm
Courtoisie Anton Kern Gallery, New York
Russian Hill, 2001
Technique mixte ; 36 × 40 × 8 cm
Courtoisie Art:Concept, Paris
Bank Of China, 2001
Technique mixte ; 55 × 38 × 6 cm
Courtoisie Art:Concept, Paris
Mein Führer !, 2002
Acrylique sur papier ; 88,5 × 20,9 cm
Collection Nicolai Gerner-Mathisen, Berlin
Monster am Aetna, 2002
Acrylique sur papier ; 118 × 41,8 cm

Collection privée, Berlin
Scharnier (Hinge), 2003
Acrylique sur papier ; 43 × 99 cm
Collection de Bruin-Heijn
Bias, 2003
Polyester ; 162,5 × 101,5 × 5 cm
Courtoisie Anton Kern Gallery, New York
Max, du grauer Vogel (Max, You Grey Bird),
2004
Acrylique sur papier sur carton sur bois ;
198,5 × 58,5 cm
Collection privée, New York
*Die Hände zum Himmel (The Hands into the
Sky)*, 2004
Technique mixte sur papier métallique ;
50 × 50 cm
Collection Olivier Antoine, Paris
Die Gruppe atmet (The Group Is Breathing),
2004
Technique mixte sur papier métallique ;
50 × 50 cm
Collection Olivier Antoine, Paris
*So wird es immer weiter gehen (This Is
Going to Carry on for Ever)*, 2004
Technique mixte sur papier métallique ;
50 × 50 cm
Collection Olivier Antoine, Paris
Im Protest (In Protest), 2004
Technique mixte sur papier métallique ;
50 × 50 cm
Collection Olivier Antoine, Paris
Die gelben Schuhe (The Yellow Shoes), 2005
Acrylique sur aluminium ; 200 × 89 cm
Collection de Bruin-Heijn
Renaissance, 2006
Impression numérique ; 102 × 102 cm
Collection privée, New York

Salle 8 *Just Because You´re Ashamed, It Doesn´t
Mean You´re Free*, 1997
Acrylique, encre, ampoules, bois
contreplaqué, bois ; 300 × 200 cm
Courtoisie c/o – Atle Gerhardsen, Berlin
*KAPUTT und die Folgen (Kaputt and
the Consequences)*, 1999
DVD, couleur, son ; 06' 28''
Courtoisie Anton Kern Gallery, New York
Untitled, 1999
Plexiglas rose, nylon ; 2 × (120 × 60 × 0,5 cm)
Courtoisie Anton Kern Gallery, New York
*Nur das Lächeln bleibt (Only the Smile
Remains)*, 1999
Bois, peinture, verre, ampoules ; 190 × 200 ×
160 cm
Collection Hort Family
Untitled #2, 1999

Technique mixte sur papier ; 53 × 44 cm
Collection Hort Family
Untitled #3, 1999
Technique mixte sur papier ; 53 × 44 cm
Collection Hort Family
Untitled #4, 1999
Technique mixte sur papier ; 53 × 44 cm
Courtoisie Anton Kern Gallery, New York
Untitled #5, 1999
Technique mixte sur papier ; 53 × 44 cm
Courtoisie Anton Kern Gallery, New York

Salle 9 *Einstand (Deuce)*, 2007
2 DVD, couleur, son ; 5 minutes (en boucle)
Collection de l'artiste

Corridor
Vorwärts ! (Forward !), 2006
Bois, peinture, métal, ampoules ;
220 × 125 × 80 cm
Collection Tim Nye et Foundation 2021

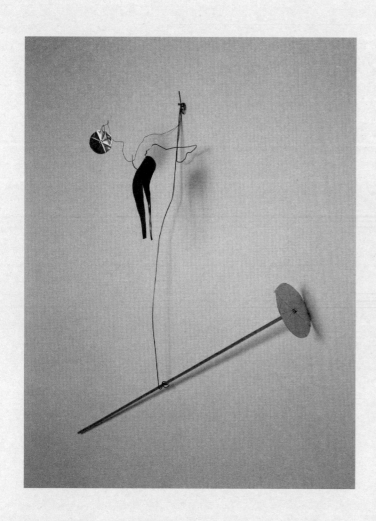

The Guard, 2004

Prisma, 2004

Biographie

Biography

Né en 1966 à Cologne. Vit et travaille à Cologne.

Formation

1987 – 1992
Kunstakademie Düsseldorf

Expositions personnelles

2006 *Tarantella*, Bar Ornella, Cologne
 Umbrella, Anton Kern Gallery, New York *

2005 *casa musica (extrema)*, c/o – Atle
 Gerhardsen, Berlin
 Butterfly, c/o – Atle Gerhardsen, Art Nova,
 Art Basel Miami Beach, Miami *

2004 *Fieber/Fever: 5 New Paintings and Other
 Stories*, Anton Kern Gallery, New York
 Ikarus, Art:Concept, Paris
 On the Olympus, Unlimited Contemporary
 Art, Athènes
 Versteck!, avec Petra Hollenbach, Parkhaus,
 Düsseldorf

2003 *Der Gesang der Vögel ist sinnlos! (The Song
 of the Bird is Nonsense!)*, Anton Kern
 Gallery, New York

2002 *Diamanten*, c/o – Atle Gerhardsen, Berlin
 Fleisch: Maschine, Magnani, Londres *
 Concentrations 42, Dallas Museum of Art,
 Dallas, Texas *
 Propaganda, ICA – Institute of Contemporary
 Arts, Londres *

2001 *Magnet!*, Art : Concept, Paris *

2000 *Das Orakel lächelt. Das Orakel lacht. Das
 Orakel lächelt*, Ars Futura Galerie, Zurich
 An Schlaf ist nicht zu denken, Lab of Gravity,
 Hambourg
 Wespennest (Wasp's Nest), Anton Kern
 Gallery, New York

1999 *Amerika verschwindet, nur das Lächeln
 bleibt (America Disappears, Only the Smile
 Remains)*, Anton Kern Gallery, New York
 *KAPUTT und die Folgen (Kaputt and the
 Consequences)*, Robert Prime, Londres

The Observer, Anton Kern Gallery, Art
Statement, Art Basel, Bâle

1998 *Ein Sandstrand voll Glas (A Beach Full
 of Glass)*, Galerie Daniel Buchholz, Cologne
 *Kunstschnee will schmelzen (Artificial Snow
 Wants to Melt)*, Stedelijk Bureau,
 Amsterdam *
 Standort Berlin – places to stay #5 M(usic),
 Büro Friedrich, Berlin

1997 *Samstag Morgen, Zuckersumpf (Saturday
 Morning, Sugar Swamp)*, Robert
 Prime, Londres
 This Bittersweet Disaster, Anton Kern
 Gallery, New York

1996 *Strom*, Anton Kern Gallery, New York
 The Bienenkorb Times, Galerie Daniel
 Buchholz, Cologne

1994 *Low*, Artistbooth, Cologne Art Fair, Cologne
 La Boum, avec Thorsten Slama, New Reality
 Mix, Stockholm
 Omron, six videos by Lothar Hempel,
 Preview Theatre Wardour Street, Londres
 Bewegungslehre (No Future), Buchholz und
 Buchholz, Cologne

1992 *240 Minuten*, avec George Graw, Galerie
 Esther Schipper, Cologne

* publications

Expositions collectives

2006 *Implosion*, Anton Kern Gallery, New York
Pelouses autorisées, Parc de la Villette, Paris
The Triumph of Painting, Part 4, The Saatchi Gallery, Londres / Leeds City Art Gallery, Leeds
Angela Bulloch, A K Dolven, Olafur Eliasson, Ceal Floyer, Liam Gillick, Lothar Hempel, Rirkrit Tiravanija, Galleri MGM, Oslo
I Love My Scene : Scene 1, Mary Boone Gallery, New York

2005 *Growing Up Absurd, Problems of Youth in the Organized System*, Herbert Read Gallery, Kent Institute of Art and Design, Kent, Grande-Bretagne
The difference between you and me, The Ian Potter Museum of Art, Melbourne
Imagination becomes Reality, Part II. Painting Surface Space, Sammlung Goetz, Munich *
Bidibidobidiboo, Fondazione Sandretto Re Rebaudengo, Turin
Eberhard Havekost "Marvel" / Lothar Hempel, Anton Kern Gallery, New York
World artists now !, Bijutsu Shuppan-Sha

2004 *She's Come Undone*, Artemis Greenberg Van Doren Gallery, New York
Now Is a Good Time, Andrea Rosen Gallery, New York
The Snow Show, Tate Liverpool, Liverpool *
The Snow Show, Kemi et Rovaniemi, Laponie, Finlande *
Rhinegold – Art from Cologne, Tate Liverpool, Liverpool
Curb Your Enthusiasm, Millers Terrace, Londres
The Drawing Project, Vamiali's, Athènes
Creative Growth, CCA, San Francisco

2003 *Hands Up, Baby, Hands Up! Kunstverein's 160th Anniversary, 160 Works on Paper*, Oldenburger Kunstverein, Oldenburg
Dark Shadows, Marc Foxx Gallery, Los Angeles
Michael Kohn Gallery, Los Angeles

2002 *Schöne Aussicht*, Galerie Otto Schweins, Cologne
It's Unfair!, Museum de Pavilijoens, Almere
Accrochage, c/o – Atle Gerhardsen, Berlin
Internationales Netzwerk, Fluxus und die Folgen, Karstadt Wiesbaden, Wiesbaden
Les vertus sont des titres, les souffrances sont des droits. Exposition de la collection du Frac Poitou-Charentes, Hôtel Saint-Simon / Théâtre d'Angoulême, Angoulême

2001 *The Beauty of Intimacy – Lens and Paper*, Kunstraum, Innsbruck / Staatliche Kunsthalle Baden-Baden, Baden-Baden / Gemeentemuseum Den Haag, La Haye *
I Love New York, Anton Kern, New York
Kunsthalle Düsseldorf, Düsseldorf
Drawings, Galeria Sales, Rome
Uniform : Order and Disorder, P.S.1, New York
A New Horizon, Art : Concept, Paris,

2000 *Age of Influence: Reflections in the Mirror of American Culture*, Museum of Contemporary Art, Chicago
10 Jahre Ars Futura, Ars Futura Galerie, Zurich
Portraits, Thomas Rehbein Galerie, Cologne

1999 *Proposals for a show*, AC Project Room, New York
oldNEWtOWn, Casey Kaplan, New York
ars viva 98 / 99 – Installationen, Brandenburgische Kunstsammlungen, Portikus, Francfort *
Who, if not we?, Elizabeth Cherry Contemporary Art, Tucson, Arizona
Nur Wasser Lässt sich leichter schneiden, Projektraum Hafen, Hamburg
ars viva 98/99 – Installationen, Kunstverein Braunschweig, Braunschweig *
A Radiant Future, Forde – Espace d'art contemporain, Genève
Officina Europa, Galeria d'Arte Moderna, Bologne *

1998 *Conspirazione*, Collection Re Rebaudengo, Turin
Roommates, Van Loon Museum, Amsterdam
Yesterday Begins Tomorrow : Ideals, Dreams, and the Contemporary Awakening, Bard College, New York
Galerie Daniel Buchholz, Cologne
El Niño, Städtisches Museum Abteiberg Mönchengladbach *
ars viva 98 / 99 – Installationen, Brandenburgische Kunstsammlungen, Cottbus *
Büro Friedrich, Berlin
Zone, Fondazione Sandretto Re Rebaudengo, Turin

1997 *Group Show : Painting, Photography, Drawing*, Anton Kern Gallery, New York

Aura, avec Walter Dahn, Rosemarie Trockel et Dirk Bell, Ars Futura Galerie, Zurich
X 2, Wiener Secession, Vienne*
Panic, ICA – Institute of Contemporary Arts, Londres
Palais des Beaux Arts, Bruxelles
Surprisen 2, Kunsthalle Nürnberg, Nuremberg*
Bring your own Walkman, W139, Amsterdam
Delta, a geographical expression, Musée d'Art moderne de la Ville de Paris, Paris*
Cologne show, Goethe Institute, Turin

1996 *Glockengeschrei nach Deutz, das Beste aller Seiten!*, Daniel Buchholz, Cologne
This really nice, a project with students from the Royal Academy of Arts, Aircondition, Copenhague
Traffic, capcMusée d'art contemporain, Bordeaux*
Push Ups, The Factory, Athènes*
Auto Reverse II, Le Magasin, Grenoble
How will we behave?, Robert Prime Gallery, Londres
Escape Attempts, Christiania, Copenhague

1995 *Atomic!*, Oberwelt Galerie, Stuttgart
Auto Reverse, Centre pour l'Image contemporaine Saint-Gervais, Genève
The Video Collection, Filmfestival Knokke, Knokke
Figures, Le Parvis – centre d'art contemporain, Ibos
Moral Maze, Le Consortium, Dijon
Stoppage, CCC, Tours / Villa Arson, Nice
I Confess, Nicolaij Art Center, Copenhague*
Purple 8 1/2, Galerie Jousse Seguin, Paris
L'Hiver de l'Amour, Part 2, PS 1, New York
Aperto, previously unreleased!, APAC, Nevers
Photo-collages, Le Consortium, Dijon
X / Y, Centre Georges Pompidou, Paris*
Palast der Künste, Utopie macht endlos (Lotus Club), Kölnischer Kunstverein, Cologne

1994 *Sonne München*, Galerie Daniel Buchholz, Cologne
Homegrown, Lotus Club, Cologne
Grand Prix, Air de Paris, Nice
L'Hiver de l'Amour, Musée d'Art moderne de la Ville de Paris, Paris*
Rue des Marins, Air de Paris, Nice
Résidence Secondaire, Galerie Sabrina Grassi, Paris
20, Galleria Pascale Laccese, Milan

Caravanserai, Galerie W139, Amsterdam
Henry Bond, Olafur Eliasson, Lothar Hempel, Saga Basement, Copenhague
Das Studium der Kunstgeschichte, Schleifschnecke, Künstlerhaus Stuttgart, Stuttgart
Miniatures, The Agency, Londres
Mixbild, Galerie Esther Schipper und Michael Krome, Cologne
13 Levels of Meaning : A New Work For Television, avec Henry Bond, Ars Futura Galerie, Zurich
Atomic, Neurotic, Ecstatic, The New Room, Göteborg

1993 *Some artists I've been thinking about who falls under the title of : Wouldn't it be more pluralistic to embrace turmoil and/or violence?*, Andrea Rosen Gallery, New York
Galerie Esther Schipper at the Christopher Grimes Gallery, Santa Monica, Californie
Biennale di Venezia, APERTO, Venise*
Summer Show, Galerie Esther Schipper, Cologne
Future Book Collection, Air de Paris, Nice
Fuck the System, Villa Rossi, Lucca
Food for Thought, Franklin Furnace, New York
Phenylovethylamour, Unfair 1993, projet de Lothar Hempel et Carsten Höller, Galerie Daniel Buchholz, Cologne
Unplugged, Inter Conti, Cologne
jeder kind is van marmer, Bloom Gallery, Amsterdam
Christmashop, Air de Paris, Paris
Video, Galerie Sabrina Grassi, Paris
7e Semaine Internationale de Vidéo (S.I.V.), Centre pour l'Image contemporaine Saint-Gervais, Genève*

1992 *Prince, Madonna, Marky Mark & Cinderella*, Ancient Etablissement Sacré, Liège
Paradise Europe, BIZART, Copenhague*
Tattoo Collection, Air de Paris & Urbi et Orbi, Galerie Jennifer Flay, Paris / Galerie Daniel Buchholz, Cologne / Andrea Rosen, New York
Galeria Pasquale Leccese, Milan
Multiples, Lukas & Hoffmann, Berlin
Lying on top of a building the clouds seemed to be nearer than they had when I was lying on the street, Galerie Monika Sprüth, Cologne / Le Case d'Arte, Milan
Rest in Peace, Esther Schipper, Cologne

Bibliographie

2006 *Umbrella*, Anton Kern Gallery, New York
 Ken Johnson, « I Love My Scene : Scene 1 »,
 in The New York Times, February 17
 « What's On », in The Art Newspaper, n° 169,
 mai

2005 *Butterfly*, c/o – Atle Gerhardsen, Berlin
 Lance Fung, *The Snow Show*, Thames &
 Hudson Ltd, Londres, p. 116 – 123 et
 p. 196 – 199
 Rainald Schumacher, « Narrative Machines –
 A conversation via e-mail with Lothar
 Hempel », Ingvild Goetz (éd.), *Imagination
 becomes Reality, Part II. Painting Surface
 Space*, Sammlung Goetz, Munich / ZKM
 Museum für Neue Kuntz, Karlsruhe
 Noah Chasim, « Marvel and Fieber / Fever »,
 in Time Out New York, 13 – 19 janvier, p. 57

2004 Sue Hubbard, « The Ego has landed », in
 The Independent, 13 juillet
 Peter Chapman, « Rhinegold – Art from
 Cologne », in The Independent, 6 juin

2003 Melissa Gronlund, « Lothar Hempel », in
 Contemporary, n° 52, p. 76

2002 Emma Stern (éd.), *Lothar Hempel –
 Propaganda*, ICA – Institute of
 Contemporary Arts, Londres
 Lothar Hempel – Concentration 42, Dallas
 Museum of Art, Dallas, Texas
 Lothar Hempel – Fleisch : Maschine,
 Magnani, Londres
 Morgan Folconer, « London ICA / Lothar
 Hempel : Propaganda », in Contemporary,
 novembre, p.84
 John Russell Taylor, « Road from nowhere »,
 in The Times, Londres, mercredi 25
 septembre
 Nick Hackworth, « Making Light of Heavy
 Themes », in The Evening Standard, 25
 septembre
 Fisun Güner, « Don't believe the hype », in
 Metro, 24 septembre
 Vincent Pécoil, « Lothar Hempel at Art :
 Concept, Paris », in arttext, printemps,
 p. 86 – 87
 Benjamin Weil, « Lothar Hempel », in Flash
 Art, mai – juin
 « Lothar Hempel – ICA », in ArtPreview,
 septembre, p. 7
 « Lothar Hempel », in I-D Magazine,
 septembre

2001 Lothar Hempel, *Magnet*, Art : Concept, Paris
 Art – Pop – City, Büro Friedrich, Berlin
 Uniform : Order and Disorder, P.S.1,
 New York

2000 Helga Meister, *Und keiner hinkt. 22 Wege
 vom Schwegler wegzukommen*, Museum
 Kurhaus, Kleve
 Carel Balth, *The Beauty of Intimacy – Lens
 and Paper*, Kunstraum, Innsbruck /
 Staatliche Kunsthalle Baden-Baden /
 Gemeentemuseum Den Haag, La Haye
 Jörn Ebner, « Jörn Ebner über Lothar
 Hempel », in Artist Kunstmagazin, n° 43,
 février, p. 30 – 33
 Justin Hoffmann, « Lothar Hempel », in
 Kunstforum, n° 150, avril – juin, p. 430

1999 *Officina Europa*, Galleria d'Arte Moderna,
 Bologne
 Bill Arning, « Lothar Hempel, America
 Disappears, Only the Smile Remains », in
 Time Out New York, 29 avril – 6 mai, p. 65
 Jennifer Higgie, « Let's get Lost », in Frieze,
 n° 48, septembre – octobre, p. 86 – 89
 Michael Archer, « Lothar Hempel », in Art
 Monthly, n° 225, avril, p. 29 – 30
 Jan Verwoert, « Lothar Hempel », in
 Springerin, n° 2, mars – juin

1998 *El Niño*, Museum Abteiberg, Mönchen-
 Gladbach
 Liam Gillick, « Surviving survival, Lothar
 Hempel's rigged rooms », *Lothar Hempel.
 Kunstschnee will schmelzen*, Stedelijk
 Bureau, Amsterdam
 Renate Goldmann (éd.), *ars viva 98 / 99 –
 Installationen*, Kulturkreis der deutschen
 Wirtschaft im Bundesverband der
 Deutschen Industrie
 e.V., Cologne, p. 23
 Liam Gillick, « Surviving survival, Lothar
 Hempel's rigged rooms », Renate Goldman
 (éd.), *Lothar Hempel*, Kulturkreis der
 deutschen Wirtschaft im Bundesverband
 der Deutschen Industrie e.V., Cologne, n. p.
 Benjamin Weil, « Lothar Hempel », in Flash
 Art, mars – avril, p. 108
 « Lothar Hempel », in Metropolis M, n° 4,
 p. 46 – 47

1997 Lothar Hempel, « Jodie », in Permanent
 Food, n° 2
 Ina Gevers, Jeanne van Heeswijk, *Beyond
 ethics and aesthetics*, Nijmegen
 X 2, Wiener Secession, Vienne

Delta, Musée d'Art moderne de la Ville de Paris, Paris
Surprisen 2, Kunsthalle Nürnberg, Nuremberg
Emmanuel Grandjean, « Lothar Hempel : I Like Music and Music Likes Me », André Iten (éd.), *7e Semaine Internationale de Vidéo (S.I.V.)*, Centre pour l'Image contemporaine Saint-Gervais, Genève, p. 80–81
Dan Cameron, « Glocal warming », in Artforum International, décembre
Jennifer Higgie, « Lothar Hempel », in Frieze, n° 37, novembre–décembre, p. 78–79
Marta Schwendener, « Lothar Hempel : This Bittersweet Disaster. Anton Kern Gallery », in Time Out New York, 8–15 mai, p. 49
Sarah Kent, « Lothar Hempel », in Time Out London, n° 1405, 23–30 juillet

1996 Lothar Hempel, « Let's smile forever », in ZAP-Magazine, n° 2, juillet
Lothar Hempel, *Strom*, Anton Kern Gallery, New York
Push Ups, The Factory, Athens Fine Arts School, Athènes
Traffic, capcMusée d'art contemporain, Bordeaux
Barbara Steiner, « Marek Garage, Lotusclub und anderes », *Nach Weimar*, Kunst-sammlungen zu Weimar, p.113–118 et p. 220–225
Carl Freedman, « Traffic », in Frieze, n° 28, mai, p. 75–76
Giorgio Verzotti, « Traffic », in Artforum, mai
Jan Avgikos, « Angus Fairhurst and Lothar Hempel. Anton Kern Gallery », in Artforum, n° 6, février, p. 90
Christiane Schneider, « Hempel, Höller, Eliasson », in Metropolis M, janvier

1995 Lothar Hempel, Olafur Eliasson, « Kryll as the Food of Tomorrow », in Buffalo Bill, september
X/Y, Centre Georges Pompidou, Paris
I Confess, Nicolaij Art Center, Copenhague

1994 Lothar Hempel, « Let yourself go », in Documents, n° 5, mars, p. 6–7
L'Hiver de l'Amour, ARC – Musée d'Art moderne de la Ville de Paris, Paris
Benjamin Weil, « Souvenirs des Immatériaux », in Purple Prose, été, vol. 3, p. 66–68
Bewegungslehre, Buchholz und Buchholz, Cologne

1993 Lothar Hempel, « Ich kämpfe um Dich », in Purple, vol. 2, hiver, p. 74–75
Lothar Hempel, « Ballance Akt », AMOKKOMA , Journal Oriental, vol. 1, n° 3
XLV Esposizione Internazionale d'Arte, La Biennale di Venzia, Venise
« Aperto '93 », in Flash Art International, p. 302–303

1992 *Paradise Europe*, BizArt Forlag, Copenhague
Gregor Schwering, « Junge Kunst aus Köln », in ZYMA, novembre

Evénements

1995 *Trinkwasser!*, Festival de Jazz de Cologne
Wie kann ich sagen, was ich denke, bevor ich höre, was ich sage!, avec Carsten Höller, production de Casino I., Red Salon in the Volksbühne, Berlin
King's Cross Project, Public Art Development Trust, Londres

Collections publiques

Sammlung Goetz, Munich
The Saatchi Gallery, Londres
Frac Poitou-Charentes, Angoulême

* publications

Colophon

Cette monographie parait à l'occasion de l'exposition *Lothar Hempel. Alphabet City*, Le Magasin – Centre National d'Art Contemporain de Grenoble, du 11 février au 6 mai 2007

Exposition

Commissariat général
 Yves Aupetitallot
Commissariat de l'exposition
 Florence Derieux
Coordination de l'exposition
 Inge Linder-Gaillard
 avec le concours de Anaëlle Pirat
Régie
 Art Project (direction Patrick Ferragne)
Administration générale
 Thomas Vasseur, secrétaire général
 avec l'assistance de Jacqueline Dervaux,
 assistante de direction, Francine
 Monteiro-Pereira, comptable et Denis
 Bastien, technicien
Communication
 Anne Morel, chargée de communication
 avec l'assistance de Frédéric Besson,
 webmaster et Roxanne Leroux, assistante,
 en collaboration avec Claudine Colin
 Communication, Paris
Service culturel
 Anne Langlais-Devanne, chargée des
 publics avec l'assistance de Laure Heinen,
 professeur relais de l'Education nationale,
 Laetitia Bischoff, Christelle Colborati,
 Guillaume Le Moine, Roman Scrittori, Karine
 Trabucco et Agnès Vidal
Ecole du Magasin
 Alice Vergara-Bastiand, coordinatrice
 avec l'assistance de Virginie Theviot
Librairie
 Alice Vergara-Bastiand, responsable
 Fadma Kaddouri, libraire

Magasin

 Centre National d'Art Contemporain
 de Grenoble
 Site Bouchayer-Viallet
 155 cours Berriat
 38028 Grenoble cedex 1
 France
 T +33 (0)4 76 21 95 84
 E communication@magasin-cnac.org
 www.magasin-cnac.org

Le Magasin est une association loi 1901 présidée par M. Daniel Janicot, subventionnée par le Ministère de la Culture et de la Communication – Direction Régionale des Affaires Culturelles Rhône-Alpes, la Région Rhône-Alpes, le Département de l'Isère et la Ville de Grenoble.

Remerciements

Le Magasin – Centre National d'Art contemporain de Grenoble souhaite remercier tous les prêteurs :
 Anton Kern Gallery, New York
 Art : Concept, Paris
 c/o – Atle Gerhardsen, Berlin
 Stuart Shave/Modern Art, Londres
 Collection Olivier Antoine, Paris
 Collection Michael Benevento, New York
 Collection BM, Dublin
 Collection Annie Camarda
 Collection Amalia Dayan et Adam
 Lindemann
 Collection De Bruin-Heijn
 Collection Fondazione Sandretto Re
 Rebaudengo, Turin
 Collection Charlotte et Bill Ford
 Collection Atle Gerhardsen, Berlin
 Collection Nicolai Gerner-Mathisen, Berlin
 Collection Hall
 Collection Hort Family
 Collection Ebrahim Melamed / Honart
 Museum, Téhéran
 Collection Tim Nye et Foundation 2021
 Collection Galerie Emmanuel Perrotin,
 Paris / Miami
ainsi que ceux qui ont souhaité conserver l'anonymat.

Nos chaleureux remerciements vont également à :
Anton Kern, Christoph Gerozissis,
Emily Schroeder (Anton Kern Gallery),
Olivier Antoine, Caroline Maestrali
(Art:Concept, Paris), Atle Gerhardsen,
Nicolai Gerner-Mathisen, Maike Fries
(c/o – Atle Gerhardsen, Berlin), Stuart Shave
(Stuart Shave / Modern Art, Londres),
Patrizia Re Rebaudengo, Francesco Bonami,
Carla Mantovani (Fondazione Sandretto Re
Rebaudengo, Turin).

L'artiste souhaite remercier particulièrement :
Florence Derieux, Yves Aupetitallot,
Inge Linder-Gaillard et l'équipe du Magasin,
Gilles Gavillet, Lionel Bovier, Anton Kern,
Christoph Gerozissis, Michael Clifton,
Emily Schroeder, Jeffrey Porterfield,
Joshua Smith, Olivier Antoine, Gió Marconi,
Stuart Shave, Atle Gerhardsen,
Nicolai Gerner-Mathisen, Maike Fries,
Lars Morell, Sir Liam Gillick, Lars Bang Larsen,
Lili Reynaud Dewar, Michael Jaeger,
Emma Stern, Walter Hempel et tous les
Hempel ; il remercie tout spécialement
Petruschka Hollenbach.

Publication

Direction éditoriale
 Florence Derieux
Lectorat et correction
 Clare Manchester
Traductions
 Gauthier Herrmann (anglais-français :
 L. Gillick, L. Bang Larsen)
 Judith Hayward (français-anglais :
 F. Derieux, L. Reynaud Dewar)
Conception graphique
 Gavillet & Rust, Genève
Image de couverture
 So wird es immer weiter gehen
 (This Is Going To Carry On For Ever), 2004
 Technique mixte sur papier métallique ;
 50 x 50 cm
 Courtoisie Art:Concept, Paris
Crédits photographiques
 Lothar Hempel
 Anton Kern Gallery : Adam Reich
 Art:Concept : Marc Domage
 c/o – Atle Gerhardsen : Matthias Kolb,
 Hans-Georg Gaul, Juerg Isler
 P.S.1/MoMA : Eileen Costa
 Sammlung Goetz : Nic Tenwiggenhorn,
 VG Bild-Kunst
 FRAC Poitou-Charentes : Christian Vignaud
 Unlimited Contemporary Art: Stathis
 Mamalakis
Lithogravure et fabrication
 Musumeci S.p.A., Quart (Aosta)
Caractère typographique
 Linotype Neuzeit Office
Remerciements
 Lars Bang Larsen, Liam Gillick, Lili Reynaud
 Dewar, Ghislaine Dantan (Unlimited
 contemporary art, Athènes), Isabelle
 Delamont (Frac Poitou-Charentes,
 Angoulême), Christoph Kölbl (Sammlung
 Goetz, Munich), Gemma Sharpe (ICA,
 Londres)

Publié par
 JRP|Ringier
 Letzigraben 134
 CH-8047 Zurich
 T +41 (0) 43 311 27 50
 F +41 (0) 43 311 27 51
 www.jrp-ringier.com
 info@jrp-ringier.com

En coédition avec Le Magasin
 Centre National d'Art Contemporain
 de Grenoble

ISBN 978-3-905770-47-6

Les titres publiés par JRP|Ringier sont disponibles
dans le réseau international de librairies spécialisées
et sont distribués par les partenaires suivants :

Suisse
 Buch 2000, AVA Verlagsauslieferung AG,
 Centralweg 16, CH – 8910 Affoltern a.A.,
 buch2000@ava.ch, www.ava.ch
Allemagne et Autriche
 Vice Versa Vertrieb, Immanuelkirchstrasse 12,
 D-10405 Berlin, info@vice-versa-vertrieb.de,
 www.vice-versa-vertrieb.de
France
 Les Presses du réel, 16 rue Quentin,
 F – 21000 Dijon, info@lespressesdureel.com,
 www.lespressesdureel.com
Angleterre
 Cornerhouse Publications, 70 Oxford Street,
 UK-Manchester M1 5NH,
 publications@cornerhouse.org,
 www.cornerhouse.org/books
Etats-Unis
 D.A.P./Distributed Art Publishers, 155 Sixth
 Avenue, 2nd Floor, New York, USA – NY
 10013, dap@dapinc.com, www.artbook.com
Autres pays
 IDEA Books, Nieuwe Herengracht 11, NL –
 1011 RK Amsterdam, idea@ideabooks.nl,
 www. ideabooks.nl

Pour obtenir une liste de nos librairies-partenaires
dans le monde ou pour toute autre question,
contactez JRP|Ringier directement à info@jrp-
ringier.com, ou visitez notre site Internet
www.jrp-ringier.com pour plus d'informations sur
la compagnie et le programme éditorial.